EVERY DAY A WORD
SURPRISES ME

& OTHER QUOTES BY WRITERS

“

”

PREFACE

The practice of writing demands extraordinary discipline and resilience. Writers work tirelessly, usually in isolation, as they take on the painstaking process of organizing thoughts into words and corralling those words into sentences, to form the sturdy building blocks of their craft. "Surely it is a magical thing," observes novelist Jhumpa Lahiri, "for a handful of words, artfully arranged, to stop time."

The art of conjuring a world for the reader is a mysterious one, in part because the creative process often takes place behind closed doors. <u>Every Day a Word Surprises Me</u> swings those doors open, giving us access to the gifted minds responsible for some of history's most celebrated novels, poems, essays, plays, and other brilliant works.

In this collection we learn where our favorite authors get their ideas; who they count among their influences; which tools they can't work without; what they think of punctuation, publishing, and book tours; whether they appreciate or dread their editors (or a mix of both); how they cope with rejection and navigate success.

We also discover more personal details otherwise buried in journals, notebooks, memoirs, and other original sources. Jorge Luis Borges admits that public speaking terrifies him. W. H. Auden is addicted to detective stories. William S. Burroughs is interested in the subject of exorcism. Marianne Moore wishes she knew how to fence.

The confessions offer insight into the minds of the writers we revere, while their guidance—generously dispensed in this volume—turns the tables, urging us to reflect on our own lives. In a few words, Jane Kenyon shares wisdom we can't afford to ignore, regardless of our age: "Be a good steward of your gifts." And Annie Dillard's deceptively simple reminder that "how we spend our days is, of course, how we spend our lives" quietly encourages us to pay attention to the small choices we make, which add up to something considerably larger: the narrative of our lives.

These philosophical life lessons are accompanied by practical words to live by. "Be happy, take care of your teeth, always let your conscience be your guide," advises Patti Smith. Marcus Aurelius contributes this two-word slogan: "Uncomplicate yourself." And in a diary entry from 1854, Leo Tolstoy channels the words of a lifestyle coach: "Keep your clothes neat and tidy; it gives you self-confidence and composure in your bearings."

"Every day a word surprises me" is a quotation by the British neurologist and author Oliver Sacks, and this collection is inspired by his legacy of wonder and curiosity. Its pages are filled with surprises and hard-earned advice, communicated with the eloquence and clarity that only the world's finest writers could summon.

LIFE IS LONG IF YOU KNOW HOW TO USE IT.

BE A GOOD STEWARD OF YOUR GIFTS.

JANE KENYON

HOW WE SPEND OUR DAYS IS, OF COURSE, HOW WE SPEND OUR LIVES.

ANNIE DILLARD

ALMOST EVERYTHING WILL WORK AGAIN IF YOU UNPLUG IT FOR A FEW MINUTES— INCLUDING YOU.

ANNE LAMOTT

GET UP QUICKLY— JUST SWITCH ON THE WHITE LIGHT OF THE WILL.

SUSAN SONTAG

KEEP BUSY
WITH SURVIVAL.
IMITATE THE TREES.
LEARN TO LOSE IN
ORDER TO RECOVER,
AND REMEMBER THAT
NOTHING STAYS THE
SAME FOR LONG.

MAY SARTON

EXPLORE UNFAMILIAR SECTIONS— ON FOOT IF WET, ON BICYCLE IF DRY.

HENRY MILLER

THE REASON TO TRAVEL: THERE ARE INNER TRANSITIONS WE CAN'T PROPERLY CEMENT WITHOUT A CHANGE OF LOCATIONS.

ALAIN DE BOTTON

TALK TO STRANGERS.

AUSTIN KLEON

SEE OTHER SKIES AND SEAS.

GUSTAVE FLAUBERT

Follow the accident,
fear the fixed plan—
that is the rule.

JOHN FOWLES

MAKE GLORIOUS, AMAZING MISTAKES.

NEIL GAIMAN

From now on
specialize; never again
make any concession
to the ninety-nine
parts of you which are
like everybody else
at the expense of the
one which is unique.

CYRIL CONNOLLY

RUPTURES ALMOST ALWAYS LEAD TO A STRONGER PROJECT.

ANNE CARSON

Self-criticism, like self-administered brain surgery, is perhaps not a good idea.

JOYCE CAROL OATES

YOU SHOULD FEEL
SLIGHTLY INCOMPETENT
AT WHAT YOU'RE TRYING
TO DO. THE MINUTE YOU
START TO FEEL LIKE AN
EXPERT, WHAT YOU REALLY
ARE IS A HACK.

MICHAEL CUNNINGHAM

Keep your clothes
neat and tidy;
it gives you
self-confidence and
composure in
your bearings.

LEO TOLSTOY

WALK TALL. KICK ASS. LEARN TO SPEAK ARABIC.

HUNTER S. THOMPSON

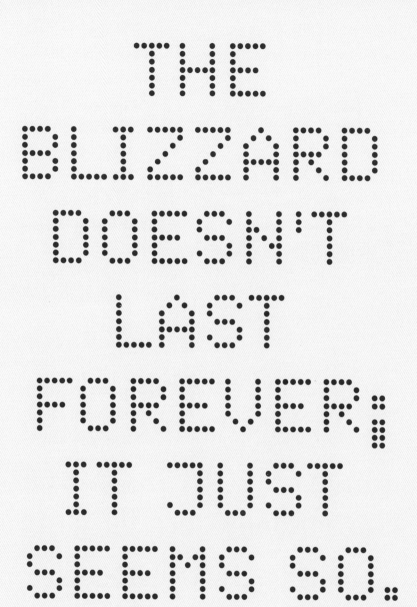

THE BLIZZARD DOESN'T LAST FOREVER; IT JUST SEEMS SO.

RAY BRADBURY

DO BACK EXERCISES. PAIN IS DISTRACTING.

MARGARET ATWOOD

PLEASE—TAKE CARE
OF YOUR HEALTH!
BEING A POET IS ONE OF
THE UNHEALTHIER JOBS—
NO REGULAR HOURS—
SO MANY TEMPTATIONS!

ELIZABETH BISHOP

BE HAPPY,
TAKE CARE OF
YOUR TEETH,
ALWAYS LET YOUR
CONSCIENCE
BE YOUR GUIDE.

PATTI SMITH

UNCOMPLICATE
YOURSELF.

MARCUS AURELIUS

APPEAR IN PLAYBOY.

IRWIN SHAW

HAVE
REGRETS.
THEY
ARE FUEL.
ON THE
PAGE THEY
FLARE
INTO DESIRE.

GEOFF DYER

I think we are well advised to keep on nodding terms with the people we used to be....Otherwise they turn up unannounced and surprise us, come hammering on the mind's door at 4 a.m. of a bad night and demand to know who deserted them, who betrayed them, who is going to make amends.

JOAN DIDION

I am very handy with my advice and then when anybody appears to be following it, I get frantic.

FLANNERY O'CONNOR

Best advice I ever got was an old friend of mine, a black friend, who said you have to go the way your blood beats. If you don't live the only life you have, you won't live some other life, you won't live any life at all.

JAMES BALDWIN

PAY ATTENTION TO WHAT YOU PAY ATTENTION TO.

AMY KROUSE ROSENTHAL

Life is not a checklist of acquisition or achievement. Your qualifications, your CV, are not your life, though you will meet many people of my age and older who confuse the two.

J. K. ROWLING

I URGE YOU TO PLEASE NOTICE WHEN YOU ARE HAPPY, AND EXCLAIM OR MURMUR OR THINK AT SOME POINT, "IF THIS ISN'T NICE, I DON'T KNOW WHAT IS."

KURT VONNEGUT

DO NOT OVERLOOK THE LITTLE JOYS!

HERMANN HESSE

TO AFFECT THE QUALITY OF THE DAY, THAT IS THE HIGHEST OF ARTS.

HENRY DAVID THOREAU

WHAT I'M REALLY CONCERNED ABOUT IS REACHING ONE PERSON.

JORGE LUIS BORGES

I want to have
a relationship with
the reader.

ITALO CALVINO

I WRITE FOR MY WIFE,
MY AGENT,
AND MY EDITOR.

DENIS JOHNSON

**BETTER
TO WRITE FOR
YOURSELF
AND HAVE
NO PUBLIC,
THAN TO
WRITE FOR
THE PUBLIC
AND HAVE
NO SELF.**

CYRIL CONNOLLY

I LET THE
AUDIENCE
FOLLOW ME,
IF IT IS
INTERESTED.

RICHARD WRIGHT

WHOM DO
I WRITE FOR?
FOR ANYBODY
WHO WILL
READ ME.
WHOM DO
I WRITE TO,
DIRECTLY TO?
NOBODY
BUT MYSELF.

ALFRED KAZIN

With almost
every book
I've written,
my secret
target audience
is the young
therapist.

IRVIN D. YALOM

You can't just
write and write and put
things in a drawer.
They wither without
the warm sun of someone
else's appreciation.

ANNE MORROW LINDBERGH

YOU MUST BE AWARE THAT YOUR READER IS AT LEAST AS BRIGHT AS YOU ARE.

WILLIAM MAXWELL

CHILDREN ARE DEMANDING. THEY ARE THE MOST ATTENTIVE, CURIOUS, EAGER, OBSERVANT, SENSITIVE, QUICK, AND GENERALLY CONGENIAL READERS ON EARTH.

E. B. WHITE

I'VE ALWAYS TRIED OUT MY MATERIAL ON MY DOGS FIRST. YOU KNOW, WITH ANGEL, HE SITS THERE AND LISTENS AND I GET THE FEELING HE UNDERSTANDS EVERYTHING. BUT WITH CHARLEY, I ALWAYS FELT HE WAS JUST WAITING TO GET A WORD IN EDGEWISE.

JOHN STEINBECK

A man really writes for an audience of about ten persons. Of course if others like it, that is clear gain. But if those ten are satisfied, he is content.

ALFRED NORTH WHITEHEAD

WITH EVERY BOOK, YOU PISS OFF A BUNCH OF PEOPLE WHO LIKE A SPECIFIC THING AND ARE HOPING FOR THAT SPECIFIC THING AGAIN.

NEIL GAIMAN

I never think of audience. I hate that word. I think of a reader. I think my poems want a reader, and they're completed by a reader.

LOUISE GLÜCK

A GREAT PART OF WRITING IS HOPING TO MAKE THINGS AS NICE AS POSSIBLE FOR THE READER— BE A GOOD HOST, HAVE THEM PUT THEIR FEET UP BY THE FIRE, PULL UP A CHAIR, GET OUT A GOOD WINE.

MARTIN AMIS

The nicest audience I ever had was children (at the American school in Rio). They asked such good questions, like, Why did you choose this word instead of that. Simple, practical things, which is the way you write, of course.

ELIZABETH BISHOP

I'M RATHER HOSTILE TOWARD AUDIENCES— I DON'T MUCH CARE FOR LARGE BODIES OF PEOPLE COLLECTED TOGETHER.

HAROLD PINTER

THE GREAT THING ABOUT WRITING A BOOK IS THAT IT BRINGS YOU INTO CONTACT WITH PEOPLE WHOSE OPINIONS YOU SHOULD HAVE CANVASSED BEFORE YOU EVER PRESSED PEN TO PAPER.

CHRISTOPHER HITCHENS

Over the years, countless readers have come up to me and declared how much they love A Thousand Acres. I've always wanted to say, "Oh, you're kidding." I find that novel interesting, moving, and challenging, but I don't find it lovable.

JANE SMILEY

I never had an audience until I was past fifty. But I wrote all the time anyway. I had to.

WILLIAM CARLOS WILLIAMS

READERS MULTIPLY THE RICHNESS OF THE BOOK, THE EXPERIENCE. OBVIOUSLY, I PUT A LOT OF THOUGHT INTO THE BOOK, TRY TO PRODUCE THE BEST BOOK POSSIBLE, BUT THE MEANING OF THE BOOK IS NOT SOMETHING THAT IS MINE.

JONATHAN SAFRAN FOER

I NEVER WROTE ONE SINGLE LINE OF POETRY WITH THE LEAST SHADOW OF PUBLIC THOUGHT.

JOHN KEATS

I DON'T EVEN WANT TO PLEASE THE READER, I WANT TO CHANGE THEM.

JEANETTE WINTERSON

MY BOOKS START ALMOST BEFORE I REALIZE IT.

E. L. DOCTOROW

I BEGIN WITH A SCENE. THREE GIRLS ARE SITTING DOWN AT A BREAKFAST TABLE IN PERU—AND I JUST KNOW THAT IF I KEEP WRITING, SOMETHING WILL HAPPEN.

MICHAEL ONDAATJE

STEPPING FROM THE TITLE TO THE FIRST LINES IS LIKE STEPPING INTO A CANOE. A LOT OF THINGS CAN GO WRONG.

BILLY COLLINS

I AM ABOUT TO START TRYING TO PUT A NEW NOVEL ON THE PAGE BEGINNING AFTER [THE] NEW YEAR, AND I AM ALL QUIVERS AND QUAKES. IT'S LIKE STARTING OUT TO SWIM ACROSS LAKE SUPERIOR IN WINTER.

WALLACE STEGNER

WHEN I START A BOOK—AND I'M SURE I'M NOT THE ONLY ONE—I FIND MYSELF LITERALLY SUBMERGED BY THE MATERIAL. SOMEWHAT AS IF A MULTITUDE OF POSSIBLE BOOKS WERE WAITING TO BE BORN.

EDMOND JABÈS

I BELIEVE THAT THE MAIN THING IN BEGINNING A NOVEL IS TO FEEL, NOT THAT YOU CAN WRITE IT, BUT THAT IT EXISTS ON THE FAR SIDE OF A GULF, WHICH WORDS CAN'T CROSS—THAT IT'S TO BE PULLED THROUGH ONLY IN A BREATHLESS ANGUISH.

VIRGINIA WOOLF

I type out beginnings and they're awful, more of an unconscious parody of my previous book than the breakaway from it that I want. I need something driving down the center of a book, a magnet to draw everything to it— that's what I look for during the first months of writing something new.

PHILIP ROTH

WHEN BEGINNING, BE HUMBLE. REMEMBER THAT YOUR FIRST, BLANK PAGE HAS THIS IN COMMON WITH ALL OTHER BLANK PAGES: IT HAS NOT READ YOUR PREVIOUS WORKS. DON'T BE ENTHRALLED BY THE SOUND OF YOUR OWN VOICE.

JOHN IRVING

NEVER OPEN A BOOK WITH WEATHER.

ELMORE LEONARD

I START ALL MY BOOKS ON JANUARY 8TH. CAN YOU IMAGINE JANUARY 7TH? IT'S HELL.

ISABEL ALLENDE

I am in the first stage of a new book, which consists in going round and round the idea, as you see a bird in his cage go about and about his sugar before he touches it.

CHARLES DICKENS

I'm convinced there is no more perfect way to begin a story than "Once upon a time."

ALICE HOFFMAN

BUILD A CORNER. THIS IS
WHAT PEOPLE WHO ARE GOOD AT
PUZZLES DO. THEY IGNORE THE HEAP
OF COLORS AND SHAPES AND SIMPLY
LOOK FOR THE STRAIGHT EDGES.
THEY FOCUS ON PIECING TOGETHER
ONE TINY CORNER. EVERY BOOK,
STORY, AND ESSAY BEGINS WITH
A SINGLE WORD.

DANI SHAPIRO

STARTING A NOVEL ISN'T
SO DIFFERENT FROM
STARTING A MARRIAGE.
THE DREAMS YOU
PIN ON THESE PEOPLE
ARE ENORMOUS.

ANN PATCHETT

EACH BOOK
I'VE WRITTEN
HAS STARTED
OFF WITH
WHAT I'D CALL
A BUZZ IN
THE HEAD.

PAUL AUSTER

THE TRUE HEART OF THE WORLD IS A BOOK.

D. H. LAWRENCE

A BOOK MUST BE THE AXE FOR THE FROZEN SEA INSIDE US.

FRANZ KAFKA

One of my earliest recollections is of playing with books in my father's study—building houses and bridges of the big dictionaries and diaries, looking at pictures, pretending to read, and scribbling on blank pages whenever pen or pencil could be found.

LOUISA MAY ALCOTT

I CAN THINK OF FEW BETTER WAYS TO INTRODUCE A CHILD TO BOOKS THAN TO LET HER STACK THEM, UPEND THEM, REARRANGE THEM, AND GET HER FINGERPRINTS ALL OVER THEM.

ANNE FADIMAN

IT WASN'T UNTIL I DISCOVERED BOOKS THAT I BEGAN TO FEEL ANY FONDNESS TOWARD THIS ADVENTURE THAT I WAS ON, THIS ADVENTURE CALLED IMMIGRATION.

JUNOT DÍAZ

There are a few books I have read that I've never been the same after.

DAVID FOSTER WALLACE

SOMETIMES I THINK OF THE BOOKS I'LL NEVER READ THAT WOULD HAVE CHANGED MY LIFE.

JONATHAN SAFRAN FOER

MY ALMA MATER WAS BOOKS.

MALCOLM X

What an astonishing thing a book is. It's a flat object made from a tree with flexible parts on which are imprinted lots of funny dark squiggles. But one glance at it and you're inside the mind of another person, maybe somebody dead for thousands of years.

CARL SAGAN

IT HAD BEEN STARTLING...TO FIND OUT THAT STORY BOOKS HAD BEEN WRITTEN BY PEOPLE, THAT BOOKS WERE NOT NATURAL WONDERS, COMING UP OF THEMSELVES LIKE GRASS.

EUDORA WELTY

WHEN SOMEONE HANDS ME A 750-PAGE TOME, MY FIRST REACTION IS, OH FUCK YOU. I DON'T WANT TO READ YOUR GIANT BOOK.

MICHAEL CUNNINGHAM

I concede very little importance to my books. I am much more interested in the books of others.

ROBERTO BOLAÑO

I quite agree with what you say about buying books, and love the planning and scheming beforehand, and if they come by post, finding the neat little parcel waiting for you on the hall table and rushing upstairs to open it in the privacy of your own room.

C. S. LEWIS

THERE ARE TWO PERFUMES TO A BOOK. IF A BOOK IS NEW, IT SMELLS GREAT. IF A BOOK IS OLD, IT SMELLS EVEN BETTER. IT SMELLS LIKE ANCIENT EGYPT.

RAY BRADBURY

The world is drowning in books; even if you read a great masterpiece every day, you'd never be able to read all the ones that exist already. So if you want to add a book to that mountain, it had better be necessary.

SALMAN RUSHDIE

Books are just like people; some have good luck in their making and some have bad.

WILLA CATHER

A book is a cubic piece of burning, smoking conscience— and nothing else.

BORIS PASTERNAK

The dearest ones of time, the strongest friends of the soul—BOOKS.

EMILY DICKINSON

BOOKS ARE
KINETIC,
AND LIKE ALL
HUGE FORCES,
NEED TO BE
HANDLED
WITH CARE.
BUT THEY DO
NEED TO
BE HANDLED.

JEANETTE WINTERSON

THERE IS NOTHING IN OUR MATERIAL WORLD MORE BEAUTIFUL THAN THE BOOK.

PATTI SMITH

YOU CAN NEVER KNOW ENOUGH ABOUT YOUR CHARACTERS.

W. SOMERSET MAUGHAM

WHILE THIS BOOK
WAS BEING WRITTEN
I FELT THAT I WAS
RESPONSIBLE
FOR SOMEONE. IF I
STOPPED, THE
CHARACTERS DIED.

JOHN STEINBECK

I BELIEVE THESE
STORIES HAVE BEEN
ENTRUSTED TO ME,
AND I WANT TO PRESENT
MY CHARACTERS
WITH THE COMPLEXITY
OF HUMAN BEINGS.

GLORIA NAYLOR

THE LEGEND
THAT CHARACTERS RUN
AWAY FROM THEIR
AUTHORS—TAKING UP
DRUGS, HAVING SEX
OPERATIONS, AND
BECOMING PRESIDENT—
IMPLIES THAT THE
WRITER IS A FOOL WITH
NO KNOWLEDGE OR
MASTERY OF HIS CRAFT.
THIS IS ABSURD.

JOHN CHEEVER

I don't have
any control over
my characters.
At any given time,
there are scores
of characters yelling
at each other,
yelling at me, inside
my head. Some
of them sort of take
over, and I become
totally intrigued or
mesmerized by them.

BHARATI MUKHERJEE

My favorite characters
are those who start
off in a box—few options,
societal constraints—
but who transcend their
circumstances and find that
they are capable of
becoming people they did
not expect to be.

GERALDINE BROOKS

**I'M DRAWN TO
CHARACTERS WHO,
FOR ONE REASON
OR ANOTHER, SEEM
TO FIND THEMSELVES
DESPERATELY OUT
OF JOINT.**

CHANG-RAE LEE

The only people who don't
really interest me are
sociopaths. Because they're
like clocks. They're set.
The springs go a certain way
and they can't vary it.
They can't say I'm sorry.

PAULA FOX

I THINK OF MY CHARACTERS AS I WANDER THROUGH THE GROCERY STORE. I WRITE OUT THEIR NAMES LIKE A TEENAGE GIRL DREAMING OF MARRIAGE.

ANN PATCHETT

I DON'T REREAD MY BOOKS BUT I REMEMBER THE CHARACTERS AND SOMETIMES I SEEM TO RUN INTO THEM IN LIFE, AT A STREET CORNER OR ON THE SUBWAY.

YIYUN LI

I DISAPPEARED INTO BOOKS WHEN I WAS VERY YOUNG, DISAPPEARED INTO THEM LIKE SOMEONE RUNNING INTO THE WOODS.

REBECCA SOLNIT

I REMEMBER AS A CHILD, MAYBE EVEN IN MY CRIB, I WAS TAPPING OUT THE RHYTHM OF SENTENCES ON THE HEADBOARD.

ROBERT PINSKY

MY INTEREST IN WRITING STARTED LONG BEFORE I KNEW HOW ONE WENT ABOUT IT. YOU COULD SAY IT STARTED AS SOON AS I LEARNED THE FIRST FEW LETTERS OF THE ARABIC ALPHABET.

NURUDDIN FARAH

I LOVED ENCYCLOPEDIA BROWN AS A KID.

JUNOT DÍAZ

AFTER I READ <u>CHARLOTTE'S WEB</u>, I BECAME SO OBSESSED WITH PIGS THAT MY STEPFATHER GOT ME ONE FOR MY NINTH BIRTHDAY. IT WAS BECAUSE OF THAT PIG THAT I BECAME A VEGETARIAN. THAT'S IMPACT.

ANN PATCHETT

AS A CHILD I WAS A CONSTANT, ALMOST OBSESSIVE READER OF ABSOLUTELY ANYTHING IN PRINT, INCLUDING APPLIANCE MANUALS.

ANNE TYLER

I READ HENRY JAMES AND EDITH WHARTON BEFORE I WAS 12 YEARS OLD.

JAMES THURBER

SINCE THE AGE OF EIGHT I HAVE BEEN MADLY SCRIBBLING.

LAWRENCE DURRELL

WHEN I WAS A KID, I DREW A LOT, SO I GRAVITATED TO OVERSIZED BOOKS WITH A LOT OF ARTWORK— BOOKS ABOUT GIANTS, GNOMES, NORSE MYTHS, AND SPACE TRAVEL.

DAVE EGGERS

My earliest fictional characters were zestfully if crudely drawn, upright chickens and cats engaged in various dramatic confrontations.

JOYCE CAROL OATES

As a very small girl I used to make up my own newspapers. I would laboriously copy the layout of The Star—even to the small black stars which used to be on the front page—and fill it with my own stories.

NADINE GORDIMER

BY THE TIME I WAS EIGHT I WAS PUTTING FOLK LEGENDS AND GHOST STORIES INTO MY OWN WORDS, TELLING THEM AROUND THE CAMPFIRE AT SUMMER CAMP AND ON BOY SCOUT TRIPS. I WAS LOUSY AT SPORTS, BUT I COULD KEEP THE OTHER KIDS ON THE EDGE OF THEIR LOGS.

ARMISTEAD MAUPIN

I wrote my first story ever when I was seven, about a robber who comes into a house and kills everybody, but miraculously they all come alive.

PAULA FOX

I REMEMBER EVERY YEAR IN SCHOOL HAVING TO WRITE AN ESSAY ON THRIFT FOR SOME ANNUAL THRIFT ESSAY CONTEST, AND NEVER WINNING.

JOE BRAINARD

The things I loved when I was young—the Bee Gees, the soundtrack to Funny Girl, the poems of Plath and Sexton— I still love.

LORRIE MOORE

I PLAYED LINUS IN MY SUMMER CAMP PRODUCTION OF YOU'RE A GOOD MAN, CHARLIE BROWN AND HAVE BEEN ADDICTED TO THE COMIC STRIP EVER SINCE.

ANDREW SOLOMON

FOR A YEAR (AGE THIRTEEN) I CARRIED THE MEDITATIONS OF MARCUS AURELIUS ALWAYS WITH ME IN MY POCKET. I WAS SO AFRAID OF DYING—AND ONLY THAT BOOK GAVE ME SOME CONSOLATION, SOME FORTITUDE.

SUSAN SONTAG

WHEN I WAS FIVE,
I AM TOLD, AND ASKED WHAT
MY FAVORITE THINGS IN THE
WORLD WERE, I ANSWERED,
"SMOKED SALMON AND BACH."
(NOW, SIXTY YEARS LATER, MY
ANSWER WOULD BE THE SAME.)

OLIVER SACKS

FOR A LONG TIME
I GLOATED OVER THE
HAPPY SECRET THAT WHEN
I PLAYED OUTDOORS
IN THE MOONLIGHT,
THE MOON FOLLOWED ME,
WHICHEVER WAY I RAN.

ZORA NEALE HURSTON

MORE THAN
ONE TEACHER I HAD
IN ELEMENTARY
SCHOOL WROTE ON MY
REPORT CARD, "PETER
IS TOO SENSITIVE."

PETER SCHJELDAHL

UNTIL I GOT
SPECTACLES
WHEN I WAS
FOUR I THOUGHT
TREES WERE
GREEN CLOUDS.

AUDRE LORDE

I'M A SUCKER FOR DOG TRAINING BOOKS.

AMY TAN

NO, I HAVE NOT READ WITTGENSTEIN.

SAMUEL BECKETT

FINNEGANS WAKE. CAN'T FINISH IT. JUST CAN'T.

JEANNETTE WALLS

I'VE SUFFERED BECAUSE I'VE BEEN SO SHY ALL MY LIFE.

ELIZABETH BISHOP

My shyness has actually grown more acute over time, just like my terror of speaking in public: I was less afraid the first time than I am now because I'm a veteran, let's say, of the panic.

JORGE LUIS BORGES

I HAVE ALWAYS BEEN A WRETCHED SPEAKER.

VLADIMIR NABOKOV

WORST OF ALL I FEAR MEDIOCRITY.

FYODOR DOSTOEVSKY

I'M SCARED OF TYPHUS!

ANTON CHEKHOV

I DON'T CRY. UNFORTUNATELY, I SEEM RATHER SHORT OF TEARS, SO MY SORROWS HAVE TO STAY INSIDE ME.

NADINE GORDIMER

VENICE MAKES ME WEEP.

SUSAN SONTAG

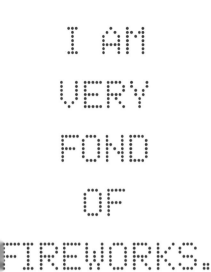

I AM VERY FOND OF FIREWORKS.

OCTAVIO PAZ

I HAPPEN TO LOVE TROLLEY CARS.

E. L. DOCTOROW

I WISH I COULD FENCE.

MARIANNE MOORE

FOR ME,
AS FOR MANY
OTHERS,
THE READING
OF DETECTIVE
STORIES IS
AN ADDICTION
LIKE TOBACCO
OR ALCOHOL.

W. H. AUDEN

I like the Geico
commercials about
the cavemen.

BHARATI MUKHERJEE

**I LOVE
EAVESDROPPING.**

GRAHAM GREENE

I adore ball gowns.
I love their cut,
their architecture,
and the thought
of the hands of so
many seamstresses
working on them.

PATTI SMITH

I AM NOT
A PASSIONATE
PERSON.

ITALO CALVINO

**Exorcism is
a subject that
interests me.**

WILLIAM S. BURROUGHS

I HAVE TO READ
ELOISE ONCE A MONTH
OR I'LL PERISH.

LENA DUNHAM

**I WILL
DO ANYTHING
TO AVOID
BOREDOM.
IT IS THE
TASK OF
A LIFETIME.**

ANNE CARSON

I'M HAPPIER
BEING OUTSIDE
THE FLOW.

NICHOLSON BAKER

I WOULD GIVE ALL MY PROFOUND GREEK TO DANCE REALLY WELL.

VIRGINIA WOOLF

I DON'T WRITE WITH A HAMMER AND CHISEL. IT'S NOT SET IN STONE.

AUGUST WILSON

I DO ALL MY WORK ON YELLOW PAPER, SHEETS CUT IN HALF, TYPED THE LONG WAY, TRIPLE-SPACED.

RAYMOND CHANDLER

Before I take pen to paper, I read. I can't begin my day reading fiction; I need the more intimate tone of letters and journals.

MARY GORDON

I KEEP NOTES— IDEAS, DETAILS. I PUT THEM ON INDEX CARDS AND FILE THE CARDS BY KEYWORD.

HA JIN

If I can move in a linear way through the story, and stay zipped inside the story, not jinx myself with despair or frustration or over-confidence or self-consciousness, **and be basically okay with not knowing what is going to happen from one sentence to the next, that's a great writing day.**

KAREN RUSSELL

I always write a book through the first time by hand.

WILLA CATHER

I MUST ALWAYS WRITE MY BOOKS TWICE.

D. H. LAWRENCE

I PAY A LOT OF ATTENTION TO WHITE SPACE.

JACQUELINE WOODSON

I am in the garret with my papers round me, and a pile of apples to eat while I write my journal, plan stories, and enjoy the patter of rain on the roof, in peace and quiet.

LOUISA MAY ALCOTT

A great deal of my poetry has been written while I have been out walking.

WALLACE STEVENS

Be sure you put to each poem the date at which you wrote it. Your poems will thus serve as a diary of your progress. I have done it for many years, and can see its use.

JOHANN WOLFGANG VON GOETHE

THERE ARE ASPECTS OF MUSIC THAT I BORROW AND USE IN MY WORK: REPETITION AND REVISION. A BIG PART OF JAZZ IS REPEAT AND REVISE, AND REPEAT AND REVISE. THAT'S WHAT MY WORK IS ALL ABOUT.

SUZAN-LORI PARKS

MY COMPUTER IS WORKING ON A MEMOIR OF THE EARLY 1950S, AND I'M SIMPLY HANGING ONTO ITS COATTAILS.

JAMES MERRILL

REVISION IS
WHEN YOU DO WHAT
YOU SHOULD HAVE
DONE THE FIRST
TIME, BUT DIDN'T.
IT'S LIKE WASHING
THE DISHES TWO
DAYS LATER INSTEAD
OF RIGHT AFTER
YOU FINISH EATING.

COLSON WHITEHEAD

THE FIRST DRAFT OF ANYTHING IS SHIT.

ERNEST HEMINGWAY

Taking a book off
the brain is akin to the
ticklish and dangerous
business of taking an
old painting off a panel.

HERMAN MELVILLE

ULYSSES
WILL NOT BE
FINISHED
PROBABLY TILL
THE END OF
NEXT YEAR—
IF EVEN THEN.
A CHAPTER
TAKES ME ABOUT
FOUR OR
FIVE MONTHS
TO WRITE.

JAMES JOYCE

Every day I write.
If there is ever any
interruption, like an
electric-meter man
or a doorbell ringing,
it drives me crazy.

MARGUERITE YOUNG

SOME WRITERS
ARE LIKE CACTI—
EVERY SEVEN
YEARS HERE COMES
A GLORIOUS FLOWER;
THEN THERE'S
ANOTHER SEVEN YEARS
OF HIBERNATION.

JULIAN BARNES

I've often fantasized
I would get a lot
of writing done if
I were put in prison
for a minor crime.
Three to six months.

AMY TAN

Novels take
me a long time;
short fiction
provides a kind
of immediate
gratification—
the relationship
of sketches to
battle paintings.

DONALD BARTHELME

I'M AT PAGE 590 OF
THIS GREAT BLOATED
OVERWRITTEN MONSTER
I'M WORKING ON.
I'M SICK OF IT, AND THERE'S
NO END IN SIGHT.

WILLIAM STYRON

I AM A SLOW WRITER,
A SNAIL CARRYING
ITS HOUSE AT THE RATE
OF TWO HUNDRED
PAGES OF FINAL COPY
PER YEAR.

VLADIMIR NABOKOV

I AM WRITING
EVERY DAY BUT I DON'T
KNOW WHAT, AS
THE BREW HAS NOT
BEGUN TO THICKEN YET.
PLEASE PRAY IT WILL.
SOMETIMES IT DOESN'T.

FLANNERY O'CONNOR

When I'm writing,
I write every day. It's lovely
when that's happening.
One day dovetailing into the
next. Sometimes I don't
even know what day of the
week it is. The "paddle
wheel of days," John Ashbery
has called it.

RAYMOND CARVER

I wrote my first novel
in 1972 (unpublished)
in a one-room apartment
on Crete, using a fragile
Royal portable typewriter,
dressed in a caftan I sewed
from a bedspread.

JANE SMILEY

When I was writing
of Emma Bovary's
poisoning I had such
a taste of arsenic in my
mouth, and was so
poisoned myself that
I had two stomach upsets
on end, two very real
attacks, for I brought up
all my dinner.

GUSTAVE FLAUBERT

I always seem
to be trying
to do six or seven
different poems
at the same time
and just hoping
I can keep them
all well nurtured
enough so that
one of them will
suddenly get
strong enough to
take over all
by itself until
it is done.

ELIZABETH BISHOP

I DON'T WRITE FOR CHILDREN. I WRITE—AND SOMEBODY SAYS, "THAT'S FOR CHILDREN."

MAURICE SENDAK

I WRITE THE WAY
I SHAVE, GOING
OVER AND OVER THE
SAME TERRITORY,
CUTTING, SCRAPING,
SMOOTHING—AND
FOREVER FINDING
ROUGH SPOTS RIGHT
UNDER MY NOSE.

FELIX POLLAK

WHEN I WRITE STORIES I AM LIKE SOMEONE WHO IS IN HER OWN COUNTRY, WALKING ALONG STREETS THAT SHE HAS KNOWN SINCE SHE WAS A CHILD, BETWEEN WALLS AND TREES THAT ARE HERS.

NATALIA GINZBURG

AS I WROTE, I DISCOVERED THAT WRITING, LIKE READING, WAS DONE ONE WORD AT A TIME, ONE PUNCTUATION MARK AT A TIME. IT REQUIRED WHAT A FRIEND CALLS "PUTTING EVERY WORD ON TRIAL FOR ITS LIFE."

FRANCINE PROSE

I sort of collage things; I write in shorter episodic passages— set pieces. I find that when I write fiction it comes to me not quite in episodes but in instances.

PAUL HARDING

WHEN I'M WRITING, MY NEURAL PATHWAYS GET BLOCKED. I CAN'T READ. I CAN BARELY HOLD A CONVERSATION WITHOUT FORGETTING WORDS AND NAMES.

KATE ATKINSON

When I'm working on a book, I'm in a very agitated mental state. My sleep is disrupted. I only dream about the project. My sex drive goes up. My need for exercise, and the catharsis I get from exercise, is greater.

MICHAEL LEWIS

I GET THIS SENSATION OF MOVEMENT, PHYSICAL MOVEMENT, WHILE SITTING THERE IN FRONT OF MY COMPUTER. I MIGHT EVEN HOLD THE EDGE OF THE DESK, AS IF TO BRACE MYSELF.

CHANG-RAE LEE

WRITING FREE VERSE IS LIKE PLAYING TENNIS WITH THE NET DOWN.

ROBERT FROST

I ALWAYS LISTEN TO MUSIC WHILE I'M WRITING. BY THE TIME I FINISH A BOOK I HAVE A HUGE PLAYLIST OF THE MUSIC I'VE BEEN LISTENING TO THROUGHOUT THE WRITING OF IT.

RUTH OZEKI

I'VE NEVER WILLINGLY WRITTEN A WORD WITHOUT LISTENING TO MUSIC.

EDMUND WHITE

AS FOR WORKING CONDITIONS, I CAN PUT UP WITH PRACTICALLY ANYTHING EXCEPT COLD FEET, AND A RADIO PLAYING ANYWHERE WITHIN HEARING.

NADINE GORDIMER

I CAN WORK IN THE
WATER CLOSET, IN THE TRAIN.
WHILE SWIMMING I
PRODUCE A LOT OF THINGS,
ESPECIALLY IN THE SEA.
LESS SO IN THE BATHTUB,
BUT THERE TOO.

UMBERTO ECO

I SPEND MUCH OF MY TIME AWAY FROM THE STUDY.

JOYCE CAROL OATES

IT DOESN'T MATTER WHERE YOU WRITE SO LONG AS YOU HAVE THE WALLS, TYPEWRITER, PAPER, BEER. YOU CAN WRITE OUT OF A VOLCANO PIT.

CHARLES BUKOWSKI

It's only now and then, maybe once every three or four days, that I manage to write a sentence in which I hear that wonderful harmonic chime that you get when, say, you flick the edge of a wine glass with a fingernail. That's what keeps me going.

JOHN BANVILLE

I DON'T KNOW WHETHER I HAVE MUCH NATURAL TALENT GOING FOR ME FICTION-WISE, BUT I KNOW I CAN HEAR THE CLICK, WHEN THERE'S A CLICK.

DAVID FOSTER WALLACE

I LIKE TOFU, BUT AFTER A COUPLE DAYS OF THAT I'M REALLY LOOKING FORWARD TO A BIG PIECE OF MEAT. AND I REALIZED RECENTLY THAT'S ALSO HOW I AM AS A WRITER: EACH BOOK I'VE WRITTEN IS TOTALLY DIFFERENT FROM ANY OTHER.

JENNIFER EGAN

The process for me of finishing a long novel— reading it aloud to my wife at the last, being sure that all of the decisions are made right— it usually stimulates so much anxiety in me, so much tension and stress, that I have to go to the fucking Mayo Clinic when it's over.

RICHARD FORD

IT OFTEN
SEEMED WHEN
I WAS SITTING
DOWN TO WRITE
THAT I WAS
SETTLING INTO
A TOBOGGAN,
READYING TO
ZOOM DOWN
A SLOPE.

HANYA YANAGIHARA

ATTACKING
BAD BOOKS
IS NOT ONLY
A WASTE OF
TIME BUT ALSO
BAD FOR THE
CHARACTER.

W. H. AUDEN

NEVER DEMEAN YOURSELF BY TALKING BACK TO A CRITIC, NEVER. WRITE THOSE LETTERS TO THE EDITOR IN YOUR HEAD, BUT DON'T PUT THEM ON PAPER.

TRUMAN CAPOTE

Every critical article, even an unjustifiably abusive one, is customarily met with a silent nod— that is literary etiquette.

ANTON CHEKHOV

WE SOMEHOW BEGIN TO WEAKEN OUR HARD-BOUGHT INTEGRITY BY LOWERING OURSELVES TO BATTLE WITH THOSE WHO ARE DEMONSTRABLY VICIOUS OR SECOND RATE.

WILLIAM STYRON

To have that sense of one's intrinsic worth which constitutes self-respect is potentially to have everything: the ability to discriminate, to love, and to remain indifferent.

JOAN DIDION

I have never been dismayed by a critic's bilge or bile, and have never once in my life asked or thanked a reviewer for a review.

VLADIMIR NABOKOV

I confess I am surprised that you altogether dislike my work, as I should have thought it was complex enough to have some things in it which would touch your heart and mind.

IRIS MURDOCH

I'VE LIVED LONG ENOUGH
TO SEE THAT JUDGMENTS
ARE OFTEN REVERSED.
BOOKS THAT GOT COMPLETELY
TRASHED CAN SUDDENLY
BE EVERYBODY'S FAVORITE.

LOUISE GLÜCK

I'M A VERY
INSTINCTIVE WRITER,
AND CRITICISM OF MY
WRITING FOR ME IS LIKE
PEOPLE TELLING ME MY
GALL BLADDER'S A FUNNY
SHAPE OR SOMETHING.

ARUNDHATI ROY

WRITERS HAVE TO GET USED TO LAUNCHING SOMETHING BEAUTIFUL AND WATCHING IT CRASH AND BURN.

URSULA K. LE GUIN

ONE YEAR
I WAS UP ON A
TEN-FOOT LADDER
TRIMMING THE
CARBON-PENCIL
LAMPS OVER THE
MULE FRAMES
IN THE ARLINGTON
TEXTILE MILLS.

ROBERT FROST

I WORKED IN
A TEDDY BEAR
FACTORY.
SOMEONE ELSE
STUFFED THE
TEDDY BEARS.
MY JOB WAS TO
SEW THE
BACK SEAM.

JANE SMILEY

MY FIRST JOB OUT OF COLLEGE, I WAS A PRODUCTION ASSISTANT AT THE AMERICAN INSTITUTE FOR CERTIFIED PUBLIC ACCOUNTANTS.

ALISON BECHDEL

I DETEST OFFICE WORK. I WOULD PREFER EVEN WORK IN A SHIPPING OFFICE AT A HARBOR WHERE I COULD GO IN AND OUT. AFTER ALL I MUST BE WORTH SOMETHING, EVEN COMMERCIALLY.

JAMES JOYCE

I WORKED AS AN ESTATE AGENT IN LEYTONSTONE AND HAD TO COLLECT RENTS, AND WAS BADLY BITTEN BY DOGS.

LAWRENCE DURRELL

I was really disheartened when I was a young mom of three kids, and I'd had multiple books published, but I was still toying with the idea of getting a job application from Home Depot so I could help support my family.

JODI PICOULT

My favorite series of jobs was the one year when I was a dishwasher in a Chinese restaurant for dinner. I pumped gas early in the morning and during the day I worked in a steel mill. I did these three jobs for a while till I just collapsed from exhaustion.

JUNOT DÍAZ

I WORKED IN ALL KINDS
OF JOBS—DISHWASHER,
INSURANCE SALESMAN—
A HUNDRED OTHERS THAT
I NO LONGER REMEMBER.
WITHOUT BRAGGING, I CAN
ASSURE YOU THAT I KNOW
HOW TO DO ANYTHING.

RICHARD WRIGHT

DON'T GIVE UP YOUR JOB. GET UP EARLIER, MAKE THE SPACE. IF IT MATTERS TO YOU, MAKE IT MATTER.

CHIMAMANDA NGOZI ADICHIE

I DON'T WAIT TO BE STRUCK BY LIGHTNING AND DON'T NEED CERTAIN SLANTS OF LIGHT IN ORDER TO WRITE.

TONI MORRISON

KEEP YOUR BUTT IN THE CHAIR. YOU DO IT AT THE SAME TIME EVERY DAY. YOU NEVER WAIT FOR INSPIRATION— IT'S RIDICULOUS, IT WILL NEVER COME.

ANNE LAMOTT

WRITING SOMETHING IS ALMOST AS HARD AS MAKING A TABLE. WITH BOTH YOU ARE WORKING WITH REALITY, A MATERIAL JUST AS HARD AS WOOD. BOTH ARE FULL OF TRICKS AND TECHNIQUES. BASICALLY VERY LITTLE MAGIC AND A LOT OF HARD WORK ARE INVOLVED.

GABRIEL GARCÍA MÁRQUEZ

Isak Dinesen said that she wrote a little every day, without hope and without despair. Someday I'll put that on a three-by-five card and tape it to the wall beside my desk.

RAYMOND CARVER

I WROTE AT LEAST A THOUSAND WORDS A DAY EVERY DAY FROM THE AGE OF TWELVE ON.

RAY BRADBURY

It's now four o'clock and I have been at work since half-past eight. I have really dried myself up into a condition which would almost justify me in pitching off the cliff, head first—but I must get richer before I indulge in a crowning luxury.

CHARLES DICKENS

I will write until my knuckles are worn and my brain bewildered, but I will write on and on.

WILLIAM STYRON

I want to get my book about the future finished by the end of the summer. It advances slowly—and the future becomes more and more appalling with every chapter.

ALDOUS HUXLEY

I don't put much value in so-called inspiration. The value is in how many times you can redo something.

JOHN IRVING

DISCIPLINE ALLOWS CREATIVE FREEDOM. NO DISCIPLINE EQUALS NO FREEDOM

JEANETTE WINTERSON

A WRITER, LIKE AN ATHLETE, MUST "TRAIN" EVERY DAY. WHAT DID I DO TODAY TO KEEP IN "FORM"?

SUSAN SONTAG

IF YOU WORK ON SOMETHING A LITTLE BIT EVERY DAY, YOU END UP WITH SOMETHING THAT IS MASSIVE.

KENNETH GOLDSMITH

I FEEL PRETTY PURITANICAL ABOUT MARIJUANA, ETC. HOW DO YOU FEEL? IS ONE JUST BEING STUFFY?

IRIS MURDOCH

GOOD THINGS CAN HAPPEN WHEN YOU'RE BEING SILLY. DOES THAT MEAN SMOKING A JOINT SOMETIMES? FOR ME IT DOES.

ARMISTEAD MAUPIN

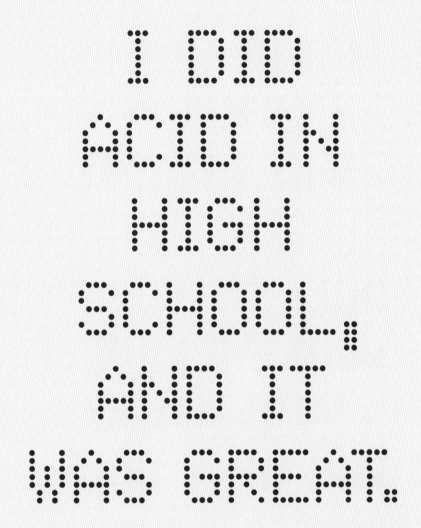

I DID ACID IN HIGH SCHOOL, AND IT WAS GREAT.

MICHAEL CUNNINGHAM

I DROPPED ACID MAYBE FIVE TIMES. THE FIRST TIME WAS KIND OF GREAT, THE SECOND WAS IFFY, THE OTHER TIMES WERE NIGHTMARES.

PETER SCHJELDAHL

YOU CAN'T WRITE ANYTHING WHEN YOU'RE ON ACID. I DID ONE PAGE ONCE WHILE ON AN ACID TRIP, BUT IT WAS IN LATIN. WHOLE DAMN THING WAS IN LATIN AND A LITTLE TINY BIT IN SANSKRIT, AND THERE'S NOT MUCH MARKET FOR THAT.

PHILIP K. DICK

I CAN ONLY WRITE WHEN I AM ABSOLUTELY SOBER.

GRAHAM GREENE

I FEEL THAT OPIATES— I INCLUDE OPIUM AND ALL ITS DERIVATIVES, SUCH AS MORPHINE, HEROIN, PANTOPON, ETC.— ARE QUITE USELESS FOR ANY SORT OF CREATIVE WORK, USEFUL THOUGH THEY MAY BE FOR ROUTINE WORK.

WILLIAM S. BURROUGHS

I WOULD GIVE ANYTHING
IF I HADN'T HAD TO WRITE
PART III OF <u>TENDER IS THE NIGHT</u>
ENTIRELY ON STIMULANT.
IF I HAD ONE MORE CRACK
AT IT COLD SOBER I BELIEVE
IT MIGHT HAVE MADE A
GREAT DIFFERENCE.

F. SCOTT FITZGERALD

DRUNKS RAMBLE; SO DO BOOKS BY DRUNKS.

JOHN IRVING

I DON'T DRINK A LOT. THAT'S PERHAPS ONE OF THE REASONS WHY MY CHARACTERS ARE ALWAYS DRINKING AND TAKING DRUGS, BECAUSE I AM NOT.

ROBERT STONE

LAST NIGHT I GOT DRUNK, VERY VERY BEAUTIFULLY DRUNK, AND NOW I AM SHOT, AFTER SIX HOURS OF WARM SLEEP LIKE A BABY, WITH RACINE TO READ, AND NOT EVEN THE ENERGY TO TYPE.

SYLVIA PLATH

I
DETEST
DRUGS.

VLADIMIR NABOKOV

In places where drinks are served, you drink. As soon as my glass is empty, the waiter comes over to inquire; if I don't empty it fast enough, he prowls around me, looking at me reproachfully.

SIMONE DE BEAUVOIR

WHEN THINGS ARE VERY VERY BAD, A DRINK IS THE ONLY MAGIC CHEAP THING LEFT TO GIVE YOU THE DREAM, TO MAKE YOU FEEL GOOD FOR A MOMENT.

CHARLES BUKOWSKI

Alcohol is the sedative when you finish the day's work— it helps you to reemerge into the world.

JIM HARRISON

I LIKE DRINKING, BUT I DON'T LIKE GOING TO BARS BECAUSE I GET IN FIGHTS.

KENZABURŌ ŌE

A MARTINI MAKES AN ORDINARY GLASS SHINE LIKE A DIAMOND AT A CORONATION, MAKES AN IRON BED IN MEXICO SEEM LIKE THE FEATHER BED OF A SULTAN, A HOTEL ROOM LIKE THE TERMINUS AND CLIMAX OF ALL VOYAGES, THE PINNACLE OF CONTENTMENT, THE PLACE OF REPOSE IN AN ALTITUDE HUNGERED FOR BY ALL THE RESTLESS ONES.

ANAÏS NIN

Only a drink makes me feel alive at all.

EUGENE O'NEILL

I RATHER LIKE THE IDEA OF ENDING MY DAYS DRINKING MYSELF TO DEATH ON A MOUNTAINSIDE IN MEXICO.

J. G. BALLARD

FINISH EACH DAY
BEFORE YOU
BEGIN THE NEXT,
AND INTERPOSE
A SOLID WALL OF
SLEEP BETWEEN
THE TWO. THIS YOU
CANNOT DO WITHOUT
TEMPERANCE.

RALPH WALDO EMERSON

I'M PROUDER OF THAT, THAT I'VE QUIT DRINKING, THAN I AM OF ANYTHING IN MY LIFE.

RAYMOND CARVER

I BELIEVE MORE IN THE SCISSORS THAN I DO IN THE PENCIL.

TRUMAN CAPOTE

MY PENCILS OUTLAST THEIR ERASERS.

VLADIMIR NABOKOV

A good editor is a man I think charming, who sends me large checks, praises my work, my physical beauty, and my sexual prowess, and who has a stranglehold on the publisher and the bank.

JOHN CHEEVER

At eighty-three, with one eye gone and a lot of my hearing, my ideal editor is a young woman, preferably a pretty one, who doesn't necessarily know anything about prose but who is a good driver and willing to take me on long journeys in my car.

E. B. WHITE

EVERY WRITER SHOULD HAVE TATTOOED BACKWARDS ON HIS FOREHEAD, LIKE "AMBULANCE" ON AMBULANCES, THE WORDS <u>EVERYBODY NEEDS AN EDITOR</u>.

MICHAEL CRICHTON

YOU DID THE PRUNING JOLLY WELL, AND I AM GRATEFUL. I HOPE YOU'LL LIVE A LONG LONG TIME, TO BARBER UP MY NOVELS FOR ME BEFORE THEY'RE PUBLISHED.

D. H. LAWRENCE

ONE OF THE THINGS YOU WANT FROM AN EDITOR IS SIMPLY THE FEELING THAT HE OR SHE UNDERSTANDS YOUR WORK. MONEY IS NO SUBSTITUTE FOR THAT.

MARGARET ATWOOD

A lot of nice touches in my stories belong to Bill Maxwell. And I've taken credit for them all.

JOHN UPDIKE

As for the reworkings and omissions done by you, some of them, as I notice now, are, of course, essential, but I regret other omissions (at the end). But let it be as you wish! I trust you thoroughly as a literary judge.

FYODOR DOSTOEVSKY

THE EDITING IS EXTREMELY ATTENTIVE, BUT DELICATE AND DONE WITH GREAT COURTESY. I'M THE ONE WHO WELCOMES DOUBTS. I ADD THEM TO MY OWN QUESTIONS AND WRITE, REWRITE, ERASE, ADD UNTIL THE DAY BEFORE THE BOOK GOES TO PRESS.

ELENA FERRANTE

STET IS MY SLOGAN.

ROBERT FROST

HOW MUCH CAN ONE REMOVE, AND STILL HAVE THE COMPOSITION BE INTELLIGIBLE? CHEKHOV REMOVED THE PLOT. PINTER, ELABORATING, REMOVED THE HISTORY, THE NARRATION; BECKETT, THE CHARACTERIZATION. WE HEAR IT ANYWAY.

DAVID MAMET

I'VE REWRITTEN IT— FOR ABOUT THE 11TH TIME— FOR CLARITY, BUT I BARE TEETH ALL THE WAY BACK TO THE 2ND MOLAR ON CUTTING IT.

DAVID FOSTER WALLACE

I am sorry but I cannot change that ending.

JOHN STEINBECK

MOST WRITERS AREN'T WILLING TO PART WITH THEIR OWN WORDS. ANYTIME ANYONE ASKS ME TO CUT ANYTHING, I SAY, "GREAT."

MARY KARR

Replace "pee" by "urinate" or, if they object to "urinate," by "relieve myself."

SAMUEL BECKETT

BE OPEN TO CHANGE: JUST BECAUSE IT'S TYPED ON YOUR LOVELY COMPUTER IT DOESN'T MEAN IT'S ANY GOOD.

TRACY CHEVALIER

COPY EDITORS ATTEND THE FLOW OF THE PROSE AND WATCH FOR LEAKS.

JOHN MCPHEE

I'VE TRIED TO REDUCE PROFANITY BUT I REDUCED SO MUCH PROFANITY WHEN WRITING THE BOOK THAT I'M AFRAID NOT MUCH COULD COME OUT.

ERNEST HEMINGWAY

WHEN YOU CATCH AN ADJECTIVE, KILL IT.

MARK TWAIN

WHEN THE
GRIM REAPER
COMES TO
GET ME, HE'LL
HAVE TO
GIVE ME A FEW
EXTRA HOURS
TO REVISE
MY LAST WORDS.

FLANNERY O'CONNOR

ONCE YOU
HAVE DONE ALL
YOU CAN TO
A MANUSCRIPT,
LET IT FIND
ITS WAY IN THE
WORLD.

CHINUA ACHEBE

ONCE UPON A TIME I ATE QUITE A LOT OF CABBAGE STRUDEL.

NORA EPHRON

IF I CAN CHOOSE,
I WON'T MEEKLY SAY
THAT THE NECK OF
THE CHICKEN IS MY
FAVORITE PORTION.

WILLA CATHER

YOU KNOW HOW INTERESTING THE PURCHASE OF A SPONGE-CAKE IS TO ME.

JANE AUSTEN

I know the look of green apples and peaches and pears on the trees, and I know how entertaining they are when they are inside of a person.

MARK TWAIN

TO-DAY I BOUGHT A BOX OF STRAWBERRIES AND ATE THEM IN MY ROOM FOR LUNCHEON. TO-MORROW I PROPOSE TO HAVE A PINEAPPLE; THE NEXT DAY, BLACKBERRIES; THE NEXT, BANANAS, ETC.

WALLACE STEVENS

BY THE WAY, RAW CARROTS ARE SPLENDID.

DYLAN THOMAS

BUY YOURSELF A BUNCH OF CARROTS AND WHEN YOU MUST EAT, EAT THEM RAW, MAKING AS MUCH NOISE AS YOU CAN. THE NEARER YOU CAN SOUND LIKE BUGS BUNNY, THE BETTER. THIS WILL SOON KILL YOUR DESIRE FOR EXCESS EATING.

FLANNERY O'CONNOR

At this time of the year all the women are out in the olive woods— you have no idea how beautiful olives are, so grey, so delicately sad, reminding one constantly of the New Testament.

D. H. LAWRENCE

NOW AND
THEN I WOULD
TREAT MYSELF
TO A SUCCULENT
SOUR PICKLE
OR A SMOKED
HERRING WRAPPED
IN NEWSPAPER.

HENRY MILLER

EATING FRESH PINEAPPLE FOR THE FIRST TIME IN MY LIFE WITH FEROCIOUS ENJOYMENT.

SAMUEL BECKETT

I COOKED THE PEACHES AS YOU TOLD ME, AND THEY SWELLED TO BEAUTIFUL FLESHY HALVES AND TASTED QUITE MAGIC.

EMILY DICKINSON

IT WAS MY FATHER
WHO INSISTED ON TURNING
EVERYTHING INTO A TREAT.
I REMEMBER HIS SHOWING ME HOW
TO EAT A PEACH BY BUILDING
A LITTLE WHITE MOUNTAIN
OF SUGAR AND THEN DIPPING
THE PEACH INTO IT.

MARY MCCARTHY

I LOVE
MCDONALD'S
DOUBLE
CHEESEBURGERS
AND I DON'T
CARE IF THEY'RE
MADE OF
PINK SLIME AND
AMMONIA.

DENIS JOHNSON

I LOVE THE SMELL OF FOOD.

JOSEPH HELLER

I LIKE MAKING COFFEE
MILKSHAKES WITHOUT
A BLENDER—ALL YOU
HAVE TO DO IS SQUASH
THE COFFEE AND THE
ICE CREAM TOGETHER
IN THE GLASS USING
A TABLESPOON.

NICHOLSON BAKER

I EAT WHATEVER MY KIDS LEAVE BEHIND. AND COFFEE.

DAVE EGGERS

GRAMMAR IS NOT JUST A PAIN IN THE ASS; IT'S THE POLE YOU GRAB TO GET YOUR THOUGHTS UP ON THEIR FEET AND WALKING.

STEPHEN KING

I NEVER USE THE WORD "WHOM." I GAVE IT UP COMPLETELY.

CALVIN TRILLIN

WHEN "WHOM" IS CORRECT, RECAST THE SENTENCE.

WILLIAM SAFIRE

Never use abstract nouns when concrete ones will do. If you mean "more people died," don't say "mortality rose."

C. S. LEWIS

Grammar is a piano I play by ear, since I seem to have been out of school the year the rules were mentioned.

JOAN DIDION

I CONSISTENTLY BREAK A RULE I CONSIDER TO BE NOT ONLY FAKE BUT PERNICIOUS. I KNOW WHAT I'M DOING AND WHY.

URSULA K. LE GUIN

I'm glad you like adverbs— I adore them; they are the only qualifications I really much respect.

HENRY JAMES

WHEN I SPLIT AN INFINITIVE, GOD DAMN IT, I SPLIT IT SO IT WILL STAY SPLIT.

RAYMOND CHANDLER

Vigorous writing is concise. A sentence should contain no unnecessary words, a paragraph no unnecessary sentences, for the same reason that a drawing should have no unnecessary lines and a machine no unnecessary parts.

WILLIAM STRUNK JR.

I REALLY DO NOT KNOW THAT ANYTHING HAS EVER BEEN MORE EXCITING THAN DIAGRAMMING SENTENCES.

GERTRUDE STEIN

PERFECT
GRAMMAR—
PERSISTENT,
CONTINUOUS,
SUSTAINED—
IS THE FOURTH
DIMENSION,
SO TO SPEAK:
MANY HAVE
SOUGHT IT,
BUT NONE HAS
FOUND IT.

MARK TWAIN

ORIGINAL THOUGHTS ARE LIKE SHY ANIMALS. WE SOMETIMES HAVE TO LOOK THE OTHER WAY—TOWARD A BUSY STREET OR TERMINAL— BEFORE THEY RUN OUT OF THEIR BURROWS.

ALAIN DE BOTTON

IDEAS ARE LIKE RABBITS. YOU GET A COUPLE AND LEARN HOW TO HANDLE THEM, AND PRETTY SOON YOU HAVE A DOZEN.

JOHN STEINBECK

I ALWAYS THINK THAT EVERYBODY IS GETTING THEIR IDEAS IN THE SHOWER AND THE PEOPLE WHO ARE WRITING THEM DOWN, KEEPING THE SOGGY NOTES, ARE THE WRITERS.

LORRIE MOORE

IDEAS ARE THE EASY PART. I SPEND A LOT OF TIME BATTING THEM AWAY, TRYING TO KEEP THEM FROM DISTRACTING ME FROM WHAT I ACTUALLY HAVE TO FOCUS ON AND FINISH.

MICHAEL CHABON

THE MORE I THINK ABOUT THE WORD "IDEA," THE LESS IDEA I HAVE WHAT IT MEANS.

URSULA K. LE GUIN

ALL MY LIFE I'VE BEEN RUNNING THROUGH THE FIELDS AND PICKING UP BRIGHT OBJECTS. I TURN IT OVER AND SAY, "HEY, THERE'S A STORY."

RAY BRADBURY

WHAT COULD BE MORE CONSIDERATE— BETTER MANNERS!— THAN TO TREAT THOUGHTS, IDEAS, INSPIRATIONAL FLASHES, AS FLOWERS OF DELIGHT?

HENRY MILLER

TO TAKE ON BLAKE IS NOT TO BE ALONE.

PATTI SMITH

BLAKE LED ME TO YEATS, WHICH LED ME TO DANTE.

KENZABURŌ ŌE

AS LONG AS THERE IS A TOLSTOY IN LITERATURE IT IS SIMPLE AND GRATIFYING TO BE A LITERARY FIGURE.

ANTON CHEKHOV

OF ALL THE AMERICAN WRITERS IN MY TIME, VONNEGUT IS STREETS AHEAD OF ALL OF THEM.

DORIS LESSING

I WOULD VERY MUCH WISH TO SPEND HALF AN HOUR WITH ANTON CHEKHOV. I WOULD BUY HIM A DRINK. I WOULD NOT DISCUSS LITERARY ISSUES WITH HIM, NOT EVEN BOTHER TO INTERVIEW HIM OR ASK HIM FOR SOME USEFUL TIPS, JUST CHAT ABOUT PEOPLE. EVEN GOSSIP WITH HIM.

AMOS OZ

RUSHDIE GOT SOME OF HIS FIREWORKS FROM GÜNTER GRASS AND GABRIEL GARCÍA MÁRQUEZ. GARCÍA MÁRQUEZ GOT THINGS FROM KAFKA AND FAULKNER. SO, WITH <u>MIDDLESEX</u>, YOU COULD SAY I INHERITED TRAITS FROM ALL THESE ANCESTORS, NOT TO MENTION GOOD OLD HOMER.

JEFFREY EUGENIDES

I ALWAYS TELL PEOPLE MY LITERARY INFLUENCES ARE STEPHEN KING, JOHN STEINBECK, MY MOTHER, MY GRANDFATHER, AND THE BRADY BUNCH.

SHERMAN ALEXIE

I REVERE NABOKOV.

SCOTT SPENCER

DON'T BE ONE OF THOSE WRITERS WHO SENTENCE THEMSELVES TO A LIFETIME OF SUCKING UP TO NABOKOV.

GEOFF DYER

JAMES JOYCE HAS NOT INFLUENCED ME IN ANY MANNER WHATSOEVER.

VLADIMIR NABOKOV

I'm always turning to Baldwin, I'm always turning to Fanon, I'm always turning to Toni Morrison, Audre Lorde, Zora Neale Hurston.

CLAUDIA RANKINE

Like most writers, I am a product of many literary parents. While I'm tempted to claim child support from Gogol, Bellow, and Nabokov… my evolution as a writer began with <u>The Adventures of Tom Sawyer</u>.

GARY SHTEYNGART

MY EAR FOR THE DICTION AND RHYTHMS OF POETRY WAS TRAINED BY— IN CHRONOLOGICAL ORDER—DR. SEUSS, DYLAN THOMAS, WALT WHITMAN, THE GUITAR SOLOS OF ERIC CLAPTON AND JIMI HENDRIX, AND T. S. ELIOT.

DENIS JOHNSON

William Trevor's <u>Collected Stories</u>, which I purchased in 1995, changed my life. If I could write a single story worthy of inclusion in this book, I thought to myself at the time, I will die happy.

JHUMPA LAHIRI

William Faulkner's <u>The Bear</u>. I bought this book for fifty cents at a garage sale when I was seventeen. The combination of storytelling and wordsmithery blew my socks off.

DAVID EAGLEMAN

Discovering Proust was a real shock—the shock of recognition. I was twenty, and my encounter with this novel gave me a shock that, I believe, is felt by every gay person reading Proust for the first time.

DANIEL MENDELSOHN

I DIDN'T WANT TO BE LIKE YEATS; I WANTED TO BE YEATS.

JOHN BERRYMAN

I LEARNED PRECISION OF LANGUAGE FROM JAPANESE POETRY.

OCTAVIO PAZ

WHENEVER I READ A PASSAGE THAT MOVES ME, I TRANSCRIBE IT IN MY DIARY, HOPING MY FINGERS MIGHT LEARN WHAT EXCELLENCE FEELS LIKE.

DAVID SEDARIS

MUSIC IS
A CONSTANT
INFLUENCE
ON MY WRITING,
SERVING BOTH
AS STIMULUS
AND AS MODEL
TO BE RENDERED
IN TERMS OF
MY OWN ART.

THOMAS MANN

MY GREATEST
INFLUENCE HAS
BEEN THE BLUES.
AND THAT'S A
LITERARY INFLUENCE,
BECAUSE I THINK
THE BLUES IS THE
BEST LITERATURE
THAT WE AS BLACK
AMERICANS HAVE.

AUGUST WILSON

THE EARLY GODARD FILMS HAD A VERY STRONG EFFECT ON THE WAY I OBSERVE AND SEE THE WORLD.

ANGELA CARTER

THE QUESTION OF INFLUENCES IS REALLY ABOUT TIME RATHER THAN TASTE— IT'S WHOEVER GOT TO YOU FIRST. C. S. LEWIS WINS; I CONSCIOUSLY CHOSE TO BE A NARNIAN RATHER THAN A MIDDLE EARTHER.

ZADIE SMITH

THE ONLY BOOKS THAT INFLUENCE US ARE THOSE FOR WHICH WE ARE READY, AND WHICH HAVE GONE A LITTLE FARTHER DOWN OUR PARTICULAR PATH THAN WE HAVE YET GOT OURSELVES.

E. M. FORSTER

AN ACCIDENT OF TIMING MAKES THE BOOK IN QUESTION INDELIBLE.

COLSON WHITEHEAD

I NEVER SHIED AWAY FROM LOVE'S HUGENESS BUT I HAD NO IDEA THAT LOVE COULD BE AS RELIABLE AS THE SUN. THE DAILY RISING OF LOVE.

JEANETTE WINTERSON

LOVE MAY BE A SLEEPY, CREEPING THING WITH SOME OTHERS, BUT IT IS A MIGHTY WAKENING THING WITH ME.

ZORA NEALE HURSTON

LOVE IS <u>NOT</u> JUST A FEELING; IT'S A PRACTICE, SOMETHING YOU PRACTICE WHETHER YOU FEEL LIKE IT OR NOT.

WENDELL BERRY

You may depend upon it, that a slight contrast of character is very material to happiness in marriage.

SAMUEL TAYLOR COLERIDGE

We headed home holding hands. For a moment I dropped back to watch him walk. His sailor's gait always touched me. I knew one day I would stop and he would keep on going, but until then nothing could tear us apart.

PATTI SMITH

I THINK FOR MOST STRAIGHT MEN, THE PROBLEM IS NOT THAT WE DON'T HAVE WOMEN WORTHY OF US, THE PROBLEM IS THAT WE HAVE WOMEN TEN TIMES MORE WORTHY THAN US.

JUNOT DÍAZ

I SHALL NEVER MARRY; I REGARD THAT NOW AS AN ESTABLISHED FACT, AND ON THE WHOLE A VERY RESPECTABLE ONE; I AM BOTH HAPPY ENOUGH AND MISERABLE ENOUGH, AS IT IS, AND DON'T WISH TO ADD TO EITHER SIDE OF THE ACCOUNT.

HENRY JAMES

I soon realized I had made no mistake in my choice of a wife. I was helping her pack an overnight bag one afternoon when she said "Put in some tooth twine." I knew then that a girl who called dental floss "tooth twine" was the girl for me. It had been a long search, but it was worth it.

E. B. WHITE

NEVER MARRY A MAN YOU WOULDN'T WANT TO BE DIVORCED FROM.

NORA EPHRON

I LOVE PETER AS
I'VE NEVER LOVED ANYONE,
AND I TELL MYSELF
HE'S ONLY GOING AROUND
WITH ALL THOSE
OTHER GIRLS TO HIDE HIS
FEELINGS FOR ME.

ANNE FRANK

DON'T WE ALL
IN THE END WRITE
ABOUT LOVE?
ALL LITERATURE IS
ABOUT LOVE.

CHIMAMANDA NGOZI ADICHIE

The right sort of
love is recognized by
the sort of joy, of general
excitement, of exultant
life which the presence
of someone produces in us
and which distinguishes
them. You feel better
when with them.

PAUL VALÉRY

Relationships
should be based on
value and fact,
on how you get on,
on what things
you enjoy together.
I think romance
has caused more
unhappiness almost
than anything.

DIANA ATHILL

I can't divide
friendship from love
or love from sex—
or sex from love, etc.

IRIS MURDOCH

I am beside myself.
If you were here I could
bite you. That is what
I long to do.

GUSTAVE FLAUBERT

Now I know that
nothing really matters
to us but the people
we love. Of course,
if we realized that when
we are young, and just
sat down and loved each
other, the beds would
not get made and very
little of the world's work
would ever get done.

WILLA CATHER

FROM THE MOMENT
YOU ARE ALIVE YOU ARE
BOUND TO BE CONCERNED
WITH LOVE, BECAUSE LOVE
IS NOT JUST SOMETHING
THAT HAPPENS TO YOU:
IT IS A CERTAIN SPECIAL
WAY OF BEING ALIVE.

THOMAS MERTON

I LIKE NOT ONLY
TO BE LOVED, BUT
ALSO TO BE TOLD
THAT I AM LOVED.
I AM NOT SURE THAT
YOU ARE OF THE
SAME MIND. BUT THE
REALM OF SILENCE
IS LARGE ENOUGH
BEYOND THE GRAVE.

GEORGE ELIOT

I CANNOT EXIST
WITHOUT YOU.
I AM FORGETFUL
OF EVERY THING
BUT SEEING YOU
AGAIN—MY LIFE
SEEMS TO STOP
THERE—I SEE NO
FURTHER.

JOHN KEATS

I AM WRITING POETRY…AND AS ALWAYS HAPPENS, NO MATTER HOW I BEGIN, IT BECOMES LOVE POETRY.

W. B. YEATS

THERE IS NO REMEDY FOR LOVE BUT TO LOVE MORE.

HENRY DAVID THOREAU

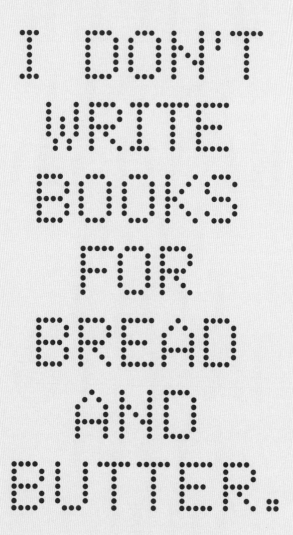

I DON'T
WRITE
BOOKS
FOR
BREAD
AND
BUTTER.

HARUKI MURAKAMI

I AM AFRAID IN ANOTHER FORTNIGHT I SHALL NOT HAVE A PENNY TO BUY BREAD AND MARGARINE.

D. H. LAWRENCE

MONEY— AS SCARCE AS HEN'S TEETH.

ANTON CHEKHOV

MONEY IS A GROTESQUE TOPIC.

PAUL THEROUX

I REMEMBER TRYING TO SAVE MONEY, FOR A DAY OR TWO, AND QUICKLY LOSING INTEREST.

JOE BRAINARD

WHAT A BORE THIS MONEY BUSINESS IS!

ALDOUS HUXLEY

I DON'T EXPECT THE LITTLE BOOK OF MICE AND MEN TO MAKE ANY MONEY. IT'S SUCH A SIMPLE LITTLE THING.

JOHN STEINBECK

I have spent all my money, am in debt to the hotel, my credit here has disappeared, and I'm in a most distressing situation.

FYODOR DOSTOEVSKY

I've exhausted my credit. I owe Viking ten grand, and my English publisher eighteen hundred.

SAUL BELLOW

IF I DON'T IN SOME WAY GET $650 IN THE BANK BY WEDNESDAY MORNING I'LL HAVE TO PAWN THE FURNITURE.

F. SCOTT FITZGERALD

How one grudges the life and energy and spirit that money steals from one. I long to spend and I have a horror of spending: money has corrupted me these last years.

KATHERINE MANSFIELD

JUST SIGNED CONTRACTS FOR TWO NEW BOOKS TODAY, AND HAVEN'T EVEN STARTED THE LAST TWO I'VE SPENT THE ADVANCES ON.

LANGSTON HUGHES

I HAVEN'T SEEN A COIN FOR WEEKS.

DYLAN THOMAS

The only reason I make any money at it is I'm a sort of literary pirate. Out of every ten stories I write, only one is any good and I throw the other nine away.

ERNEST HEMINGWAY

I admire those who live graciously with little money.

ANAÏS NIN

I DON'T YET
THINK OF
WRITING AS A
PROFESSION.
IF I CAN GET
MONEY FOR IT,
THAT'S FINE.
BUT I'D RATHER
WASH DISHES
THAN WRITE
JUST FOR MONEY.

RICHARD WRIGHT

STEAL OLD STUFF.

AUSTIN KLEON

YOU HAVE TO WORK AT YOUR ORIGINALITY. YOU CREATE IT; IT DOESN'T CREATE YOU.

JEFFREY EUGENIDES

EVERY AUTHOR I FALL IN LOVE WITH I WANT TO IMITATE. IF ONLY I COULD IMITATE MYSELF!

HENRY MILLER

I'm beginning to develop a style, which is maybe a good sign: after having imitated others so much, I can now afford to imitate myself a bit.

ITALO CALVINO

THE POINT IS NOT TO COPY BUT TO IMITATE— TO FIND FORMS AS SUITABLE FOR OUR TIMES AS IAMBIC PENTAMETER WAS FOR ELIZABETHAN ENGLAND.

WILLIAM CARLOS WILLIAMS

I by no means owe my works to my own wisdom alone, but to a thousand things and persons around me, who provided me with material.

JOHANN WOLFGANG VON GOETHE

I QUOTE OTHERS ONLY IN ORDER THE BETTER TO EXPRESS MYSELF.

MICHEL DE MONTAIGNE

The only way to be new is constantly to change yourself, and the only way to be original is to increase, enlarge, deepen your own personality.

W. SOMERSET MAUGHAM

When you imitate the old poets, you have a better chance of sounding like yourself than when you're copying your contemporaries.

ELIZABETH BISHOP

THE TRUE ARTIST IS KNOWN BY THE USE HE MAKES OF WHAT HE ANNEXES, AND HE ANNEXES EVERYTHING.

OSCAR WILDE

THE GOOD POET
WELDS HIS THEFT
INTO A WHOLE OF
FEELING WHICH IS
UNIQUE, UTTERLY
DIFFERENT FROM
THAT FROM WHICH
IT WAS TORN.

T. S. ELIOT

I AM
PROBABLY THE
BIGGEST THIEF
IMAGINABLE.
I STEAL FROM
PEOPLE—
MY SENIORS,
I MEAN.

LAWRENCE DURRELL

ORIGINALITY IS PARTLY
A MATTER OF HAVING
YOUR OWN INFLUENCES:
READ EVOLUTIONARY
BIOLOGY TEXTBOOKS OR
THE OLD TESTAMENT,
FIND YOUR METAPHORS
WHERE NO ONE'S LOOKING,
DON'T BELONG.

REBECCA SOLNIT

THE LAST THING WE DECIDE ON IN WRITING A BOOK IS WHAT SHALL BE THE FIRST WE PUT IN IT.

BLAISE PASCAL

I ALWAYS KNOW THE ENDING; THAT'S WHERE I START.

TONI MORRISON

THE FIRST SENTENCE CAN'T BE WRITTEN UNTIL THE LAST SENTENCE HAS BEEN WRITTEN. ONLY THEN DO YOU KNOW WHERE YOU'VE BEEN GOING, AND WHERE YOU'VE BEEN.

JOYCE CAROL OATES

THE LAST PAGE OF <u>OLIVE</u> I WROTE WAY, WAY BEFORE THE BOOK WAS DONE. THANK GOODNESS IT DIDN'T GET LOST—I'M NOT VERY ORGANIZED.

ELIZABETH STROUT

I'M NOT A BIG OUTLINER.

MICHAEL CHABON

WHEN IN DOUBT HAVE A MAN COME THROUGH A DOOR WITH A GUN IN HIS HAND.

JOHN CHEEVER

I can't do the business of shoving a blank piece of paper in the typewriter and having a brainstorming session to see what comes out. I have to have a very clear map next to me.

KAZUO ISHIGURO

I have no chart. I hold everything in my head while I'm writing and then I tend to forget everything.

KATE ATKINSON

DON'T BEGIN WITH A POLISHED IDEA IN WHICH EVERY INCIDENT IS FIXED IN YOUR MIND. JUST SHOVE A GIRL ON A SEA-SHORE ON A SUMMER DAY AND LET HER MAKE HER OWN STORY.

DYLAN THOMAS

THE ORDER OF PIECES IN A GIVEN BOOK IS MOSTLY A MATTER OF TRYING TO MAKE SURE THEY DON'T GET IN EACH OTHER'S WAY. MUCH LIKE HANGING PICTURES FOR A SHOW. SOME PICTURES FIGHT OTHER PICTURES, NOT BECAUSE EITHER IS A BAD PICTURE, BUT BECAUSE THE SCALE FIGHTS OR THE COLOR FIGHTS.

DONALD BARTHELME

No story should be planned out too elaborately in detail beforehand, or the characters become mere puppets and will not act for themselves when the occasion arises.

CHARLES DICKENS

PLOT IS NO MORE THAN FOOTPRINTS LEFT IN THE SNOW AFTER YOUR CHARACTERS HAVE RUN BY ON THEIR WAY TO INCREDIBLE DESTINATIONS.

RAY BRADBURY

I START WITH THE IDEA OF CONSTRUCTING A TREEHOUSE AND END WITH A SKYSCRAPER MADE OF WOOD.

NORMAN MAILER

YOU DON'T ASK A POEM WHAT IT MEANS, YOU HAVE TO LET IT TELL YOU.

ELIZABETH BISHOP

AUDEN COMPARED
WRITING A POEM
TO CLEANING AN OLD
PIECE OF SLATE
UNTIL THE LETTERS
APPEAR.

MARTIN AMIS

YEATS SAID ABOUT
WRITING PROSE AND
POETRY, THAT WHEN
YOU FINISH A POEM IT
CLICKS SHUT LIKE THE
TOP OF A JEWEL BOX
BUT PROSE IS ENDLESS.

KENNETH KOCH

It is raining. I am tempted to write a poem. But I remember what it said on one rejection slip: after a heavy rainfall, poems titled "Rain" pour in from across the nation.

SYLVIA PLATH

POETRY IS NOT PLAY-DOH. YOU CAN'T TAKE A POEM AND KEEP RE-FORMING IT.

AUDRE LORDE

I owe absolutely everything I am to poetry—all I know about the pronunciation and spelling of words, all I know of geography, history, and philosophy and all I know of true thought and feeling.

ROBERT FROST

IF PROSE IS A HOUSE, POETRY IS A MAN ON FIRE RUNNING QUITE FAST THROUGH IT.

ANNE CARSON

I don't believe that as a poet I am here to make others feel good, feel happy. I'm supposed to chronicle what is so. And it would be nice to forget history, but we do it at our peril, as we have seen lately.

LUCILLE CLIFTON

To bring poetry out of the clouds and down to earth I still believe possible. Using common words in a rare manner will advance the cause of the Poem infinitely.

WILLIAM CARLOS WILLIAMS

THE BEST CRAFTSMANSHIP
ALWAYS LEAVES HOLES AND
GAPS IN THE WORKS OF THE
POEM SO THAT SOMETHING
THAT IS <u>NOT</u> IN THE POEM
CAN CREEP, CRAWL, FLASH,
OR THUNDER IN.

DYLAN THOMAS

I AM SENDING
YOU SOME POEMS.
READ THEM SOME
MORNING IN THE
SUNLIGHT WHERE
I COMPOSED THEM.

ARTHUR RIMBAUD

POETRY (AT ANY RATE IN MY CASE) IS LIKE TRYING TO REMEMBER A TUNE YOU'VE FORGOTTEN. ALL CORRECTIONS ARE ATTEMPTS TO GET NEARER TO THE FORGOTTEN TUNE.

PHILIP LARKIN

IF I FEEL PHYSICALLY AS IF THE TOP OF MY HEAD WERE TAKEN OFF, I KNOW THAT IS POETRY.

EMILY DICKINSON

A TRULY EXCITING POEM HAS SOMETHING EVASIVE OR MYSTERIOUS AT THE CORE, AND IT SUCCEEDS IN SUGGESTING TO US THAT THE CORE IS ESSENTIAL TO OUR BEING.

MARK STRAND

LET IT ALL BEGIN ONCE MORE, THE STEP-BY-STEP JOYFUL EFFORT TO LIFT A POEM OUT.

MAY SARTON

I SUFFER FROM A NERVOUS IMPULSE THAT MAKES ME FIND EXCUSES TO CALL MY PUBLISHER.

JOSEPH HELLER

I THINK I WOULD HAVE DIED IF IT HADN'T BEEN PUBLISHED. I WAS DESPERATE TO GET STARTED— I WAS POSSESSED.

JANE GARDAM

MY RECORD NOW,
FOR SIGNING,
IS TEN AND A
HALF HOURS IN
ONE SITTING.

DAVID SEDARIS

NO MORE TALK, PLEASE, ABOUT SIGNINGS—I AM ILL WITH DOING THEM.

SAMUEL BECKETT

I used to go on the Greyhound bus with copies of my books in a cardboard box, and give readings in school gymnasiums. I'd sell my own books and collect the money, put it in a brown paper envelope, and take it back to the publisher.

MARGARET ATWOOD

ONLY ONE PERSON ATTENDED MY FIRST READING IN BOSTON, MY BEST FRIEND, SHUYA OHNO.

JUNOT DÍAZ

I have a stack of those plastic card hotel room keys that I picked up on this latest book tour. It's about a yard tall. Ah yes, a stack of lonely nights.

BILLY COLLINS

Think about Gulliver's Travels, Robinson Crusoe, Tristram Shandy. They were celebrated books, but their authors didn't have to do anything to promote them.

SALMAN RUSHDIE

MY EXPERIENCES ON THIS TOUR ARE MOVING AND ABASHING. THE GENERAL EXCITEMENT, THE OVERCROWDED HALLS, THE SILENT ATTENTIVENESS, THE GRATITUDE— THERE IS SOMETHING CONFUSING AND INCOMPREHENSIBLE ABOUT IT ALL.

THOMAS MANN

Book tours are almost designed to beat out of an author any affection he has for his book.

MICHAEL LEWIS

HERE IS THE PREFACE. I'M SORRY I'M SO LATE WITH IT.

ERNEST HEMINGWAY

ON THE PROOFS— I HOPE I'M TO BE ALLOWED RANDALL'S "FUCK" AT THE END OF PART ONE! I HAVE ABANDONED MILDRED'S "BUGGER" LATER ON!

IRIS MURDOCH

PUBLISHERS ARE LIKE OBSTETRICIANS. THERE IS THE SAME FUSS OF MAKING YOU FEEL WHAT A WONDERFUL LITTLE WOMAN YOU ARE, AND THEN GETTING DOWN TO THE FACTS ABOUT HEAD SIZE, PELVIC BONES, ETC. THEY HAVE A DECIDED BEDSIDE MANNER. AFTER ALL, THOUGH, THEY ARE RIGHT, YOU MUST GET OVER THE FEELING THAT YOU ARE ACCOMPLISHING GOD'S MISSION.

ANNE MORROW LINDBERGH

I AM NO SPEAKER AND NEVER INTEND TO BE.

JOHN STEINBECK

I TURNED UP FOR AN INTERVIEW, AND ON THE STUDIO DOOR THERE WAS [A] LITTLE POST-IT SAYING, "VERY SORRY, JUST HAD TO POP OUT. DO YOU THINK YOU COULD INTERVIEW YOURSELF? AND I'LL JUST DROP THE QUESTIONS IN AFTER."

ADAM NICOLSON

FOR ME, WRITING IS A GREAT BUT SOLITARY ACTIVITY, NORMALLY UNDERTAKEN IN A DARK ROOM, ALONE, WHILE I'M IN MY PAJAMAS. I ENJOY THE ADRENALINE OF PERFORMANCE; THE BIGGER THE AUDIENCE, THE BETTER.

NOAH CHARNEY

THE ANTIDOTE TO THE SELF-LOATHING THAT COMES FROM TALKING ABOUT YOURSELF CONSTANTLY IS LISTENING.

AUSTIN KLEON

WHY IS IT SO UPSETTING TO BE INVOLVED WITH THE SELLING OF BOOKS? HOW DOES A WRITER OF MY KIND SURVIVE THE BIG MACHINE?

MAY SARTON

My first book Some Trees published in an edition of eight hundred copies, took eight years to sell out.

JOHN ASHBERY

It is a very beautiful thought to me that eighty thousand people should want to read The House of Mirth, and if the number should ascend to one hundred thousand I fear my pleasure would exceed the bounds of decency.

EDITH WHARTON

I can't stand feeling like a salesman. I don't like poetry readings—I don't like going to them and I don't like doing them. I feel all the subtlety of my work is lost, replaced by a kind of shallow drama.

LOUISE GLÜCK

THE BOOK JUMPED FROM NOWHERE TO TWO ON THE NEW YORK TIMES BEST-SELLER LIST, WHERE IT REMAINS THIS WEEK, AND I ONLY HAVE TO DISLODGE A MORONIC THRILLER BY SOMEONE NAMED LUDLUM TO REIGN SUPREME (AT LEAST FOR A WHILE).

WILLIAM STYRON

I NEVER EXPECTED ANY SORT OF SUCCESS WITH MOCKINGBIRD. I WAS HOPING FOR A QUICK AND MERCIFUL DEATH AT THE HANDS OF THE REVIEWERS, BUT AT THE SAME TIME I SORT OF HOPED SOMEONE WOULD LIKE IT WELL ENOUGH TO GIVE ME ENCOURAGEMENT.

HARPER LEE

The little books sell extraordinarily well. Besides being in every bookshop window in every place, my men alone will sell from six to twelve dozen in a night.

CHARLES DICKENS

I AM NEVER BETTER PLEASED THAN WHEN I KNOW A BOOK OF MINE CAN BE BOUGHT FOR FIFTY CENTS OR, BETTER STILL, FOR TWENTY-FIVE. NO PEOPLE CAN BE EDUCATED OR EVEN CULTIVATED UNTIL BOOKS ARE CHEAP ENOUGH FOR EVERYBODY TO BUY.

PEARL S. BUCK

THE PRINCIPAL EVENT OF THE WINTER IS THE APPEARANCE OF MY BOOK FLOWER FABLES. AN EDITION OF SIXTEEN HUNDRED. IT HAS SOLD VERY WELL, AND PEOPLE SEEM TO LIKE IT.

LOUISA MAY ALCOTT

IT TAKES
AT LEAST A
YEAR AND
A HALF <u>AFTER</u>
PUBLICATION
TO GET BACK
IN STRIDE.

J. D. SALINGER

I GAVE THE
BOOK EVERYTHING.
I'M PROUD OF IT.
I CAN SIGN IT OR READ
FROM IT OR TWEET
ABOUT IT OR GIFT WRAP
IT BUT THE BOOK ITSELF
IS STILL THE SAME.
IF YOU'VE GOT THAT,
YOU'VE GOT ME.

ANN PATCHETT

BE CAREFUL WITH PERIODS!

FRIEDRICH NIETZSCHE

I NEVER COULD BRING MYSELF TO USE A QUESTION MARK, I ALWAYS FOUND IT POSITIVELY REVOLTING.

GERTRUDE STEIN

I DECIDED TO ELIMINATE THE APOSTROPHES.

RICHARD WRIGHT

SEMICOLONS
ARE NOT QUITE AS
FORCEFUL AS COLONS.
AND DASHES ARE
VERY IMPORTANT TO ME—
I ESTABLISH MY
RHYTHM WITH THEM.

ROBERT CARO

DO NOT USE SEMICOLONS.

KURT VONNEGUT

TOO MANY
EXCLAMATION
POINTS MAKE
ME THINK
THE WRITER IS
TALKING ABOUT
THE PANIC IN
HIS OWN HEAD.

RUSSELL BAKER

AN
EXCLAMATION
POINT
IS LIKE
LAUGHING
AT YOUR
OWN JOKE.

F. SCOTT FITZGERALD

KEEP YOUR EXCLAMATION POINTS UNDER CONTROL. YOU ARE ALLOWED NO MORE THAN TWO OR THREE PER 100,000 WORDS OF PROSE.

ELMORE LEONARD

I SHARE ISAAC BABEL'S BELIEF THAT THE WELL-PLACED COMMA CAN STAB THE HEART.

BHARATI MUKHERJEE

COMMAS IN THE <u>NEW YORKER</u> FALL WITH THE PRECISION OF KNIVES IN A CIRCUS ACT, OUTLINING THE VICTIM.

E. B. WHITE

I LIKE COMMAS.

E. L. DOCTOROW

IF YOU AREN'T
INTERESTED
IN PUNCTUATION,
OR ARE AFRAID
OF IT, YOU'RE
MISSING OUT ON
SOME OF THE
MOST BEAUTIFUL,
ELEGANT TOOLS
A WRITER HAS
TO WORK WITH.

URSULA K. LE GUIN

READ TO LIVE!

GUSTAVE FLAUBERT

I WOULD RATHER BE DEAD THAN NOT READ.

ANNIE PROULX

I was a reader.
My parents would
frisk me before
family events.
Before weddings,
funerals, bar
mitzvahs, and what
have you. Because
if they didn't,
then the book would
be hidden inside
some pocket or
other and as soon
as whatever it
was got under way
I'd be found in
a corner.

NEIL GAIMAN

**Word by word
is how we learn to
hear and then read,
which seems only
fitting, because it is
how the books we are
reading were written
in the first place.**

FRANCINE PROSE

You think your
pain and your heartbreak
are unprecedented in the
history of the world, but then
you read. It was Dostoevsky and
Dickens who taught me that
the things that tormented
me most were the very things
that connected me with all the
people who were alive.

JAMES BALDWIN

SOME PEOPLE GO TO THE SEA SHORE AND SEE PEOPLE SWIMMING AND THEY WANT TO SWIM TOO. WHEN I STARTED TO READ I WANTED TO WRITE. I HAD MY FIRST STORY PUBLISHED WHEN I WAS 14.

RICHARD WRIGHT

Throughout my
twenties and early thirties—
my two-books-per-week
years—I did most of my
reading at the International
House of Pancakes.

DAVID SEDARIS

MOST OF MY BOOKS HAVE GOTTEN WET BECAUSE I READ IN THE TUB.

DAVE EGGERS

I DON'T NEED TO READ IN THE BATHROOM; IT TAKES ME LESS THAN A MINUTE.

ISABEL ALLENDE

THE PLEASURE OF ALL READING IS DOUBLED WHEN ONE LIVES WITH ANOTHER WHO SHARES THE SAME BOOKS.

KATHERINE MANSFIELD

MORNING READING—
LIKE MORNING
NEWSPAPERS,
MORNING SEX,
MORNING LIE-INS,
AND MORNING
RUNNING—IS THE
LUXURY OF
CHILDLESS PEOPLE.

ZADIE SMITH

I'D READ THE WHOLE RESERVATION LIBRARY BY THE TIME I WAS IN FIFTH GRADE.

SHERMAN ALEXIE

MY MOTHER MADE THE LIBRARY A VERY ACCESSIBLE PLACE... SHE TOLD US, "ONCE YOU CAN PRINT YOUR NAME, YOU CAN GET A LIBRARY CARD AND ALL OF THESE BOOKS CAN BE YOURS FOR TWO WEEKS."

GLORIA NAYLOR

I DISCOVERED ME IN THE LIBRARY.

RAY BRADBURY

I WAS CONSTANTLY READING, BUT NOT THINGS THAT WERE ASSIGNED.

AUDRE LORDE

I REMEMBER COMING BACK FROM THE LIBRARY WITH THREE BOOKS, ONE TUCKED UNDER EITHER ARM AND READING THE THIRD.

ISAAC ASIMOV

I HAPPEN TO BE A KIND OF WORD WHORE. I WILL READ ANYTHING FROM RACINE TO A NURSE ROMANCE, IF IT'S A GOOD NURSE ROMANCE.

ROBERT GOTTLIEB

I find that by reading what I feel I want to read, I get the most benefit. Then my soul keeps bonny and healthy. So if you feel like going for something wildly emotional, like <u>Jane Eyre</u>, or Balzac, or <u>Manon Lescaut</u>, you have it, and don't let that pragmatical ass shove shredded wheat down you when you want the red apple of feeling.

D. H. LAWRENCE

Although we read with our minds, the seat of artistic delight is between the shoulder blades. That little shiver behind is quite certainly the highest form of emotion that humanity has attained when evolving pure art and pure science. Let us worship the spine and its tingle.

VLADIMIR NABOKOV

I LIKED BOOKS ABOUT PROSTITUTES, THERE WERE A GOOD MANY THEN, AND VIVIDLY RECOLLECT A NOVEL CALLED <u>THE SANDS OF PLEASURE</u> WRITTEN BY A MAN NAMED FILSON YOUNG.

JEAN RHYS

IF YOU DON'T HAVE TIME TO READ, YOU DON'T HAVE THE TIME (OR THE TOOLS) TO WRITE. SIMPLE AS THAT.

STEPHEN KING

MY IDEAL STATE AS A READER WHEN I'M READING OTHER PEOPLE IS FEELING I'M VAGUELY WASTING MY TIME WHEN I'M NOT READING THAT NOVEL.

IAN MCEWAN

I WOULD LIKE MY PERSONAL READING MAP TO RESEMBLE A MAP OF THE BRITISH EMPIRE CIRCA 1900; I'D LIKE PEOPLE TO LOOK AT IT AND THINK, HOW THE HELL DID HE END UP RIGHT OVER THERE?

NICK HORNBY

KNOWING ABOUT A GOOD STORY YOU HAVEN'T READ IS LIKE WATCHING FOR A COMET.

EUDORA WELTY

IF YOU WANT TO KNOW WHAT'S GOING ON IN THE WORLD, IF YOU'RE INTERESTED IN POLITICS AND HISTORY, YOU GO TO GEORGE ELIOT.

JOYCE CAROL OATES

READ MONTAIGNE. READ HIM SLOWLY, UNHURRIEDLY. HE WILL CALM YOU.

GUSTAVE FLAUBERT

I WAKE UP EVERY NIGHT AND READ <u>WAR AND PEACE</u>. ONE READS WITH SUCH CURIOSITY AND NAIVE ENTHUSIASM AS THOUGH ONE HAD NEVER READ ANYTHING PREVIOUSLY.

ANTON CHEKHOV

I'M GLAD YOU LIKE CHEKHOV. HE IS A VERY GREAT WRITER, IMMENSE. HE PICKS ALL HUMAN ARROGANCES CLEAN TO THE BONE BUT HAS AN UNSHAKABLE CONFIDENCE IN THE FUTURE OF HUMANITY.

ITALO CALVINO

READ CHEKHOV, READ THE STORIES STRAIGHT THROUGH. ADMIT THAT YOU UNDERSTAND NOTHING OF LIFE, NOTHING OF WHAT YOU SEE. THEN GO OUT AND LOOK AT THE WORLD.

FRANCINE PROSE

have read James Joyce's Dubliners this week for the first time. It is pretty nearly a manual, I think, of the fundamentals of composition.

MARIANNE MOORE

I'M READING [BECKETT'S] MALONE DIES. THAT'S PROSE THAT CHANGES YOUR LIFE— THAT IS, THE WAY YOU WRITE. HOW CAN ANYONE WRITE THE SAME IN ENGLISH AFTER READING THAT?

SUSAN SONTAG

HAVE YOU READ ULYSSES AND WHAT DO YOU THINK OF IT?

EDITH WHARTON

THE BEST DICKENS ALWAYS SEEMS TO ME TO BE THE ONE I HAVE READ LAST.

C. S. LEWIS

A poem by Rilke is as real and as important as a young man falling out of an airplane. That's something I must engrave on my heart.

ETTY HILLESUM

Yeats's Autobiography is one of the very few books I have ever read that suggests a great spiritual personality, achievement, imaginative life, capacity—yet remains full of good, hard common sense.

ALFRED KAZIN

If I had to make a list of six books which were to be preserved when all others were destroyed, I would certainly put <u>Gulliver's Travels</u> among them.

GEORGE ORWELL

Every young author ought to read Samuel Butler's notebooks.

F. SCOTT FITZGERALD

I AM READING MOBY DICK. IT IS A VERY ODD, INTERESTING BOOK: TO ME INTERESTING, THE OTHERS CAN'T BEAR IT.

D. H. LAWRENCE

I hope you don't have friends who recommend Ayn Rand to you....She makes Mickey Spillane look like Dostoevsky.

FLANNERY O'CONNOR

I sat on my brand-new wide-wale corduroy couch and read <u>The Golden Notebook</u> by Doris Lessing, the extraordinary novel that changed my life and the lives of so many other young women in the 1960s.

NORA EPHRON

I am alternately reading Dostoevsky and Balzac. What wild greatness! One bows one's head.

THOMAS MANN

I am reading another Henry James called <u>The Ambassadors</u>—the man is uncanny the way he unravels a psychological situation. He writes in about five dimensions—and in that gorgeous convoluted style which, if you give it your closest attention, is nevertheless not obscure.

IRIS MURDOCH

I DON'T LIKE DANTE, WHEREAS HOMER IS ADORABLE.

ALDOUS HUXLEY

I BELIEVE DANTE'S DIVINE COMEDY CAN STILL SAVE THE WORLD.

KENZABURŌ ŌE

NOBODY SEEMS TO WANT MY WORK.

JOHN STEINBECK

A PORTRAIT OF THE ARTIST AS A YOUNG MAN WAS REFUSED BY EVERY PUBLISHER.

JAMES JOYCE

I HAVE SEVERAL WALLS
IN SEVERAL ROOMS OF MY HOUSE
COVERED WITH THE SNOWSTORM
OF REJECTIONS, BUT THEY DIDN'T
REALIZE WHAT A STRONG PERSON
I WAS; I PERSEVERED AND WROTE
A THOUSAND MORE DREADFUL
SHORT STORIES, WHICH WERE
REJECTED IN TURN.

RAY BRADBURY

The play fell flat
and flopped with
a bang. The audience
was bewildered.
They acted as if they
were ashamed to be
in the theater.

ANTON CHEKHOV

**IF AND WHEN
POEMS OF MINE ARE
REJECTED, I USUALLY
USE THE OPPORTUNITY
TO REWRITE THEM.**

JOYCE CAROL OATES

I remember
in Philadelphia
I was very angry
on opening night.
Great blocks of
people would get up
and start walking
out, and I would get
in the aisle and try
to turn them back
into their seats.

TENNESSEE WILLIAMS

My book Watt has been
turned down by Routledge.
Mr. Ragg and Mr. Read
agreed that it was
"wild and unintelligible."

SAMUEL BECKETT

Of course Henry Holt
rejected my book
last night with the most
equivocal of letters.
I wept, simply because
I want to get rid of
the book, mummify
it in print so that
everything I want to
write now doesn't get
sucked in its maw.

SYLVIA PLATH

**REJECTIONS ARE NOT
ALTOGETHER A BAD THING.
THEY TEACH A WRITER
TO RELY ON HIS OWN
JUDGMENT AND TO SAY
IN HIS HEART OF HEARTS,
"TO HELL WITH YOU."**

SAUL BELLOW

DEVELOPING AN ADEQUATE RESPONSE TO REJECTION, NEITHER DEFENSIVE NOR SENTIMENTAL, LIES AT THE HEART OF ANY SERIOUS ATTEMPT AT SANITY.

ALAIN DE BOTTON

TAKE NOTHING FOR GRANTED IF YOU CAN CHECK IT.

RUDYARD KIPLING

IF YOU PUT THE WRONG UNDERPANTS ON HENRY VIII, YOU'RE IN TROUBLE.

MARGARET ATWOOD

THE WRONG INFORMATION ABOUT A BUMBLEBEE IN A POEM IS ANNOYING ENOUGH, BUT INACCURACY IN NONFICTION IS A CARDINAL SIN.

REBECCA SOLNIT

I start to write without having completed the research, because once you start writing, it opens up a lot of other questions that you need to do research on, and so I feel like my research process is never complete.

TRACY CHEVALIER

THE BEST RESEARCH GETS YOUR FINGERS DUSTY AND YOUR SHOES DIRTY, ESPECIALLY BECAUSE A NOVEL IS MADE OF DETAILS.... I HAD TO KNOW WHAT A PLACE SMELLED LIKE, WHAT IT SOUNDED LIKE WHEN IT RAINED IN MEXICO CITY. THERE'S NO SUBSTITUTE FOR THAT. I'VE BEEN STEEPED IN EVIDENCE-BASED TRUTH.

BARBARA KINGSOLVER

THERE IS NO NEED FOR THE WRITER TO EAT A WHOLE SHEEP TO BE ABLE TO TELL YOU WHAT MUTTON TASTES LIKE. IT IS ENOUGH IF HE EATS A CUTLET. BUT HE SHOULD DO THAT.

W. SOMERSET MAUGHAM

Things get passed around so easily on the internet. And fact becomes fiction and fiction becomes fact, without anyone stepping in to arbitrate and say, What are your sources?

HILARY MANTEL

When you write fiction, you are telling a lie. It's a game, but you must get the facts straight. The reader doesn't want to be reminded that it's a lie. It must be convincing, or the story will never take off in the reader's mind.

DAVID FOSTER WALLACE

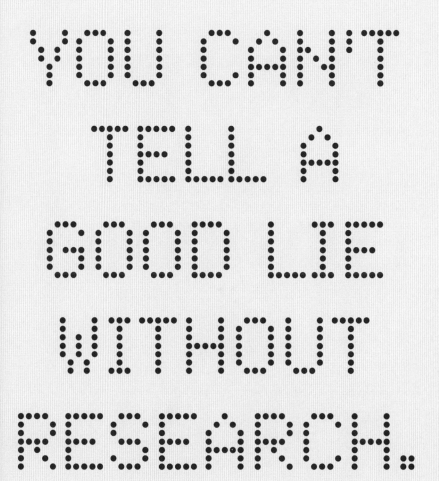

YOU CAN'T TELL A GOOD LIE WITHOUT RESEARCH.

MICHAEL CHABON

ROUTINE IS A CONDITION OF SURVIVAL.

FLANNERY O'CONNOR

WHEN I SIT AT MY TYPEWRITER I ALWAYS FACE EAST.

HENRY MILLER

I sharpen all the pencils in the morning and it takes one more sharpening for a day's work. That's twenty-four sharp points. I can make a newly sharpened pencil last almost a page.

JOHN STEINBECK

For the past few months I've been trying to meditate in the morning—I'm terrible at it, but I think it's likely a better start to one's writing day than pounding a pot of coffee.

KAREN RUSSELL

I HAVEN'T MADE DINNER IN A WHILE. I'M LONGING TO HAVE SOME NORMAL TIME.

SARAH RUHL

I GET UP AT NINE, STUFF MYSELF WITH LOBSTER, AND LIE ON MY BED AT MIDDAY. THEN I TAKE A WALK ALONG THE SHORE, AND GO BACK TO BED AT TEN. I READ NOTHING, AND LIVE LIKE A VEGETABLE.

GUSTAVE FLAUBERT

There were times over the years when life was not easy, but if you're working a few hours a day and you've got a good book to read, and you can go outside to the beach and dig for clams, you're okay.

MARY OLIVER

I SIT DOWN EVERY
EVENING AFTER DINNER AND,
AFTER A LITTLE MUSIC,
PUT MY FOREFINGER IN THE
MIDDLE OF MY FOREHEAD
AND STRUGGLE WITH MY
IMAGINATION.

WALLACE STEVENS

THE BEST TIME IS
AT THE END OF THE DAY,
WHEN YOU'VE WRITTEN AND
FORGOTTEN. YOU WROTE
LONGER THAN YOU EXPECTED TO.
YOU'VE BEEN SO ABSORBED
IN IT THAT IT GOT LATE.
YOU UNHITCH YOURSELF
FROM THE PLOW.

MARY KARR

THE WHOLE STORY IS JUNK.

FYODOR DOSTOEVSKY

I'm sending you my book, though I don't want to, because I'm sick about it—poor miserable lifeless lump that it is!

EDITH WHARTON

FEEL TERRIBLE AFTER CHRISTMAS AND HATE MY NOVEL EVEN MORE. THINK I HAD BETTER TAKE UP LEATHER WORK OR SOMETHING USEFUL.

IRIS MURDOCH

This is a terrible opus: I wonder how I have the patience to write it. Do you think other people will have the patience to read it?

JAMES JOYCE

I hardly expect you to like the book. I don't like it. It is terrible.

JOHN STEINBECK

I SUFFER FROM TERRIBLE NAUSEA ABOUT MY OWN WORK, PURELY PHYSICAL NAUSEA.

LAWRENCE DURRELL

On getting into bed I was attacked by a series of gloomy thoughts about professional and literary failure.

C. S. LEWIS

I HOPE HERZOG WILL AMOUNT TO SOMETHING.

SAUL BELLOW

LIKE MY HERO VIRGINIA WOOLF, I DO LACK CONFIDENCE. I ALWAYS FIND THAT THE NOVEL I'M FINISHING, EVEN IF IT'S TURNED OUT FAIRLY WELL, IS NOT THE NOVEL I HAD IN MY MIND.

MICHAEL CUNNINGHAM

AT EVERY TURN, I THOUGHT I WOULD FAIL. THAT'S WHY IT'S GOOD FOR ME TO HAVE A REGULAR JOB. A GOOD BOOK DOESN'T ALWAYS SELL.... BUT BECAUSE I HAVE A JOB, I DON'T CARE ABOUT THAT.

HA JIN

I DON'T THINK I'M GIFTED AT ALL.

JORGE LUIS BORGES

WONDER IF I SHALL EVER BE FAMOUS ENOUGH FOR PEOPLE TO CARE TO READ MY STORY AND STRUGGLES.

LOUISA MAY ALCOTT

I'M SCARED UNTIL THREE OR FOUR MONTHS AFTER EACH BOOK COMES OUT.

MICHAEL ONDAATJE

WHEN I WRITE
I'M VERY
UNCERTAIN
WHETHER IT'S
GOOD ENOUGH.
THAT IS,
OF COURSE,
THE WRITER'S
AGONY.

SUSAN SONTAG

THE WORST ENEMY TO CREATIVITY IS SELF-DOUBT.

SYLVIA PLATH

I CONSIDER MYSELF A SENTENCE PERSON.

FRANCINE PROSE

YOU WANT
TO WRITE
A SENTENCE
AS CLEAN
AS A BONE.
THAT IS
THE GOAL.

JAMES BALDWIN

The single-sentence paragraph more closely resembles talk than writing, and that's good. Writing is seduction. Good talk is part of seduction. If not so, why do so many couples who start the evening at dinner wind up in bed?

STEPHEN KING

THE SENTENCES IN MY FIRST BOOK ARE SO SIMPLE I REALLY COULDN'T MANAGE ANYTHING VERY COMPLEX.

MARK STRAND

I CAN HANG ON TO A SENTENCE FOR SEVERAL YEARS AND THEN PUT IT INTO A BOOK THAT'S COMPLETELY DIFFERENT FROM THE ONE IT STARTED IN.

KATE ATKINSON

A single sentence, particularly a long, involved one, can carry a story forward. I put a lot of time into them. Carefully constructed sentences cast a tint of indefinable substance over a story.

ANNIE PROULX

THERE ARE TIMES WHEN THE ONLY ACCESS I HAVE TO THE TRUEST PERSON THAT I AM IS WHEN I'M ALONE AND TRYING TO SOLVE A SENTENCE. IT'S EXCITING, EVEN WHEN IT'S FRUSTRATING, EVEN WHEN I CAN'T DO IT RIGHT.

ELIZABETH GILBERT

A sentence should read as if its author, had he held a plough instead of a pen, could have drawn a furrow deep and straight to the end

HENRY DAVID THOREAU

THE SENTENCE IS THE GREATEST INVENTION OF CIVILIZATION.

JOHN BANVILLE

THAT'S MY ONLY DEFENSE AGAINST THIS WORLD: TO BUILD A SENTENCE OUT OF IT.

JIM HARRISON

GREAT SEX IS MORE RARE IN ART THAN IN LIFE BECAUSE IT'S HARDER TO DO.

BARBARA KINGSOLVER

WHEN YOU'RE NOT IN THE MOOD, THERE'S NOTHING WORSE THAN A SEX SCENE.

NICHOLSON BAKER

When I was a teenager my guilty reading was, of course, erotic stuff. At 14, living in Lebanon, I discovered the irresistible mixture of eroticism and fantasy reading <u>One Thousand and One Nights</u> inside a closet with a flashlight.

ISABEL ALLENDE

I was very sexually successful as a young man, but I did not believe in going so far that I lost my head. I wanted always to be conscious. I didn't want to indulge in sex so much that I lost my head.

WILLIAM CARLOS WILLIAMS

I AM VERY INCOMPETENTLY ORGANIZED SEXUALLY.

IRIS MURDOCH

YOU CAN TELL EXACTLY WHICH WOMEN I'VE SLEPT WITH, BECAUSE I MARRIED THEM.

SLAVOJ ŽIŽEK

Reading a book of expert sexual instruction must rank near the bottom on the scale of erotic pastimes—somewhere below peeling an orange, not far above flossing.

JONATHAN FRANZEN

The only person who deals with sex in an explicit way whom I can read without being made profoundly uncomfortable is Norman Mailer. I know that's not an opinion shared by many. Mailer deals with sex in a very clean, direct way.

JOAN DIDION

I WOULDN'T BE AFRAID TO SHOW SEX AS FUNNY.

JOHN UPDIKE

ABSTRACTLY CHEERING THOUGHT: THE MILLIONS OF PEOPLE AROUND THE WORLD WHO WILL TONIGHT SLEEP TOGETHER FOR THE FIRST TIME.

ALAIN DE BOTTON

THERE IS NO AGONY LIKE BEARING AN UNTOLD STORY INSIDE YOU.

ZORA NEALE HURSTON

WHEN ANYBODY
ASKS WHAT A
STORY IS ABOUT,
THE ONLY PROPER
THING IS TO
TELL HIM TO READ
THE STORY.

FLANNERY O'CONNOR

I NEVER FEEL
SPIRITUAL
ANYWHERE,
EXCEPT IN
THE PRESENCE
OF MY OWN
STORIES.

SHERMAN ALEXIE

When you feel owned by a story rather than you owning a story, you wait for it to let you know how it wants to be told; that engages every faculty of mine, and I am ceaselessly grateful for that. It's a beautiful thing.

ARUNDHATI ROY

THE SHORT STORY IS LIKE AN EXQUISITE PAINTING AND YOU MIGHT, WHEN LOOKING AT THIS PAINTING, BE WONDERING WHAT CAME BEFORE OR AFTER, BUT YOU ARE FULLY ABSORBED IN WHAT YOU'RE SEEING.

EDWIDGE DANTICAT

With a short story… you put the lid on tightly, and these characters are in the bottle, and you really put the pressure on.

YIYUN LI

Before I wrote stories, I listened for stories. Listening for them is something more acute than listening to them. I suppose it's an early form of participation in what goes on. Listening children know stories are there. When their elders sit and begin, children are just waiting and hoping for one to come out, like a mouse from its hole.

EUDORA WELTY

Once we hear each other's stories we realize that the things we see as dividing us are, all too often, illusions… the walls between us are in truth no thicker than scenery.

NEIL GAIMAN

THROUGH STORY, EVERY CULTURE DEFINES ITSELF AND TEACHES ITS CHILDREN HOW TO BE PEOPLE AND MEMBERS OF THEIR PEOPLE.

URSULA K. LE GUIN

I THINK THERE IS AN ITCH THAT'S ONLY SCRATCHABLE WITH A STORY.

KAREN RUSSELL

I AM A STORYTELLER, FOR BETTER AND FOR WORSE.

OLIVER SACKS

A STORY SHOULD BREAK THE READER'S HEART.

SUSAN SONTAG

ONE DOES NOT CHOOSE ONE'S SUBJECT.

GUSTAVE FLAUBERT

I discovered that my own little postage stamp of native soil was worth writing about and that I would never live long enough to exhaust it.

WILLIAM FAULKNER

THE LARGER THE ISSUE THE LESS IT INTERESTS ME. SOME OF MY BEST CONCERNS ARE MICROSCOPIC PATCHES OF COLOR.

VLADIMIR NABOKOV

Make the familiar exotic (Americans won't recognize their country when I get finished with it) and make the exotic—the India of elephants and arranged marriages—familiar.

BHARATI MUKHERJEE

I WRITE ABOUT LITTLE THINGS BECAUSE THE BIG ONES ARE LIKE ABYSSES.

ANAÏS NIN

People love to read about work. God knows why, but they do. If you're a plumber who enjoys science fiction, you might well consider a novel about a plumber aboard a starship or on an alien planet.

STEPHEN KING

I KEEP WRITING ABOUT THE ORDINARY BECAUSE FOR ME IT'S THE HOME OF THE EXTRAORDINARY.

PHILIP LEVINE

MY JOB
IS TO NOTICE
THE THINGS
THAT YOU'RE
NOT SUPPOSED
TO NOTICE.

FRANCINE PROSE

**I HAVE A
TERRIBLE FEAR
OF VERTIGO,
SO WHAT DO
I WRITE ABOUT?
I WRITE ABOUT
A BRIDGE BUILDER
IN TORONTO.**

MICHAEL ONDAATJE

IN DESCRIBING
WHAT I DO, I RESORT
TO THE LATIN PHRASE
SILVA RERUM: THE
FOREST OF THINGS.
THAT'S MY SUBJECT:
THE FOREST OF THINGS,
AS I'VE SEEN IT, LIVING
AND TRAVELING IN IT.

RYSZARD KAPUŚCIŃSKI

I'm afraid
I sometimes take
notes on telephone
conversations even
as they're going on,
but I hasten to
say only within my
own family.

LYDIA DAVIS

I've always
been writing
about my family,
but up until
now I'd been very
clever to hide
everyone in giant
costumes made out
of chicken wire
and masking tape.

ANN PATCHETT

My goal would be to
find a big fat subject that
would occupy me to the
end of my life, and when
I finish it I'll die.

PHILIP ROTH

WE NEVER KNOW WHAT THE HELL WE'RE WRITING ABOUT, NOT EVEN WHEN THE BOOK'S OVER.

JANE GARDAM

DON'T CONFUSE HONORS WITH ACHIEVEMENT.

ZADIE SMITH

I NEVER WANTED TO BECOME A CELEBRITY. BEING A MAVERICK SAVED MY LIFE.

JAMES BALDWIN

I NEVER DO ANYTHING BECAUSE I'M A CELEBRITY, AS A RULE. I DO WHAT I DO AS A CITIZEN.

ARUNDHATI ROY

LOOK AT ME.
THEY BUILD ME UP,
TEAR ME DOWN,
BUILD ME UP,
TEAR ME DOWN, UP,
DOWN, UP, DOWN.

TRUMAN CAPOTE

I WROTE
FOR SIXTEEN
YEARS BEFORE
I COULD MAKE
A LIVING OUT
OF IT.

MARGARET ATWOOD

PEOPLE ASSOCIATE MY NAME WITH SUCCESSES. I'VE HAD A SUCCESSION OF FAILURES.

TENNESSEE WILLIAMS

The Pulitzer Surprise,
as my then-nine-year-old
son so accurately
dubbed it, affected my
writing only in that it
interrupted it for a while
by drawing renewed
attention to March.
But after a few weeks
of pleasant distraction
I was back at my desk,
alone in a room,
simply doing what I've
always done, which
is trying to write as best
I can, day after day.

GERALDINE BROOKS

IT'S AMAZING LUCK THAT ONE'S BEST BOOK SHOULD BE THE WIDEST READ ONE, AND THE ONE MOST LIKELY TO DO GOOD, AS WELL.

E. M. FORSTER

Everybody looks upon
me as a wonder of the world.
If I but open my mouth,
the air resounds with what
Dostoevsky said, what
Dostoevsky means to do.

FYODOR DOSTOEVSKY

THE UTMOST RENOWN NEVER SLAKES A MAN'S APPETITE AND, UNLESS HE IS A FOOL, HE ALMOST ALWAYS DIES UNCERTAIN OF HIS OWN FAME.

GUSTAVE FLAUBERT

NO ONE IN THE HISTORY
OF MY FAMILY,
INCLUDING MY FATHER,
WAS SUCCESSFUL,
AND I HAVE A LOT OF
QUESTIONS ABOUT
WHETHER IT'S PROPER TO
BE SUCCESSFUL.

JIM HARRISON

WHEN PEOPLE
WRITE A NOVEL,
THEY WANT TO
HAVE THAT REACH
AND THAT IMPACT.
TO GET IT WITH
A FIRST NOVEL,
YOU CAN EITHER
SEE IT AS AN
ALBATROSS OR A
CALLING CARD.

IRVINE WELSH

While I am
working I do not think
of the public and of
success, and if success
comes it is a fortuitous
event that falls upon
me out of the clouds.
Or rather, I myself fall
out of the clouds and
down to earth with
a thud, for I have never
yet finished a book
without being convinced
of its unreadability.

THOMAS MANN

REPORTERS SIT
ON THE WALL
AND TAKE NOTES;
ARTISTS SKETCH
ME AS I PICK PEARS
IN THE GARDEN....
IT LOOKS LIKE
IMPERTINENT CURIOSITY
TO ME; BUT IT IS
CALLED "FAME,"
AND CONSIDERED
A BLESSING TO
BE GRATEFUL FOR.

LOUISA MAY ALCOTT

**ALONG WITH
SUCCESS COME
DRUGS, DIVORCE,
FORNICATION,
BULLYING, TRAVEL,
MEDITATION,
MEDICATION,
DEPRESSION,
NEUROSIS, AND
SUICIDE. WITH
FAILURE COMES
FAILURE.**

JOSEPH HELLER

I'M CERTAINLY NO LUDDITE.

J. G. BALLARD

TECHNOLOGY IS A BITCH.

NORA EPHRON

I AM A PREINDUSTRIAL MAN.

CHINUA ACHEBE

I AM NOT ON FACEBOOK OR ON TWITTER BECAUSE THE PURPOSE OF MY LIFE IS TO AVOID MESSAGES.

UMBERTO ECO

The only reason
I stay loyal to
my piece-of-shit
computer is that I
have invested so
much ingenuity into
building one of the
great autocorrect
files in literary history.
Perfectly formed
and spelt words emerge
from a few brief
keystrokes: "Niet"
becomes "Nietzsche,"
"phoy" becomes
"photography," and
so on. Genius!

GEOFF DYER

I DON'T
KNOW HOW
TO TYPE,
BUT I DO HAVE
TWO TYPISTS
WHO MANAGE TO
DECIPHER
WHAT I WRITE.

SIMONE DE BEAUVOIR

I have an old
video-writer,
which is probably
an antique
or something.
It's from Magnavox,
one of the very
early computers.

LUCILLE CLIFTON

I DON'T HAVE
A SMARTPHONE.
I HAVE A
FLIP PHONE.

ZADIE SMITH

IMAGINE,
WE ARE BUILDING
A GARAGE AND
GETTING AN
AUTOMOBILE!
I WON'T BE ABLE
TO BELIEVE
IT WHEN I AM
SITTING IN IT.
A PLAIN PERSON
LIKE ME!

THOMAS MANN

AUDIOBOOKS
ARE GENERALLY
RESERVED
FOR POETRY.
HOW NEAT IS IT
TO LISTEN TO
PHILIP LEVINE ON
THE WAY TO THE
GROCERY STORE?

SCOTT TUROW

NOVELS
THAT LEAVE OUT
TECHNOLOGY
MISREPRESENT
LIFE AS BADLY
AS VICTORIANS
MISREPRESENTED
LIFE BY LEAVING
OUT SEX.

KURT VONNEGUT

I DON'T WANT TO CHANGE THE TITLE.

ITALO CALVINO

I DON'T FUCK
AROUND WITH TITLES.
I COME UP WITH
THEM IMMEDIATELY
AND THEN DON'T
EVER THINK ABOUT
CHANGING THEM.

ZADIE SMITH

MOST OF THE TIME THE TITLE COMES AT THE END. BLUBBER AND FRECKLE JUICE WERE EXCEPTIONS— I HAD THE TITLES BEFORE I WROTE THESE BOOKS.

JUDY BLUME

I have an alternative title: Gold-hatted Gatsby.

F. SCOTT FITZGERALD

DICKENS KNEW BLEAK HOUSE WAS GOING TO BE CALLED BLEAK HOUSE BEFORE HE STARTED WRITING IT. THE REST MUST HAVE BEEN EASY.

RODDY DOYLE

THE HANDMAID'S TALE WAS CALLED OFFRED WHEN I FIRST BEGAN IT. IT CHANGED BY PAGE 110.

MARGARET ATWOOD

We have a title at last. See how you like it. The Grapes of Wrath from "Battle Hymn of the Republic." I think it is swell.

JOHN STEINBECK

THINKING ABOUT THE TITLE WOMEN IN LOVE. IF YOU CARE TO CHANGE IT TO DAY OF WRATH, I AM WILLING.

D. H. LAWRENCE

Still no revelations on the goddamn title. My head feels like a theater marquee.

WALLACE STEGNER

EVERY ONE OF
MY NOVELS COULD BE
ENTITLED <u>THE UNBEARABLE</u>
<u>LIGHTNESS OF BEING</u>
OR <u>THE JOKE</u> OR <u>LAUGHABLE</u>
<u>LOVES</u>; THE TITLES ARE
INTERCHANGEABLE.

MILAN KUNDERA

<u>CLAUDE</u> IS THE
<u>ONLY</u> TITLE FOR THIS STORY—
ANY OTHER TITLE WOULD
SPOIL THE BOOK FOR ME,
AND THIS BOOK IS A PRESENT
I AM MAKING TO MYSELF.
I WON'T HAVE IT SPOILED.

WILLA CATHER

I HAVE A FILE IN MY COMPUTER CALLED "TITLES."

MIRANDA JULY

I ANSWERED A QUESTIONNAIRE THAT ASKED IF I HAVE ANY TITLES THAT I HAVE NOT USED YET THAT I WANTED TO USE. I DO HAVE ONE, <u>THE SAINT AND THE PSYCHOPATH</u>, AND I'M JUST WAITING FOR THE RIGHT BOOK.

NORMAN MAILER

NOT "TRILOGY," I BESEECH YOU, JUST THE THREE TITLES AND NOTHING ELSE.

SAMUEL BECKETT

AS USUAL I DON'T LIKE THE TITLE. IT SOUNDS TOO CLEVER.

FLANNERY O'CONNOR

ALTHOUGH THE TITLE OF THIS BOOK MAY SEEM ALARMIST, THERE'S NOTHING TO BE ANXIOUS ABOUT.

DANIEL MENDELSOHN

IN MY COUNTRY, THE TITLES OF MY NOVELS ARE BETTER KNOWN THAN MY NAME.

ELENA FERRANTE

I HAVE PECULIAR IDEAS ABOUT TITLES. THEY SHOULD NEVER BE OBVIOUSLY PROVOCATIVE, NOR SAY ANYTHING ABOUT MURDER.

RAYMOND CHANDLER

THE TITLES HAVE GONE WEIRD, HAVEN'T THEY?

ADAM NICOLSON

WEARING DOWN SEVEN NUMBER-TWO PENCILS IS A GOOD DAY'S WORK.

ERNEST HEMINGWAY

MY PEN. IT IS A WATERMAN, BLACK ENAMEL WITH A TRIM OF GOLD. WHEN I WRITE WITH IT, I FEEL AS IF I'M WEARING A PERFECTLY TAILORED SUIT, AND MY HAIR IS FLAWLESSLY PULLED BACK INTO A CHIGNON.

MARY GORDON

I ALWAYS WRITE FICTION BY HAND, ON GRAPH PAPER.

CLAIRE MESSUD

MY SCHEDULE IS FLEXIBLE BUT I AM RATHER PARTICULAR ABOUT MY INSTRUMENTS: LINED BRISTOL CARDS AND WELL-SHARPENED, NOT TOO HARD PENCILS CAPPED WITH ERASERS.

VLADIMIR NABOKOV

DON'T BE ASHAMED TO USE A THESAURUS.

SUSAN ORLEAN

DO KEEP A THESAURUS, BUT IN THE SHED AT THE BACK OF THE GARDEN OR BEHIND THE FRIDGE, SOMEWHERE THAT DEMANDS TRAVEL OR EFFORT.

RODDY DOYLE

WHEN I SIT DOWN TO WRITE I FEEL EXTRAORDINARILY AT EASE....I USE TOOLS THAT ARE FAMILIAR TO ME AND THEY FIT SNUGLY IN MY HANDS.

NATALIA GINZBURG

MELODRAMA IS ONE OF MY WORKING TOOLS AND IT ENABLES ME TO OBTAIN EFFECTS THAT WOULD BE UNOBTAINABLE OTHERWISE.

GRAHAM GREENE

THE TOOLS I NEED FOR MY TRADE ARE PAPER, TOBACCO, FOOD, AND A LITTLE WHISKEY.

WILLIAM FAULKNER

MY FIRST NOTEBOOK WAS A BIG FIVE TABLET, GIVEN TO ME BY MY MOTHER WITH THE SENSIBLE SUGGESTION THAT I STOP WHINING AND LEARN TO AMUSE MYSELF BY WRITING DOWN MY THOUGHTS.

JOAN DIDION

ALWAYS CARRY A NOTEBOOK.... THE SHORT-TERM MEMORY ONLY RETAINS INFORMATION FOR THREE MINUTES; UNLESS IT IS COMMITTED TO PAPER YOU CAN LOSE AN IDEA FOREVER.

WILL SELF

I WILL WRITE ON ANYTHING—LINED, UNLINED, SCRAP— BUT I SAVOR THE PAGES THAT I WRITE ON OLD, BRITTLE PAPER.

LOUISE ERDRICH

MY IDEA OF HELL IS A BLANK SHEET OF PAPER.

NEIL GAIMAN

THE WHITE PAGE FOR ME IS LIKE A SKI SLOPE; I GO ABSOLUTELY MAD!

ANAÏS NIN

TRUTH IS TO BE HANDLED GINGERLY. THAT'S AN EGG WITH A VERY THIN SHELL.

WALLACE STEGNER

THE TRUTH IS IMPORTANT, BUT IT'S A CERTAIN KIND OF TRUTH.

JAMAICA KINCAID

PAGE AFTER PAGE, THE DRIVE TO CAPTURE WHAT IS TRUE, AND NOT WHAT RESEMBLES THE TRUTH, SHAPES THE WORK.

ELENA FERRANTE

I THINK I TELL LESS TRUTH WHEN I WRITE JOURNALISM THAN WHEN I WRITE FICTION.

JULIAN BARNES

I WANT TO WRITE SO THAT THE READER IN DES MOINES, IOWA, IN KOWLOON, CHINA, IN CAPE TOWN, SOUTH AFRICA, CAN SAY, "YOU KNOW, THAT'S THE TRUTH. I WASN'T THERE, AND I WASN'T A SIX-FOOT BLACK GIRL, BUT THAT'S THE TRUTH."

MAYA ANGELOU

I DON'T FEEL ANY COMMITMENT TO ANY EXTERNAL IDEA OF THE TRUTH.

CLAUDIA RANKINE

I DON'T CARE
ABOUT FACTS—
I'VE SAID THAT
LOTS OF TIMES.
BUT I CARE
TREMENDOUSLY
ABOUT THE
TRUTH; I CARE
TREMENDOUSLY
ABOUT JUSTICE.

LUCILLE CLIFTON

FACTS ARE SLIPPERY. THE TRUTH IS IMPERFECT. FICTION RECOGNIZES THAT.

SALMAN RUSHDIE

THE WORDS WE USE ARE THE WORLDS WE LIVE IN.

RICHARD FORD

WORDS ARE, OF COURSE, THE MOST POWERFUL DRUG USED BY MANKIND.

RUDYARD KIPLING

EVERY WORD BOTH SEPARATES AND LINKS; IT DEPENDS ON THE WRITER WHETHER IT BECOMES WOUND OR BALM, CURSE OR PROMISE.

ELIE WIESEL

OTHER PEOPLE'S WORDS ARE THE BRIDGE YOU USE TO CROSS FROM WHERE YOU WERE TO WHEREVER YOU'RE GOING.

ZADIE SMITH

INTERESTING
VERBS ARE
SELDOM VERY
INTERESTING.

JONATHAN FRANZEN

WHY USE
TEN WORDS
WHEN TWENTY
WILL DO.

HARLAND MILLER

INCOMPETENCE WILL SHOW IN THE USE OF TOO MANY WORDS.

EZRA POUND

THE INUIT
HAVE FIFTY-TWO
WORDS FOR
SNOW. EACH OF
THOSE WORDS
DESCRIBES A
DIFFERENT KIND
OF SNOW.

MARGARET ATWOOD

I've always
sensed that
language is the
great liberator.
The fitting phrase,
the precise word—
these permit us
to be more nearly
ourselves.

CAROL SHIELDS

The music, the sound
of words working
together, has always
mattered to me.

ADRIENNE RICH

WHENEVER I READ
A BOOK, I MARVEL
AT THE NUMBER OF
WORDS I MEET IN IT AND
I LONG TO USE THEM.

JEAN COCTEAU

**IMPOVERISHED
VOCABULARY
DISTURBS ME.**

ROBERT GOTTLIEB

IF I COULD STRIKE
ONE WORD OUT
OF THE AMERICAN
VOCABULARY,
IT WOULD BE
"COMPETITION."

MARILYNNE ROBINSON

THE WORD "CREATIVE" DRIVES ME CRAZY.

ELIZABETH BISHOP

SUMMER AFTERNOON; TO ME THOSE HAVE ALWAYS BEEN THE TWO MOST BEAUTIFUL WORDS IN THE ENGLISH LANGUAGE.

HENRY JAMES

SURELY IT IS
A MAGICAL THING
FOR A HANDFUL
OF WORDS, ARTFULLY
ARRANGED, TO STOP
TIME. TO CONJURE
A PLACE, A PERSON,
A SITUATION, IN ALL
ITS SPECIFICITY
AND DIMENSIONS.
TO AFFECT US
AND ALTER US, AS
PROFOUNDLY AS
REAL PEOPLE AND
THINGS DO.

JHUMPA LAHIRI

A writer lives
in awe of words
for they can be cruel
or kind, and they
can change their
meanings right in
front of you. They
pick up flavors and
odors like butter in
a refrigerator.

JOHN STEINBECK

Words, so innocent
and powerless as they
are, as standing in a
dictionary, how potent
for good and evil they
become in the hands
of one who knows how
to combine them.

NATHANIEL HAWTHORNE

The writer has to
take the most used,
most familiar objects—
nouns, pronouns, verbs,
adverbs—ball them
together and make them
bounce, turn them a
certain way and make
people get into a romantic
mood; and another way,
into a bellicose mood.

MAYA ANGELOU

DO NOT DRESS WORDS UP
BY ADDING "-LY" TO THEM,
AS THOUGH PUTTING A
HAT ON A HORSE.

WILLIAM STRUNK JR. AND E. B. WHITE

DON'T SAY "INFINITELY" WHEN YOU MEAN "VERY"; OTHERWISE YOU'LL HAVE NO WORD LEFT WHEN YOU WANT TO TALK ABOUT SOMETHING <u>REALLY</u> INFINITE.

C. S. LEWIS

Well-wishers have tried to translate <u>Lolita</u> into Russian, but with such execrable results that I'm now doing a translation myself. The word "jeans," for example, is translated in Russian dictionaries as "wide, short trousers"— a totally unsatisfactory definition.

VLADIMIR NABOKOV

THE RIGHT WORD IS, SIMPLY, THE WANTED ONE; THE WANTED WORD IS THE ONE MOST NEARLY TRUE. TRUE TO WHAT? YOUR VISION AND YOUR PURPOSE.

ELIZABETH BOWEN

INDIVIDUAL WORDS HAVE TO DO A LOT OF WORK. LIKE THE WORD <u>HERE</u>. I LOVE THAT WORD.

CLAUDIA RANKINE

WORDS HAVE WEIGHT, SOUND, AND APPEARANCE; IT IS ONLY BY CONSIDERING THESE THAT YOU CAN WRITE A SENTENCE THAT IS GOOD TO LOOK AT AND GOOD TO LISTEN TO.

W. SOMERSET MAUGHAM

I BELIEVE IN THE WORD.

BHARATI MUKHERJEE

LOVE THE WORDS.

DYLAN THOMAS

YESTERDAY INCAPABLE OF WRITING EVEN ONE WORD. TODAY NO BETTER. WHO WILL SAVE ME?

FRANZ KAFKA

I had writer's blocks
when I was twelve
and seventeen.

ELIZABETH BISHOP

I've been
blocked myself....
The thing to do
is rest, to take
time off and let
the energy rebuild.
The desire to
create is one
of the strongest
urges a human
spirit can contain.
It will always
break through.

TENNESSEE WILLIAMS

**Never stop
when you are stuck.
You may not be able
to solve the problem,
but turn aside and
write something else.
Do not stop altogether.**

JEANETTE WINTERSON

**I FEEL
INTUITIVELY
THAT IF YOU'RE
CRAMPED YOU JUST
HAVE TO LURCH.
SOMETIMES GOING
INTO ANOTHER FORM
WILL LOOSEN UP
THE GAME A BIT.**

GEORGE SAUNDERS

I AM BEGINNING
TO RESPECT THE
APATHETIC DAYS.
PERHAPS THEY'RE A
NECESSARY PAUSE:
BETTER TO GIVE
IN TO THEM THAN
TO FIGHT THEM AT
YOUR DESK HOPELESSLY;
THEN YOU LOSE
BOTH THE DAY AND
YOUR SELF-RESPECT.
TREAT THEM AS
PHYSICAL PHENOMENA—
CASUALLY—AND
OBEY THEM.

ANNE MORROW LINDBERGH

ROME HAS BEEN DARK AND RAINY AND I'VE BEEN UTTERLY PARALYZED AND UNABLE TO WRITE A LINE.

WILLIAM STYRON

I once wrote a story about a writer who could not write anymore, and my friend Tennessee Williams said, "How could you dare write that story, it's the most terrifying work I have ever read."

CARSON MCCULLERS

People have writer's block not because they can't write, but because they despair of writing eloquently.

ANNA QUINDLEN

Block. It puts some writers down for months. It puts some writers down for life.

JOHN MCPHEE

There is all the glamorous folklore surrounding writer's block, an affliction known sometimes to resolve itself dramatically and without warning, much like constipation, and (hence?) finding wide sympathy among readers.

THOMAS PYNCHON

WRITER'S BLOCK IS GIBBERISH.

EDWARD ALBEE

If you get stuck, get away from your desk. Take a walk, take a bath, go to sleep, make a pie, draw, listen to music, meditate, exercise; whatever you do, don't just stick there scowling at the problem. But don't make telephone calls or go to a party; if you do, other people's words will pour in where your lost words should be. Open a gap for them, create a space. Be patient.

HILARY MANTEL

IT WOULD BE
WISEST NOT TO
WORRY TOO
MUCH ABOUT THE
STERILE PERIODS.
THEY VENTILATE
THE SUBJECT AND
INSTILL INTO
IT THE REALITY OF
DAILY LIFE.

ANDRÉ GIDE

GOOD PROSE IS LIKE A WINDOW PANE.

GEORGE ORWELL

THE WRITER IS THE MIDWIFE OF UNDERSTANDING.

ARUNDHATI ROY

The only end of writing is to enable the readers better to enjoy life, or better to endure it.

SAMUEL JOHNSON

THE WRITER'S ART CONSISTS IN ENTICING WORDS, LITTLE BY LITTLE, TO TAKE AN INTEREST IN HIS BOOKS.

EDMOND JABÈS

The most essential gift for a good writer is a built-in, shockproof shit detector. This is the writer's radar and all great writers have had it.

ERNEST HEMINGWAY

It puts me in mind of a description of writing I heard somewhere: that what we writers do is create, every day, the very ground we need to stand on.

NAM LE

OUR JOB IS TO EMPATHIZE WITH OTHER PEOPLE, TO UNDERSTAND THEIR STORY, BUT ALSO TO REVEAL OURSELVES.

HILTON ALS

A writer is not a confectioner, not a provider of cosmetics, not an entertainer; he is a man bound under contract, by his sense of duty and his conscience.

ANTON CHEKHOV

GOOD WRITING
IS SUPPOSED
TO EVOKE
SENSATION IN
THE READER—
NOT THE FACT
THAT IT'S RAINING,
BUT THE FEEL
OF BEING
RAINED UPON.

E. L. DOCTOROW

DON'T TELL
US THE JEWELS
HAD AN
"EMOTIONAL"
GLITTER;
MAKE US
FEEL THE
EMOTION.

C. S. LEWIS

It is necessary
to write, if the days
are not to slip emptily by.
How else, indeed, to clap
the net over the butterfly
of the moment?

VITA SACKVILLE-WEST

**YOU SHOULD FEEL,
WHEN YOU'VE
FINISHED A STORY,
THAT IT HAS
ACHIEVED A LIFE
INDEPENDENT OF
YOURS, THAT IT
HAS SOMEHOW
GATHERED UP THE
GOLDEN CHAIN THAT
CONNECTED YOU.**

TOBIAS WOLFF

The best thing you
can do for a writer is
to keep him from
starving, and to provide
some degree of free
time for him.

GWENDOLYN BROOKS

IF YOU'RE
LONELY, AS MOST
WRITERS ARE,
WRITE YOUR WAY
OUT OF IT.

J. D. SALINGER

Why am I a writer?
Why have I risked my
life so many times,
come so close to dying?
Is it to report the
weirdness? To earn
my salary? Mine
is not a vocation,
it's a mission.

RYSZARD KAPUŚCIŃSKI

GOOD WRITERS
ARE THOSE
WHO KEEP
THE LANGUAGE
EFFICIENT.
THAT IS TO
SAY, KEEP IT
ACCURATE,
KEEP IT CLEAR.

EZRA POUND

THIS ABOVE ALL—ASK YOURSELF IN THE STILLEST HOUR OF YOUR NIGHT: <u>MUST</u> I WRITE?

RAINER MARIA RILKE

I'M JUST GOING TO WRITE BECAUSE I CANNOT HELP IT.

CHARLOTTE BRONTË

IT WAS ONLY WHEN I WROTE MY FIRST BOOK THAT THE WORLD I WANTED TO LIVE IN OPENED TO ME.

ANAÏS NIN

THE PROCESS OF WRITING DOESN'T, FOR ME, VARY MUCH, EXCEPT IN THE TIME IT TAKES. AND MY FEELINGS REMAIN OF A KIND OF GRADE SCHOOL SIMPLICITY. I AM DEAD. THEN I AM ALIVE.

LOUISE GLÜCK

I STARTED WRITING BECAUSE I KEPT FAINTING IN HUMAN ANATOMY CLASS AND NEEDED A CAREER CHANGE.

SHERMAN ALEXIE

THERE'S A CERTAIN KIND OF FREEDOM THAT I VALUE. WRITING WAS THE BEST APPROXIMATION OF THE LIFE THAT I WANTED.

JONATHAN SAFRAN FOER

I WANT TO BE ABLE TO WRITE WHETHER IN SICKNESS OR IN HEALTH, FOR INDEED, MY HEALTH DEPENDS ALMOST COMPLETELY ON MY WRITING.

CARSON MCCULLERS

Over a lifetime, I have written millions of words, but the act of writing seems as fresh, and as much fun, as when I started it nearly seventy years ago.

OLIVER SACKS

MY FRIEND MARTIN AMIS HAS A WONDERFUL PHRASE: "WHAT YOU HOPE TO DO IS LEAVE BEHIND A SHELF OF BOOKS." YOU WANT TO BE ABLE TO WALK INTO A BOOKSTORE AND SAY, "FROM HERE TO HERE, IT'S ME."

SALMAN RUSHDIE

I USED TO THINK OF THE ZEN PRACTICE AND THE WRITING PRACTICE AS BEING TWO DIFFERENT THINGS. BUT THE MORE I PRACTICE BOTH THE MORE I REALIZE THAT ACTUALLY THEY'RE THE SAME.

RUTH OZEKI

WOULD YOU NOT LIKE TO TRY ALL SORTS OF LIVES—ONE IS SO VERY SMALL— BUT THAT IS THE SATISFACTION OF WRITING—ONE CAN IMPERSONATE SO MANY PEOPLE.

KATHERINE MANSFIELD

DOESN'T WRITING PROVIDE AN EXCELLENT MEANS OF SOUL-SEARCHING? YOU FIND SO MUCH IN A CHARACTER THAT'S ACTUALLY YOUR SELF THAT IT'S ALMOST EMBARRASSING.

WILLIAM STYRON

WRITING SAVED MY LIFE.

SLAVOJ ŽIŽEK

I'VE SEEN TIME AND TIME AGAIN THE WAY THAT THE PROCESS OF TRYING TO SAY SOMETHING DIGNIFIES AND IMPROVES A PERSON.

GEORGE SAUNDERS

The good writer seems to be writing about himself (but never is) but has his eye always on that thread of the Universe which runs through himself, and all things.

RALPH WALDO EMERSON

What I would like my stuff to do is make people less lonely.

DAVID FOSTER WALLACE

YOU'RE GOING TO FEEL LIKE HELL IF YOU WAKE UP SOMEDAY AND YOU NEVER WROTE THE STUFF THAT IS TUGGING ON THE SLEEVES OF YOUR HEART.

ANNE LAMOTT

DO NOT WRITE THE CONCLUSION OF A WORK IN YOUR FAMILIAR STUDY. YOU WOULD NOT FIND THE NECESSARY COURAGE THERE.

WALTER BENJAMIN

WRITING IS AN ACT OF LOVE.

JEAN COCTEAU

A REAM OF FRESH PAPER LIES ON MY DESK WAITING FOR THE NEXT BOOK. I AM A WRITER AND I TAKE UP MY PEN TO WRITE.

PEARL S. BUCK

WRITER INDEX

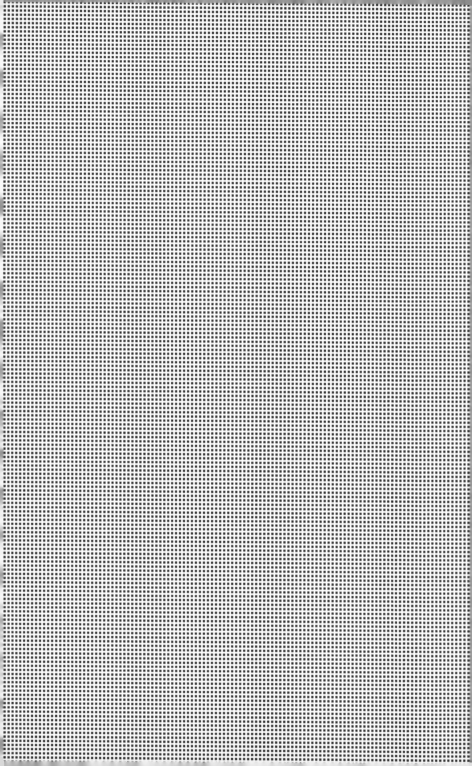

SOURCES

ADVICE

8 "LIFE IS LONG"
On the Shortness of Life, trans. C. D. N. Costa
(New York: Penguin, 1997), 2.

9 "BE A GOOD"
"Everything I Know About Writing Poetry,"
in A Hundred White Daffodils
(Saint Paul, MN: Graywolf, 1999), 141.

9 "HOW WE SPEND"
The Writing Life (New York:
HarperPerennial, 1990), 32.

10 "ALMOST EVERYTHING"
"12 Truths I Learned from Life and Writing,"
TED Talk, April 2017, transcript,
https://www.ted.com/talks/anne_lamott_
12_truths_i_learned_from_life_and_writing/
transcript?language=en.

11 "GET UP QUICKLY"
Journal entry, October 15, 1973, in
As Consciousness Is Harnessed to Flesh: Journals
and Notebooks, 1964–1980, ed. David Rieff
New York: Farrar, Straus and Giroux, 2012), 365.

11 "KEEP BUSY"
Journal of a Solitude (New York:
W. W. Norton, 1973), 34.

12 "EXPLORE"
"Work Schedule, 1932–1933," in
Henry Miller on Writing (New York:
New Directions, 1964), 162.

12 "THE REASON"
Twitter, April 12, 2010, 9:03 a.m.,
http://twitter.com/alaindebotton/
status/12042492487.

12 "TALK TO STRANGERS"
"More Advice for the Recent Graduate,"
author's website, May 25, 2017, http://
austinkleon.com/2017/05/25/
more-advice-for-the-recent-graduate.

13 "SEE OTHER SKIES"
Letter to Mademoiselle Leroyer de Chantepie,
March 30, 1857, in Letters of Gustave Flaubert,
ed. Richard Rumbold, trans. J. M. Cohen (London:
George Weidenfeld and Nicolson, 1950), 104.

14 "FOLLOW THE ACCIDENT"
"Notes on an Unfinished Novel," in The Novel
Today: Contemporary Writers on Modern
Fiction, ed. Malcolm Bradbury (Manchester:
Manchester University Press, 1977), 137.

14 "MAKE GLORIOUS"
"My New Year Wish," author's website,
December 31, 2011, http://journal.neilgaiman.
com/2011/12/my-new-year-wish.html.

14 "FROM NOW ON"
The Unquiet Grave (New York: Persea Books,
1981), 95.

14 "RUPTURES"
Megan Berkobien, "An Interview with
Anne Carson and Robert Currie," Asymptote,
n.d., http://www.asymptotejournal.com/
interview/an-interview-with-anne-carson-
and-robert-currie/.

14 "SELF-CRITICISM"
"The Enigmatic Art of Self-Criticism,"
in The Faith of a Writer: Life, Craft, Art
(New York: Ecco, 2003), 127.

14 "YOU SHOULD FEEL"
Interview by Hephzibah Anderson,
Independent, May 23, 2014, http://www.
independent.co.uk/arts-entertainment/
books/features/michael-cunningham-
interview-shining-a-light-on-ageing-love-and-
innocence-9424673.html.

14 "KEEP YOUR CLOTHES"
Diary entry, January 6, 1854,
in Tolstoy's Diaries, ed. and trans.
R. F. Christian, vol. 1, 1847–1894
(London: Faber and Faber, 2010), 83.

14 "WALK TALL"
William McKeen, Outlaw Journalist:
The Life and Times of Hunter S. Thompson
(New York: W. W. Norton, 2008), 350.

15 "THE BLIZZARD"
Barnaby Conrad and Monte Schulz, eds.,
Snoopy's Guide to the Writing Life (Cincinnati,
OH: Writer's Digest Books, 2002), 162.

16 "DO BACK EXERCISES"
"Ten Rules for Writing Fiction: Part 1,"
Guardian, February 19, 2010, https://www.
theguardian.com/books/2010/feb/20/
ten-rules-for-writing-fiction-part-one.

16 "PLEASE—TAKE CARE"
Letter to Robert Lowell, August 26, 1963,
in Words in Air: The Complete Correspondence
between Elizabeth Bishop and Robert Lowell,
ed. Thomas Travisano and Saskia Hamilton
(New York: Farrar, Straus and Giroux, 2010), 495.

17 "BE HAPPY"
Pratt Institute Commencement Address,
May 17, 2010, transcript, https://www.
brainpickings.org/2014/04/21/patti-smith-
pratt-commencement/.

17 "UNCOMPLICATE"
Meditations, trans. Gregory Hays (New York:
Modern Library, 2003), 43.

18 "APPEAR IN PLAYBOY"
"Advice to a Young Writer," in Nabokov:
Criticism, Reminiscences, Translations and
Tributes, ed. Alfred Appel Jr. and Charles
Newman (Evanston, IL: Northwestern
University Press, 1970), 359.

19 "HAVE REGRETS"
"Ten Rules for Writing Fiction: Part 1,"
Guardian, February 19, 2010, https://www.
theguardian.com/books/2010/feb/20/
ten-rules-for-writing-fiction-part-one.

20 "I THINK WE ARE"
"On Keeping a Notebook," in
Slouching towards Bethlehem (New York:
Farrar, Straus and Giroux, 2008), 139.

20 "I AM VERY HANDY"
Letter to "A," December 11, 1956, in
The Habit of Being: The Letters of Flannery
O'Connor, ed. Sally Fitzgerald (New York:
Farrar, Straus and Giroux, 1979), 188.

20 "BEST ADVICE"
"'Go the Way Your Blood Beats,'"
interview by Richard Goldstein, Village Voice,
June 26, 1984, reprinted in James Baldwin:
The Last Interview and Other Interviews
(Brooklyn: Melville House, 2014), 73–74.

20 "PAY ATTENTION"
Twitter, March 15, 2013, 7:02 a.m.,
http://twitter.com/missamykr/
status/312564535242395648.

20 "LIFE IS NOT"
Harvard Commencement Address, June 5,
2008, transcript, http://harvardmagazine.
com/2008/06/the-fringe-benefits-failure-
the-importance-imagination.

20 "I URGE YOU"
A Man without a Country (New York:
Seven Stories, 2005), 132.

21 "DO NOT OVERLOOK"
"On Little Joys," in My Belief: Essays on
Life and Art, ed. Theodore Ziolkowski,
trans. Denver Lindley (New York: Farrar,
Straus and Giroux, 1974), 8.

21 "TO AFFECT"
Walden, or, Life in the Woods
(Philadelphia: Henry Altemus, 1899), 103.

AUDIENCE

22 "WHAT I'M REALLY"
"Reality Is Perplexing Enough,"
interview by Patricia Marx and John Simon,
Commonweal, October 25, 1968,
https://www.commonwealmagazine.org/
interview-jorge-luis-borges.

23 "I WANT TO HAVE"
Interview by Alexander Stille, Saturday
Review, March–April 1985, 39.

23 "I WRITE FOR"
Interview by Bret Anthony Johnston,
National Book Foundation, n.d.,
http://www.nationalbook.org/nba2007_f_
johnson_interv.html.

23 "BETTER TO WRITE"
"Last Words of Logan Pearsall Smith
(and Others)," New Statesman and Nation,
February 25, 1933, 221.

23 "I LET"
Interview by L'Express, October 18, 1955,
reprinted in Conversations with
Richard Wright, ed. Keneth Kinnamon
and Michel Fabre (Jackson: University Press
of Mississippi, 1993), 164.

23 "WHOM DO I WRITE"
Journal entry, January 17, 1990, in Alfred Kazin's
Journals, ed. Richard M. Cook (New Haven, CT:
Yale University Press, 2011), 559.

23 "WITH ALMOST"
Interview by Simmy Richman, Independent,
March 25, 2015, http://www.independent.
co.uk/news/people/profiles/irvin-d-yalom-
interview-the-grand-old-man-of-american-
psychiatry-on-what-he-has-learnt-about-
life-10134092.html.

23 "YOU CAN'T JUST"
Diary entry, June 25, 1933, in
Locked Rooms and Open Doors: Diaries
and Letters, 1933–1935 (New York:
Harcourt Brace Jovanovich, 1974), 44.

24 "YOU MUST BE"
Bette Pesetsky, "Eternal Verities Take a
Beating," New York Times, August 14, 1988,
http://www.nytimes.com/1988/08/14/
books/eternal-verities-take-a-beating.html.

25 "CHILDREN ARE"
"The Art of the Essay No. 1," interview
by George Plimpton and Frank H. Crowther,
Paris Review, no. 48 (Fall 1969):
https://www.theparisreview.org/
interviews/4155/e-b-white-the-art-of-
the-essay-no-1-e-b-white.

25 "I'VE ALWAYS"
"The Art of Fiction No. 45 (Continued),"
interview by George Plimpton and
Frank Crowther, Paris Review,
no. 63 (Fall 1975): https://www.
theparisreview.org/interviews/
4156/john-steinbeck-the-art-of-fiction-
no-45-continued-john-steinbeck.

26 "A MAN REALLY"
Dialogue with Lucien Price, August 25, 1935,
in Dialogues of Alfred North Whitehead
(Jaffrey, NH: David R. Godine, 2001), 64.

26 "WITH EVERY"
Interview by Jessa Crispin, Bookslut,
October 2006, http://www.bookslut.com/
features/2006_10_010057.php.

26 "I NEVER THINK"
"For a Dollar," interview by Dana Levin,
Poets.org, February 21, 2009,
https://www.poets.org/poetsorg/text/
dollar-louise-glück-conversation.

26 "A GREAT PART"
"The Past Gets Bigger and the Future Shrinks,"
interview by Jane Graham, Los Angeles
Review of Books, July 21, 2013,
https://lareviewofbooks.org/article/the-
past-gets-bigger-and-the-future-shrinks-an-
interview-with-marti-amis/.

26 "THE NICEST"
"Women Writers in America,"
interview by Sheila Hale, Harpers and
Queen, July 1978, reprinted in
Conversations with Elizabeth Bishop, ed.
George Monteiro (Jackson: University Press
of Mississippi, 1996), 113.

27 "I'M RATHER HOSTILE"
"The Art of Theater No. 3," interview
by Larry Bensky, Paris Review, no. 39
(Fall 1966): https://www.theparisreview.org/
interviews/4351/harold-pinter-the-art-
of-theater-no-3-harold-pinter.

28 "THE GREAT THING"
"Finding Morals under Empty Heavens,"
Science and Spirit, July–August 2007, 66.

28 "OVER THE YEARS"
Thirteen Ways of Looking at a Novel
(New York: Alfred A. Knopf, 2005), 12.

28 "I NEVER HAD"
Dorothy Tooker, "The Editors Meet
William Carlos Williams," A.D. 3,
no. 1 (Winter 1952), reprinted in
Interviews with William Carlos Williams:
"Speaking Straight Ahead," ed. Linda
Welshimer Wagner (New York: New
Directions, 1976), 31.

28 "READERS MULTIPLY"
Interview by Karen Heller, Independent,
September 8, 2016, http://www.independent.
co.uk/arts-entertainment/books/features/
jonathan-safran-foer-interview-the-meaning-
of-the-book-is-not-something-that-is-
mine-a7231901.html.

28 "I NEVER WROTE"
Letter to John Hamilton Reynolds,
April 9, 1818, in The Selected Letters of
John Keats, ed. Lionel Trilling (New York:
Farrar, Straus and Young, 1951), 118.

29 "I DON'T EVEN"
Maya Jaggi, "Redemption Songs,"
Guardian, May 28, 2004, https://www.
theguardian.com/books/2004/may/29/
fiction.jeanettewinterson.

BEGINNING

30 "MY BOOKS START"
Interview by Sarah Crown, Guardian,
January 22, 2010, https://www.theguardian.
com/books/2010/jan/23/el-doctorow-
homer-and-langley.

31 "I BEGIN WITH"
"Adventures in the Skin Trade:
Colum McCann and Michael Ondaatje in
Conversation," PEN World Voices Festival,
New York Public Library, May 4, 2008, transcript,
http://colummccann.com/interviews/
pen-conversation-with-michael-ondaatje/.

31 "STEPPING FROM"
Bruce Weber, "On Literary Bridge,
Poet Hits a Roadblock," New York Times,
December 19, 1999, http://www.nytimes.com/
1999/12/19/us/on-literary-bridge-poet-
hits-a-roadblock.html.

32 "I AM ABOUT"
Letter to Ansel Adams, December 29, 1973,
in The Selected Letters of Wallace Stegner, ed.
Page Stegner (Berkeley, CA: Shoemaker
and Hoard, 2007), 202.

32 "WHEN I START"
From the Desert to the Book: Dialogues
with Marcel Cohen, trans. Pierre Joris
(Barrytown, NY: Station Hill, 1990), 43.

32 "I BELIEVE THAT"
Letter to Vita Sackville-West,
September 8, 1928, in The Letters of
Virginia Woolf, ed. Nigel Nicolson and
Joanne Trautmann, vol. 3, 1923–1928
(New York: Harcourt Brace Jovanovich,
1977), 529.

33 "I TYPE OUT"
"The Art of Fiction No. 84," interview
by Hermione Lee, Paris Review, no. 93
(Fall 1984): https://www.theparisreview.org/
interviews/2957/philip-roth-the-art-of-
fiction-no-84-philip-roth.

33 "WHEN BEGINNING"
"Getting Started," in Writers on
Writing, ed. Robert Pack and Jay Parini
(Hanover, NH: University Press of
New England, 1991), 98–99.

33 "NEVER OPEN"
"Ten Rules for Writing Fiction: Part 1,"
Guardian, February 19, 2010, https://
www.theguardian.com/books/2010/feb/20/
ten-rules-for-writing-fiction-part-one.

33 "I START"
Meredith Maran, ed., Why We Write
(New York: Plume, 2013), 6.

33 "I AM IN THE FIRST"
Letter to Elisha Morgan, March 19, 1855, in
The Selected Letters of Charles Dickens, ed.
Jenny Hartley (Oxford: Oxford University
Press, 2012), 292.

33 "I'M CONVINCED"
"The Hum Inside the Skull: A Symposium,"
New York Times, May 13, 1984, http://
www.nytimes.com/1984/05/13/books/the-
hum-inside-the-skull-a-symposium.html.

34 "BUILD A CORNER"
Still Writing (New York:
Atlantic Monthly Press, 2013), 17.

34 "STARTING A NOVEL"
"Why Not Put Off Till Tomorrow the Novel You
Could Begin Today?," New York Times, August 26,
2002, http://www.nytimes.com/2002/08/26/
arts/writers-on-writing-why-not-put-off-till-
tomorrow-the-novel-you-could-begin-today.html.

35 "EACH BOOK"
Interview by Michael Wood (2003), in The
Paris Review Interviews, ed. Philip Gourevitch,
vol. 4 (New York: Picador, 2009), 328.

BOOK

36 "THE TRUE HEART"
Letter to May Chambers Holbrook,
December 2, 1908, in The Collected Letters
of D. H. Lawrence, ed. Harry T. Moore, vol. 1
(New York: Viking, 1962), 38.

37 "A BOOK"
Letter to Oskar Pollak, January 27, 1904,
in Franz Kafka: Letters to Friends, Family,
and Editors, trans. Richard and Clara Winston
(New York: Schocken, 1977), 16.

38 "ONE OF MY"
Journal entry, n.d., in Louisa May Alcott:
Her Life, Letters, and Journals, ed. Ednah D.
Cheney (Boston: Roberts Brothers, 1889), 27.

38 "I CAN THINK OF"
"My Ancestral Castles," in Ex Libris:
Confessions of a Common Reader (New York:
Farrar, Straus and Giroux, 1998), 123.

38 "IT WASN'T UNTIL"
Interview by Olga Segura, America, May 4,
2017, http://www.americamagazine.org/
arts-culture/2017/05/04/junot-diaz-
talks-dominican-identity-immigration-and-
complicated-american.

38 "THERE ARE"
"Looking for a Garde of Which to Be Avant,"
interview by Hugh Kennedy and Geoffrey Polk,
Whiskey Island, Spring 1993, reprinted in
Conversations with David Foster Wallace, ed.
Stephen J. Burn (Jackson: University Press of
Mississippi, 2012), 16.

38 "SOMETIMES I THINK"
"The Hum Inside the Skull, Revisited,"
New York Times, January 16, 2005, http://
www.nytimes.com/2005/01/16/books/
review/the-hum-inside-the-skull-revisited.html.

39 "MY ALMA MATER"
The Autobiography of Malcolm X
(New York: Random House, 2015), 207.

40 "WHAT AN ASTONISHING"
"The Persistence of Memory," Cosmos,
episode 11, PBS, December 7, 1980.

40 "IT HAD BEEN"
One Writer's Beginnings (Cambridge, MA:
Harvard University Press, 1984), 5.

40 "WHEN SOMEONE"
Emma Brockes, "A Life in Writing,"
Guardian, February 7, 2011, https://www.
theguardian.com/culture/2011/feb/07/
michael-cunningham-life-writing.

41 "I CONCEDE"
"The Last Interview," interview
by Mónica Maristain, Playboy Mexico,
July 2003, trans. Sybil Perez, reprinted
in Roberto Bolaño: The Last Interview
and Other Conversations (Brooklyn:
Melville House, 2009), 117.

41 "I QUITE AGREE"
Letter to Arthur Greeves,
October 1915, in Letters of C. S. Lewis,
ed. W. H. Lewis (New York: Harcourt,
Brace and World, 1966), 27.

41 "THERE ARE TWO"
"The Art of Fiction No. 203," interview
by Sam Weller, Paris Review, no. 192
(Spring 2010): https://www.theparisreview.
org/interviews/6012/ray-bradbury-the-art-
of-fiction-no-203-ray-bradbury.

41 "THE WORLD"
Interview by Alison Beard,
Harvard Business Review, September 2015,
https://hbr.org/2015/09/lifes-work-
salman-rushdie.

41 "BOOKS ARE JUST"
Letter to Helen Louise Cather,
December 20, 1939, in The Selected Letters of
Willa Cather, ed. Andrew Jewell and Janis Stout
(New York: Alfred A. Knopf, 2013), 574.

41 "A BOOK IS A CUBIC"
Angela Livingstone, The Marsh of Gold:
Pasternak's Writings on Inspiration
and Creation (Brighton, MA: Academic
Studies Press, 2008), 16.

41 "THE DEAREST"
Letter to Joseph Lyman, n.d., in
Richard B. Sewall, "The Lyman Letters:
New Light on Emily Dickinson and
Her Family," Massachusetts Review 6,
no. 4 (Autumn 1965): 772.

42 "BOOKS ARE KINETIC"
Art Objects: Essays on Ecstasy and Effrontery
(London: Jonathan Cape, 1995), 123.

43 "THERE IS NOTHING"
Julie Bosman, "National Book Award
for Patti Smith," New York Times,
November 17, 2010, http://www.nytimes.
com/2010/11/18/books/18awards.html.

CHARACTER

44 "YOU CAN NEVER"
The Summing Up (London:
William Heinemann, 1948), 91.

45 "WHILE THIS BOOK"
Quoted in Jackson J. Benson, The True
Adventures of John Steinbeck, Writer:
A Biography (New York: Viking, 1984), 173.

45 "I BELIEVE"
Interview by Diane Osen, National Book
Foundation, n.d., http://www.nationalbook.
org/authorsguide_gnaylor.html.

46 "THE LEGEND"
"The Art of Fiction No. 62," interview
by Annette Grant, Paris Review, no. 67
(Fall 1976): https://www.theparisreview.org/
interviews/3667/john-cheever-the-art-of-
fiction-no-62-john-cheever.

46 "I DON'T HAVE"
Interview by Ron Hogan, Beatrice, 1997,
http://www.beatrice.com/interviews/mukherjee.

46 "MY FAVORITE"
Interview by Joye Shepperd,
Washington Independent Review of
Books, October 13, 2015, http://www.
washingtonindependentreviewofbooks.com/
features/an-interview-with-geraldine-brooks.

46 "I'M DRAWN"
"By the Book," New York Times Book Review,
January 23, 2014, https://www.nytimes.
com/2014/01/26/books/review/
chang-rae-lee-by-the-book.html.

46 "THE ONLY PEOPLE"
Interview by Greg Gerke, Rumpus, February
24, 2010, http://therumpus.net/2010/02/
the-rumpus-long-interview-with-paula-fox.

47 "I THINK"
"Why Not Put Off Till Tomorrow the Novel
You Could Begin Today?," New York Times,
August 26, 2002, http://www.nytimes.
com/2002/08/26/arts/writers-on-writing-
why-not-put-off-till-tomorrow-the-novel-you-
could-begin-today.html.

47 "I DON'T REREAD"
Interview by Alicia Oltuski, Harvard
Review, February 25, 2015, http://www.
harvardreview.org/?q=features/inside-the-
book/writing-second-life-interview-yiyun-li.

CHILDHOOD

48 "I DISAPPEARED"
The Faraway Nearby (New York:
Penguin, 2014), 60.

49 "I REMEMBER"
"Wendy Lesser and Robert Pinsky,"
in Upstairs at the Strand: Writers in
Conversation at the Legendary Bookstore, ed.
Jessica Strand and Andrea Aguilar
(New York: W. W. Norton, 2016), 162.

49 "MY INTEREST"
Interview by Kwame Anthony Appiah, BOMB,
no. 87 (Spring 2004): http://bombmagazine.
org/article/2646/nuruddin-farah.

50 "I LOVED"
"By the Book," New York Times
Book Review, August 30, 2012, http://www.
nytimes.com/2012/09/02/books/review/
junot-diaz-by-the-book.html.

50 "AFTER I READ"
"By the Book," New York Times
Book Review, October 31, 2013, http://www.
nytimes.com/2013/11/03/books/review/
ann-patchett-by-the-book.html.

51 "AS A CHILD"
"By the Book," New York Times
Book Review, February 5, 2015, https://www.
nytimes.com/2015/02/08/books/review/
anne-tyler-by-the-book.html.

51 "I READ HENRY JAMES"
"Pupils Delighted by Thurber—They Laughed,
They Listened," Cincinnati Post and Times-
Star, February 12, 1960, 41.

52 "SINCE THE AGE"
"The Art of Fiction No. 23," interview
by Julian Mitchell and Gene Andrewski,
Paris Review, no. 22 (Autumn–Winter
1959–60): https://www.theparisreview.org/
interviews/4720/lawrence-durrell-the-art-
of-fiction-no-23-lawrence-durrell.

52 "WHEN I WAS A KID"
"By the Book," New York Times
Book Review, July 12, 2012,
http://www.nytimes.com/2012/07/15/
books/review/dave-eggers-by-the-book.html.

52 "MY EARLIEST"
"District School #7, Niagara County,
New York," in The Faith of a Writer: Life,
Craft, Art (New York: Ecco, 2003), 7.

52 "AS A VERY SMALL"
Interview by The Star (Johannesburg),
July 11, 1958, reprinted in Conversations
with Nadine Gordimer, ed. Nancy Topping
Bazan and Marilyn Dallman Seymour (Jackson:
University Press of Mississippi, 1990), 4.

52 "BY THE TIME"
Meredith Maran, ed., Why We Write
(New York: Plume, 2013), 130.

53 "I WROTE MY"
Interview by Lynne Tillman, BOMB, no. 95
(Spring 2006): http://bombmagazine.org/
article/2817/paula-fox.

53 "I REMEMBER"
I Remember (New York: Granary Books,
2001), 72.

53 "THE THINGS"
Interview by Angela Pneuman, Believer,
October 2005, http://www.believermag.com/
issues/200510/?read=interview_moore.

53 "I PLAYED LINUS"
"By the Book," New York Times Book Review,
September 26, 2013, http://www.nytimes.
com/2013/09/29/books/review/andrew-
solomon-by-the-book.html.

53 "FOR A YEAR"
Journal entry, September 6, 1965, in
As Consciousness Is Harnessed to Flesh: Journals
and Notebooks, 1964–1980, ed. David Rieff
(New York: Farrar, Straus and Giroux, 2012), 114.

54 "WHEN I WAS FIVE"
Uncle Tungsten: Memories of a Chemical
Boyhood (New York: Knopf, 2001), 182.

54 "FOR A LONG"
Dust Tracks on a Road (New York:
HarperPerennial, 1996), 26.

55 "MORE THAN ONE"
Interview by Jarrett Earnest, Brooklyn Rail,
July 13, 2015, http://brooklynrail.org/2015/
07/art/peter-schjeldahl-with-jarrett-earnest.

55 "UNTIL I GOT"
Interview by Adrienne Rich, Signs 6, no. 4
(Summer 1981): 717.

CONFESSIONS

56 "I'M A SUCKER"
"By the Book," New York Times Book Review,
November 14, 2013, http://www.nytimes.
com/2013/11/17/books/review/amy-
tan-by-the-book.html.

57 "NO, I HAVE NOT"
Letter to Christian Ludvigsen, April 22, 1957,
in The Letters of Samuel Beckett, ed. George
Craig et al., vol. 3, 1957–1965 (Cambridge:
Cambridge University Press, 2011), 44.

57 "FINNEGANS WAKE"
Pamela Paul, ed., By the Book:
Writers on Literature and the Literary Life
from the New York Times Book Review
(New York: Picador, 2014), 188.

58 "I'VE SUFFERED"
"The Art of Poetry No. 27," interview
by Elizabeth Squires, Paris Review, no. 80
(Summer 1981): https://www.theparisreview.
org/interviews/3229/elizabeth-bishop-the-
art-of-poetry-no-27-elizabeth-bishop.

58 "MY SHYNESS"
Interview by Gloria López Lecube, La Isla FM
Radio (Argentina), 1985, trans. Kit Maude,
reprinted in Jorge Luis Borges: The Last
Interview and Other Conversations (Brooklyn:
Melville House, 2013), 156.

58 "I HAVE ALWAYS"
Interview at the St. Regis Hotel,
New York, June 5, 1962, in Strong Opinions
(New York: McGraw-Hill, 1973), 4.

59 "WORST OF ALL"
Letter to Sofya Ivanova, ca. September 29,
1867, in Fyodor Dostoevsky: Complete Letters,
ed. and trans. David A. Lowe, vol. 2,
1860–1867 (Ann Arbor, MI: Ardis, 1989), 275.

59 "I'M SCARED"
Letter to Maria Kiseleva, September 21, 1886,
in The Selected Letters of Anton Chekhov, ed.
Lillian Hellman, trans. Sidonie Lederer
(New York: Farrar, Straus, 1955), 16.

60 "I DON'T CRY"
Interview by Rosanna Greenstreet, Guardian,
March 9, 2012, https://www.theguardian.com/
books/2012/mar/09/nadine-gordimer-
author-activist.

60 "VENICE"
Journal entry, May 24, 1978, in
As Consciousness Is Harnessed to Flesh:
Journals and Notebooks, 1964–1980, ed.
David Rieff (New York: Farrar, Straus
and Giroux, 2012), 457.

61 "I AM VERY FOND"
"The Art of Poetry No. 42," interview by
Alfred MacAdam, Paris Review, no. 119
(Summer 1991): https://www.theparisreview.
org/interviews/2192/octavio-paz-the-
art-of-poetry-no-42-octavio-paz.

61 "I HAPPEN TO LOVE"
Interview by Charles Ruas and Judith Sherman,
WBAI-FM New York, 1975, http://clocktower.
org/show/el-doctorow-ragtime-1975.

61 "I WISH"
Letter to Bryher, December 13, 1920,
in The Selected Letters of Marianne Moore, ed.
Bonnie Costello (New York: Alfred A. Knopf,
1997), 138.

62 "FOR ME"
"The Guilty Vicarage," in
The Dyer's Hand and Other Essays
(New York: Random House, 1962), 146.

62 "I LIKE THE GEICO"
Interview by Bradley C. Edwards (2007),
in Conversations with Bharati Mukherjee, ed.
Bradley C. Edwards (Jackson: University
Press of Mississippi, 2009), 157.

62 "I LOVE"
"Saving Graces," interview by Alex Hamilton,
Guardian, September 11, 1971,
https://www.theguardian.com/books/2007/
sep/11/fromthearchives.britishidentity.

62 "I ADORE"
Ruth La Ferla, "A Rare Spirit, a Rarer Eye,"
New York Times, March 19, 2010,
http://www.nytimes.com/2010/03/21/
fashion/21patti.html.

62 "I AM NOT"
Letter to Franco Lucentini, March 20, 1964, in
Italo Calvino: Letters, 1941–1985, ed. Michael
Wood, trans. Martin McLaughlin (Princeton,
NJ: Princeton University Press, 2013), 261.

62 "EXORCISM"
Interview by Allen Ginsberg
(March 17–22, 1992), Sensitive Skin, no. 8
(Spring 2012): https://sensitiveskinmagazine.
com/william-s-burroughs-interview/.

62 "I HAVE TO READ"
Pamela Paul, ed., By the Book:
Writers on Literature and the Literary Life
from the New York Times Book Review
(New York: Picador, 2014), 7.

62 "I WILL DO ANYTHING"
Sam Anderson, "The Inscrutable
Brilliance of Anne Carson,"
New York Times Magazine, March 14, 2013,
http://www.nytimes.com/2013/03/17/
magazine/the-inscrutable-brilliance-
of-anne-carson.html.

62 "I'M HAPPIER"
Charles McGrath, "The Mad Scientist of Smut,"
New York Times Magazine, August 4, 2011,
http://www.nytimes.com/2011/08/07/
magazine/nicholson-bakers-dirty-mind.html.

63 "I WOULD GIVE"
Letter to Violet Dickinson, ca. December 27,
1902, in The Letters of Virginia Woolf, ed.
Nigel Nicolson and Joanne Trautmann,
vol. 1, 1888–1912 (New York: Harcourt Brace
Jovanovich, 1977), 63.

CREATIVE PROCESS

64 "I DON'T WRITE"
Interview by Miles Marshall Lewis, Believer,
November 2004, http://www.believermag.
com/issues/200411/?read=interview_wilson.

65 "I DO ALL"
Letter to unknown recipient,
October 1, 1957, in The Raymond Chandler
Papers: Selected Letters and Nonfiction,
1909–1959, ed. Tom Hiney and Frank
MacShane (New York: Atlantic Monthly Press,
2000), 243.

65 "BEFORE I TAKE"
"Putting Pen to Paper, but Not Just Any Pen or
Just Any Paper," New York Times, July 5, 1999,
http://www.nytimes.com/1999/07/05/
books/putting-pen-to-paper-but-not-just-any-
pen-or-just-any-paper.html.

65 "I KEEP NOTES"
"The Art of Fiction No. 202,"
interview by Sarah Fay, Paris Review, no. 191
(Winter 2009): https://www.theparisreview.
org/interviews/5991/ha-jin-the-art-of-
fiction-no-202-ha-jin.

65 "IF I CAN MOVE"
Interview by Noah Charney, Daily Beast,
February 6, 2013, http://www.thedailybeast.
com/karen-russell-how-i-write.

65 "I ALWAYS WRITE"
Letter to Roscoe Cather, August 26, 1940,
in The Selected Letters of Willa Cather, ed.
Andrew Jewell and Janis Stout
(New York: Alfred A. Knopf, 2013), 587.

65 "I MUST"
Letter to Edward Garnett, February 18, 1913,
in The Collected Letters of D. H. Lawrence, ed.
Harry T. Moore, vol. 1 (New York:
Viking, 1962), 186.

66 "I PAY A LOT"
Interview by Catherine Cusick, Rumpus,
December 14, 2016, http://therumpus.
net/2016/12/the-rumpus-interview-
with-jacqueline-woodson/.

67 "I AM IN THE GARRET"
Journal entry, April 1855, in
Louisa May Alcott: Her Life, Letters,
and Journals, ed. Ednah D. Cheney
(Boston: Roberts Brothers, 1889), 80.

67 "A GREAT DEAL"
Letter to Irita Van Doren, September 20, 1954,
in Letters of Wallace Stevens, ed. Holly Steven
(New York: Alfred A. Knopf, 1966), 844.

67 "BE SURE"
October 29, 1823, entry, in Conversations
of Goethe with Johann Peter Eckermann, ed.
J. K. Moorhead, trans. John Oxenford
(New York: Da Capo, 1998), 17.

67 "THERE ARE ASPECTS"
Interview by Han Ong, BOMB, no. 47
(Spring 1994): http://bombmagazine.org/
article/1769/suzan-lori-parks.

67 "MY COMPUTER"
Interview by Thomas Bolt, BOMB, no. 36
(Summer 1991): http://bombmagazine.org/
article/1452/james-merrill.

68 "REVISION"
"How to Write," New York Times Book
Review, July 26, 2012, http://www.nytimes.
com/2012/07/29/books/review/colson-
whiteheads-rules-for-writing.html.

69 "THE FIRST DRAFT"
Arnold Samuelson, With Hemingway:
A Year in Key West and Cuba (New York:
Random House, 1984), 11.

70 "TAKING A BOOK"
Letter to Evert A. Duyckinck,
December 13, 1850, in The Letters of
Herman Melville, ed. Merrell R. Davis and
William H. Gilman (New Haven, CT:
Yale University Press, 1960), 117.

70 "ULYSSES"
Letter to John Quinn, August 3, 1919, in
Letters of James Joyce, ed. Richard Ellmann,
vol. 2 (New York: Viking, 1966), 448.

70 "EVERY DAY I WRITE"
Charles Ruas, Conversations with American
Writers (New York: Alfred A. Knopf, 1985), 12.

70 "SOME WRITERS"
"The Art of Fiction No. 165," interview
by Shusha Guppy, Paris Review, no. 157
(Winter 2000): https://www.theparisreview.
org/interviews/562/julian-barnes-the-art-
of-fiction-no-165-julian-barnes.

70 "I'VE OFTEN FANTASIZED"
"By the Book," New York Times Book Review,
November 14, 2013, http://www.nytimes.
com/2013/11/17/books/review/amy-
tan-by-the-book.html.

70 "NOVELS"
Interview by Larry McCaffery (1980),
in Not-Knowing: The Essays and Interviews
of Donald Barthelme, ed. Kim Herzinger
(New York: Random House, 1997), 261.

71 "I'M AT PAGE"
Letter to Mac Hyman, April 29, 1957,
in Selected Letters of William Styron,
Rose Styron and R. Blakeslee Gilpin
(New York: Random House, 2012), 230.

71 "I AM A SLOW"
Interview by Alfred Appel Jr.,
Wisconsin Studies in Contemporary Literature
8, no. 2 (Spring 1967): 132.

72 "I AM WRITING"
Letter to Sister Julie, June 17, 1962, in
The Habit of Being: The Letters of Flannery
O'Connor, ed. Sally Fitzgerald (New York:
Farrar, Straus and Giroux, 1979), 480.

72 "WHEN I'M WRITING"
"The Art of Fiction No. 76," interview
by Mona Simpson and Lewis Buzbee,
Paris Review, no. 88 (Summer 1983):
https://www.theparisreview.org/
interviews/3059/raymond-carver-the-
art-of-fiction-no-76-raymond-carver.

72 "I WROTE MY"
Dan Crowe and Philip Oltermann, eds.,
How I Write: The Secret Lives of Authors
(New York: Rizzoli, 2007), 76.

72 "WHEN I WAS"
Letter to Hippolyte Taine, ca. 1868,
in Letters of Gustave Flaubert, ed. Richard
Rumbold, trans. J. M. Cohen (London:
George Weidenfeld and Nicolson, 1950), 154.

72 "I ALWAYS SEEM"
Letter to Robert Lowell, January 11, 1949,
Words in Air: The Complete Correspondence
between Elizabeth Bishop and Robert Lowell,
ed. Thomas Travisano and Saskia Hamilton
New York: Farrar, Straus and Giroux, 2010), 77.

73 "I DON'T WRITE"
"Grim Colberty Tales with Maurice Sendak
Pt. 1," interview by Stephen Colbert,
The Colbert Report, season 8, episode 49,
Comedy Central, January 24, 2012,
http://www.cc.com/video-clips/gzi3ec/
the-colbert-report-grim-colberty-tales-
with-maurice-sendak-pt--1.

74 "I WRITE THE WAY"
"Aphorisms by Felix Pollak," in
Arrows of Longing, ed. Gregory H. Mason
Athens: Ohio University Press, 1998), 227.

75 "WHEN I WRITE STORIES"
"My Vocation," in The Little Virtues, trans.
Dick Davis (New York: Seaver, 1962), 53–54.

75 "AS I WROTE"
Reading Like a Writer
(New York: HarperCollins, 2006), 3.

75 "I SORT OF COLLAGE"
Interview by Tony Perez, Tin House,
January 10, 2011, http://www.tinhouse.com/
blog/6382/a-conversation-with-
paul-harding.html.

75 "WHEN I'M WRITING"
Helen Brown, "A Writer's Life: Kate Atkinson,"
Telegraph, August 29, 2004, http://www.
telegraph.co.uk/culture/books/3622950/
A-writers-life-Kate-Atkinson.html.

75 "WHEN I'M WORKING"
Meredith Maran, ed., Why We Write
(New York: Plume, 2013), 122.

76 "I GET THIS"
Interview by Cressida Leyshon, New Yorker,
January 6, 2014, http://www.newyorker.com/
books/page-turner/the-chorus-of-we-an-
interview-with-chang-rae-lee.

76 "WRITING FREE"
Address at Milton Academy, Massachusetts,
May 17, 1935.

77 "I ALWAYS LISTEN"
Interview by Teresa Burns Gunther, Bookslut,
May 2013, http://www.bookslut.com/
features/2013_05_020064.php.

77 "I'VE NEVER"
"Before a Rendezvous with
the Muse, First Select the Music," in
Writers on Writing, vol. 2, More Collected
Essays from the New York Times
(New York: Times Books, 2003), 261.

77 "AS FOR WORKING"
"Nadine Gordimer: A Writer in South Africa,"
interview by Alan Ross, London Magazine,
May 1965, reprinted in Conversations with
Nadine Gordimer, ed. Nancy Topping Bazin
and Marilyn Dallman Seymour (Jackson:
University Press of Mississippi, 1990), 39.

78 "I CAN WORK IN"
"The Art of Fiction No. 197," interview by
Lila Azam Zanganeh, Paris Review, no. 185
(Summer 2008): https://www.theparisreview.
org/interviews/5856/umberto-eco-the-art-
of-fiction-no-197-umberto-eco.

78 "I SPEND MUCH"
"The Writer's Studio," in The Faith of a Writer:
Life, Craft, Art (New York: Ecco, 2003), 141.

79 "IT DOESN'T MATTER"
"Charles Bukowski Speaks Out," interview
by Arnold L. Kaye, Chicago Literary Times,
March 1963, https://bukowski.net/poems/
int-first.php.

80 "IT'S ONLY NOW"
"The Art of Fiction No. 200," interview
by Belinda McKeon, Paris Review, no. 200
(Spring 2009): https://www.theparisreview.
org/interviews/5907/john-banville-the-art-
of-fiction-no-200-john-banville.

80 "I DON'T KNOW"
"Looking for a Garde of Which to
Be Avant," interview by Hugh Kennedy
and Geoffrey Polk, Whiskey Island,
Spring 1993, reprinted in Conversations
with David Foster Wallace, ed.
Stephen J. Burn (Jackson: University
Press of Mississippi, 2012), 35.

80 "I LIKE TOFU"
Helen Rosner, "Writer Jennifer Egan
Risks Airport Sushi, Comes Around on
Bone Marrow," Grub Street, July 30, 2010,
http://www.grubstreet.com/2010/07/
author_jennifer_egan_risks_eat.html.

80 "THE PROCESS"
Interview with Ben Pfeiffer,
Rumpus, November 26, 2014,
http://therumpus.net/2014/11/the-
rumpus-interview-with-richard-ford/.

81 "IT OFTEN SEEMED"
Interview by Kirstin Valdez Quade,
National Book Foundation, n.d.,
http://www.nationalbook.org/
nba2015_f_hyanagihara_interv.html.

CRITICISM

82 "ATTACKING"
"Reading," in The Dyer's Hand and Other Essays
(New York: Random House, 1962), 11.

83 "NEVER DEMEAN"
"The Art of Fiction No. 17," interview by
Pati Hill, Paris Review, no. 16 (Spring–Summer
1957): https://www.theparisreview.org/
interviews/4867/truman-capote-the-art-
of-fiction-no-17-truman-capote.

83 "EVERY CRITICAL"
Letter to Maria Kiseleva, January 14, 1887,
in The Selected Letters of Anton Chekhov, ed.
Lillian Hellman, trans. Sidonie Lederer
(New York: Farrar, Straus, 1955), 17.

83 "WE SOMEHOW"
Letter to Lillian Hellman, April 2, 1980,
in Selected Letters of William Styron, ed.
Rose Styron and R. Blakeslee Gilpin
(New York: Random House, 2012), 544.

83 "TO HAVE THAT"
"On Self-Respect," in Slouching towards
Bethlehem (New York: Farrar, Straus
and Giroux, 2008), 147.

83 "I HAVE NEVER BEEN"
Interview by Alvin Toffler, Playboy, January
1964, reprinted in The Playboy Interview: Men
of Letters (Beverly Hills: Playboy, 2012).

83 "I CONFESS"
Letter to Brigid Brophy,
November 19, 1960, in Living on Paper:
Letters from Iris Murdoch, 1934–1995, ed.
Avril Horner and Anne Rowe (Princeton, NJ:
Princeton University Press, 2016), 215.

84 "I'VE LIVED"
"Sitting Down with Louise Glück," interview by
Cindy Ok, Yale Herald, November 8, 2013.

84 "I'M A VERY"
Interview by Aishwarya Subramanyam,
Elle India, July 1, 2016, http://elle.in/
magazine/arundhati-roy-you-know-her-
politics-you-know-her-fiction/.

85 "WRITERS HAVE TO"
"Where Do You Get Your Ideas From?"
(1987), in Dancing at the Edge of the World:
Thoughts on Words, Women, Places
(New York: Grove, 1989), 199–200.

DAY JOB

86 "ONE YEAR"
Letter to Louis Untermeyer,
February 15, 1950, in The Letters of
Robert Frost to Louis Untermeyer (New York:
Holt, Rinehart and Winston, 1963), 353.

87 "I WORKED IN"
Meredith Maran, ed., Why We Write
(New York: Plume, 2013), 209.

88 "MY FIRST JOB"
Interview by Lynn Emmert, Comics Journal,
no. 282 (April 2007): http://www.tcj.com/
the-alison-bechdel-interview/.

88 "I DETEST"
Letter to Stanislaus Joyce, March 1, 1907,
in Letters of James Joyce, ed. Richard Ellmann,
vol. 2 (New York: Viking, 1966), 219.

88 "I WORKED AS"
"The Art of Fiction No. 23," interview
by Julian Mitchell and Gene Andrewski,
Paris Review, no. 22 (Autumn–Winter
1959–60): https://www.theparisreview.org/
interviews/4720/lawrence-durrell-the-
art-of-fiction-no-23-lawrence-durrell.

88 "I WAS REALLY"
Meredith Maran, ed., Why We Write
(New York: Plume, 2013), 199.

88 "MY FAVORITE"
Interview by David Bianculli, Fresh Air,
NPR, May 2, 2008, http://www.npr.org/
templates/transcript/transcript.
php?storyId=90111248.

89 "I WORKED IN ALL"
Maurice Fleurent, "Richard Wright in Paris,"
Paru, December 1946, trans. Keneth Kinnamon,
reprinted in Conversations with Richard Wright,
ed. Keneth Kinnamon and Michel Fabre (Jackson:
University Press of Mississippi, 1993), 115.

89 "DON'T GIVE UP"
Interview by Erica Wagner, British Vogue,
November 3, 2015, http://www.vogue.co.uk/
article/chimamanda-ngozi-adichie-novelist-
ted-speaker-interview.

DISCIPLINE

90 "I DON'T WAIT"
"The Language Must Not Sweat,"
interview by Thomas LeClair, New Republic,
March 21, 1981, https://newrepublic.com/
article/130043/language-must-not-sweat.

91 "KEEP YOUR"
"Beyond Bird by Bird," interview
by Kurt Andersen, Studio 360, WNYC,
April 29, 2011, http://www.wnyc.org/
story/192108-anne-lamott-beyond-bird-bird/.

91 "WRITING SOMETHING"
"The Art of Fiction No. 69," interview by
Peter H. Stone, Paris Review, no. 82 (Winter
1981): https://www.theparisreview.org/
interviews/3196/gabriel-garcia-marquez-the-
art-of-fiction-no-69-gabriel-garcia-marquez.

92 "ISAK DINESEN"
"A Storyteller's Shoptalk," New York Times
Book Review, February 15, 1981,
http://www.nytimes.com/books/01/01/21/
specials/carver-shoptalk.html.

92 "I WROTE AT LEAST"
Zen in the Art of Writing (Santa Barbara, CA:
Joshua Odell Editions, 1990), 15.

92 "IT'S NOW"
Letter to John Forster, June 17, 1840, in
The Selected Letters of Charles Dickens, ed.
Jenny Hartley (Oxford: Oxford University
Press, 2012), 65.

92 "I WILL WRITE"
Letter to William C. Styron Sr., June 1, 1951,
in Selected Letters of William Styron, ed.
Rose Styron and R. Blakeslee Gilpin
(New York: Random House, 2012), 94.

92 "I WANT TO GET"
Letter to Mary Hutchinson, June 21, 1931,
in Aldous Huxley: Selected Letters, ed. James
Sexton (Chicago: Ivan R. Dee, 2007), 257.

92 "I DON'T PUT"
"Wrestling Life into Fable,"
Academy of Achievement, June 3, 2005,
http://www.achievement.org/achiever/
john-irving/#interview.

92 "DISCIPLINE ALLOWS"
"Ten Rules for Writing Fiction: Part 2,"
Guardian, February 19, 2010, https://www.
theguardian.com/books/2010/feb/20/10-
rules-for-writing-fiction-part-two.

93 "A WRITER"
Journal entry, July 5, 1972, in As Consciousness
Is Harnessed to Flesh: Journals and Notebooks,
1964–1980, ed. David Rieff (New York:
Farrar, Straus and Giroux, 2012), 327.

93 "IF YOU WORK"
Interview by Mark Allen, Awl, February 6,
2013, https://theawl.com/proudly-fraudulent-
an-interview-with-momas-first-poet-laureate-
kenneth-goldsmith-5df6a2aae22.

DRUGS + ALCOHOL

94 "I FEEL"
Letter to Brigid Brophy, August 18, 1965,
in Living on Paper: Letters from Iris Murdoch,
1934–1995, ed. Avril Horner and Anne Rowe
(Princeton, NJ: Princeton University Press,
2016), 303.

95 "GOOD THINGS"
Meredith Maran, ed., Why We Write
(New York: Plume, 2013), 137.

96 "I DID ACID"
Interview by Christopher Bollen,
Interview, May 30, 2014, http://www.
interviewmagazine.com/culture/michael-
cunningham-the-snow-queen.

97 "I DROPPED ACID"
Interview by Jarrett Earnest, Brooklyn Rail,
July 13, 2015, http://brooklynrail.org/2015/
07/art/peter-schjeldahl-with-jarrett-earnest.

97 "YOU CAN'T WRITE"
"The Acid Truth," interview by Arthur Byron
Cover, Vertex, February 1974, reprinted in
Philip K. Dick: The Last Interview and Other
Conversations, ed. David Streitfeld (Brooklyn:
Melville House, 2015), 12–13.

98 "I CAN ONLY"
"The Art of Fiction No. 3," interview by
Simon Raven and Martin Shuttleworth, Paris
Review, no. 3 (Autumn 1953): https://www.
theparisreview.org/interviews/5180/graham-
greene-the-art-of-fiction-no-3-graham-greene.

98 "I FEEL THAT"
"Prophet or Pornographer," interview by
Jaguar Magazine, 1966, reprinted in Burroughs
Live: The Collected Interviews of William S.
Burroughs, 1960–1997, ed. Sylvère Lotringer
(Los Angeles: Semiotext(e), 2001), 93.

99 "I WOULD GIVE"
Letter to Max Perkins, March 11, 1935,
in Dear Scott/Dear Max: The Fitzgerald-
Perkins Correspondence, ed. John Kuehl
and Jackson R. Bryer (New York:
Charles Scribner's Sons, 1971), 219.

99 "DRUNKS RAMBLE"
"The Art of Fiction No. 93," interview by
Ron Hansen, Paris Review, no. 100 (Summer-
Fall 1986): https://www.theparisreview.org/
interviews/2757/john-irving-the-art-of-
fiction-no-93-john-irving.

100 "I DON'T DRINK"
Charles Ruas, Conversations with American
Writers (New York: Alfred A. Knopf, 1985), 284.

100 "LAST NIGHT"
Journal entry, February 26, 1956, in
The Unabridged Journals of Sylvia Plath:
1950–1962, ed. Karen V. Kukil (New York:
Anchor Books, 2000), 210.

101 "I DETEST"
Interview by Martha Duffy and Ron Sheppard,
March 1969, reprinted in Strong Opinions
(New York: McGraw-Hill, 1973), 129.

102 "IN PLACES"
America Day by Day, trans. Carol Cosman
(Berkeley: University of California Press,
2000), 16.

102 "WHEN THINGS"
Interview by Elisa Leonelli (1981),
Cultural Weekly, August 4, 2015,
http://www.culturalweekly.com/charles-
bukowski-its-humanity-that-bothers-me/.

102 "ALCOHOL IS"
Interview by Kay Bonetti, Missouri Review 8,
no. 3 (1985): 67.

102 "I LIKE DRINKING"
"The Art of Fiction No. 195," interview
by Sarah Fay, Paris Review, no. 183 (Winter
2007): https://www.theparisreview.org/
interviews/5816/kenzaburo-oe-the-art-of-
fiction-no-195-kenzaburo-oe.

102 "A MARTINI"
Diary entry, Summer 1953, in
The Diary of Anaïs Nin, ed. Gunther
Stuhlmann, vol. 5, 1947–1955
(New York: Swallow, 1974), 118.

102 "ONLY A DRINK"
Letter to Agnes Boulton O'Neill, ca.
February 16, 1920, in Selected Letters
of Eugene O'Neill, ed. Travis Bogard and
Jackson R. Bryer (New York: Limelight
Editions, 1994), 114.

103 "I RATHER LIKE"
"The Art of Fiction No. 85," interview
by Thomas Frick, Paris Review, no. 94
(Winter 1984): https://www.theparisreview.
org/interviews/2929/j-g-ballard-the-art-
of-fiction-no-85-j-g-ballard.

104 "FINISH EACH DAY"
Journal entry, January 26, 1844, in
The Journals and Miscellaneous Notebooks
of Ralph Waldo Emerson, ed. Ralph H. Orth
and Alfred R. Ferguson, vol. 9, 1843–1847
(Cambridge, MA: Belknap, 1971), 65.

105 "I'M PROUDER"
"The Art of Fiction No. 76," interview
by Mona Simpson and Lewis Buzbee,
Paris Review, no. 88 (Summer 1983):
https://www.theparisreview.org/
interviews/3059/raymond-carver-the-
art-of-fiction-no-76-raymond-carver.

EDITING

106 "I BELIEVE"
Lawrence Grobel, Conversations with Capote
(New York: New American Library, 1985), 20.

107 "MY PENCILS"
Interview at the St. Regis Hotel,
New York, June 5, 1962, in Strong Opinions
(New York: McGraw-Hill, 1973), 4.

108 "A GOOD EDITOR"
"The Art of Fiction No. 62," interview
by Annette Grant, Paris Review, no. 67
(Fall 1976): https://www.theparisreview.org/
interviews/3667/john-cheever-the-art-
of-fiction-no-62-john-cheever.

108 "AT EIGHTY-THREE"
Letter to Elsie Myers Stainton,
May 24, 1983, in Letters of E. B. White,
ed. Dorothy Lobrano Guth and Martha
White, rev. ed. (New York: HarperPerennial,
2007), 664.

108 "EVERY WRITER"
"Robert Gottlieb, The Art of Editing
No. 1," interview by Larissa MacFarquhar,
Paris Review, no. 132 (Fall 1994):
http://www.theparisreview.org/
interviews/1760/robert-gottlieb-the-art-of-
editing-no-1-robert-gottlieb.

109 "YOU DID"
Letter to Edward Garnett, February 18, 1913,
in The Collected Letters of D. H. Lawrence, ed.
Harry T. Moore, vol. 1 (New York:
Viking, 1962), 186.

109 "ONE OF THE THINGS"
"The Art of Fiction No. 121," interview by
Mary Morris, Paris Review, no. 117 (Winter
1990): https://www.theparisreview.org/
interviews/2262/margaret-atwood-the-art-
of-fiction-no-121-margaret-atwood.

109 "A LOT OF NICE"
Wilborn Hampton, "William Maxwell, 91,
Author and Legendary Editor, Dies," New York
Times, August 1, 2000, http://www.nytimes.
com/2000/08/01/arts/william-maxwell-91-
author-and-legendary-editor-dies.html.

109 "AS FOR THE REWORKINGS"
Letter to Mikhail Katkov, July 19, 1866, in
Fyodor Dostoevsky: Complete Letters, ed.
and trans. David A. Lowe, vol. 2, 1860–1867
(Ann Arbor, MI: Ardis, 1989), 208.

109 "THE EDITING"
Interview by Rachel Donadio, New York Times,
December 9, 2014, https://www.nytimes.com/
2014/12/10/books/writing-has-always-
been-a-great-struggle-for-me.html.

110 "STET"
Letter to Louis Untermeyer, September 6,
1938, in The Letters of Robert Frost to Louis
Untermeyer (New York: Holt, Rinehart and
Winston, 1963), 311.

111 "HOW MUCH"
"Writers on Writing; Hearing the Notes That
Aren't Played," New York Times, July 15, 2002,
http://www.nytimes.com/2002/07/15/
arts/writers-on-writing-hearing-the-notes-
that-aren-t-played.html.

111 "I'VE REWRITTEN"
Michael Pietsch, "Editing Infinite Jest,"
Infinite Summer, July 3, 2009,
http://infinitesummer.org/archives/569.

111 "I AM SORRY"
Letter to Pascal Covici, January 16, 1939,
in Steinbeck: A Life in Letters, ed.
Elaine Steinbeck and Robert Wallsten
(New York: Viking, 1975), 178.

111 "MOST WRITERS"
Meredith Maran, ed., Why We Write
(New York: Plume, 2013), 113.

111 "REPLACE 'PEE'"
Letter to George Devine, December 26, 1957,
in The Letters of Samuel Beckett, ed. George
Craig et al., vol. 3, 1957–1965 (Cambridge:
Cambridge University Press, 2014), 81.

111 "BE OPEN"
Interview by Felicity Librie, Fiction
Writers Review, January 6, 2011, http://
fictionwritersreview.com/interview/many-
voices-an-interview-with-tracy-chevalier/.

112 "COPY EDITORS"
"Draft No. 4," New Yorker, April 29, 2013,
http://www.newyorker.com/magazine/
2013/04/29/draft-no-4.

112 "I'VE TRIED TO"
Letter to Maxwell Perkins, August 21, 1926,
in The Only Thing That Counts: The Ernest
Hemingway/Maxwell Perkins Correspondence,
1925–1947, ed. Matthew J. Bruccoli
(New York: Scribner, 1996), 44.

113 "WHEN YOU CATCH"
Letter to David Watt Bowser,
March 20, 1880, in Collected Nonfiction,
vol. 1, Selections from the Autobiography,
Letters, Essays, and Speeches (New York:
Everyman's Library, 2016), 327.

114 "WHEN THE GRIM REAPER"
Letter to Catharine Carver, March 27, 1959,
in The Habit of Being: The Letters of Flannery
O'Connor, ed. Sally Fitzgerald (New York:
Farrar, Straus and Giroux, 1979), 324.

115 "ONCE YOU HAVE"
"The Art of Fiction No. 139," interview by
Jerome Brooks, Paris Review, no. 133 (Winter
1994): https://www.theparisreview.org/
interviews/1720/chinua-achebe-the-art-of-
fiction-no-139-chinua-achebe.

FOOD

116 "ONCE UPON A TIME"
"The Lost Strudel or Le Strudel Perdu,"
in I Feel Bad About My Neck and Other
Thoughts on Being a Woman (New York:
Vintage, 2008), 113.

117 "IF I CAN"
Letter to Fanny Butcher, ca. January 9, 1941,
in The Selected Letters of Willa Cather, ed.
Andrew Jewell and Janis Stout (New York:
Alfred A. Knopf, 2013), 596.

117 "YOU KNOW HOW"
Letter to Cassandra Austen,
June 15–17, 1808, in Jane Austen's Letters, ed.
Deirdre Le Faye, 4th ed. (Oxford:
Oxford University Press, 2011), 133.

118 "I KNOW THE LOOK"
"My Autobiography [Random Extracts
from It]" (1897–98), in Autobiography of
Mark Twain: The Complete and Authoritative
Edition, ed. Harriet Elinor Smith, vol. 1
(Berkeley: University of California Press,
2010), 217.

118 "TO-DAY I BOUGHT"
Journal entry, June 19, 1900, in
Letters of Wallace Stevens, ed. Holly Stevens
(New York: Alfred A. Knopf, 1966), 39.

118 "BY THE WAY"
Letter to Pamela Hansford Johnson,
May 2, 1934, in Selected Letters of
Dylan Thomas, ed. Constantine Fitzgibbon
(New York: New Directions, 1966), 119.

118 "BUY YOURSELF"
Letter to "A," January 2, 1960, in The Habit of
Being: The Letters of Flannery O'Connor, ed.
Sally Fitzgerald (New York: Farrar, Straus
and Giroux, 1979), 368.

118 "AT THIS TIME"
Letter to William Hopkin, December 18, 1913,
in The Letters of D. H. Lawrence, ed.
George J. Zytaruk and James T. Boulton, vol. 2,
1913–16 (Cambridge: Cambridge University
Press, 2002), 122.

119 "NOW AND THEN"
"The Book of Life," in Henry Miller on Writing
(New York: New Directions, 1964), 65.

120 "EATING FRESH"
Letter to Nancy Cunard, July 4, 1956,
in The Letters of Samuel Beckett, ed.
George Craig et al., vol. 2, 1941–1956
(Cambridge: Cambridge University Press,
2011), 631.

121 "I COOKED"
Letter to the Misses —, May 1870, in The Letters
of Emily Dickinson, ed. Mabel Loomis Todd,
vol. 2 (Boston: Roberts Brothers, 1894), 260.

121 "IT WAS MY FATHER"
Memories of a Catholic Girlhood
(New York: Harcourt, 1957), 10.

122 "I LOVE MCDONALD'S"
Interview, Yale Literary Magazine 26,
no. 2 (Fall 2013): http://yalelitmag.com/
denis-johnson-interview/.

122 "I LOVE THE SMELL"
Charles Ruas, Conversations with American
Writers (New York: Alfred A. Knopf, 1985), 146.

122 "I LIKE MAKING"
"The Art of Fiction No. 212," interview
by Sam Anderson, Paris Review, no. 198
(Fall 2011): https://www.theparisreview.org/
interviews/6097/nicholson-baker-the-art-
of-fiction-no-212-nicholson-baker.

123 "I EAT WHATEVER"
"The Illustrated Interview," interview by
Gabé Doppelt, New York Times Style Magazine,
September 9, 2015, https://www.nytimes.com/
2015/09/09/t-magazine-the-illustrated-
interview-dave-eggers.html.

GRAMMAR

124 "GRAMMAR IS"
On Writing: A Memoir of the Craft
(New York: Pocket Books, 2002), 114.

125 "I NEVER USE"
"Whom Says So?," in If You Can't Say
Something Nice (New York: Ticknor and Fields,
1987), 37.

125 "WHEN 'WHOM'"
"On Language: Who Trusts Whom?,"
New York Times Magazine, October 4, 1992,
http://www.nytimes.com/1992/10/04/
magazine/on-language-who-trusts-whom.html.

126 "NEVER USE"
Letter to Joan Lancaster, June 26, 1956,
in The Collected Letters of C. S. Lewis, ed.
Walter Hooper, vol. 3, Narnia, Cambridge
and Joy, 1950–1963 (New York:
HarperCollins, 2007), 766.

126 "GRAMMAR IS"
"Why I Write," in Joan Didion: Essays
and Conversations, ed. Ellen G. Friedman
(Princeton, NJ: Ontario Review Press, 1984), 7.

126 "I CONSISTENTLY"
"Punctuation and Grammar," in
Steering the Craft: A Twenty-First-Century
Guide to Sailing the Sea of Story
(Boston: Mariner Books, 2015), 17.

126 "I'M GLAD"
Letter to Miss M. Bentham Edwards,
January 5, 1912, in The Letters of Henry James,
ed. Percy Lubbock, vol. 2 (New York:
Charles Scribner's Sons, 1920), 214–15.

126 "WHEN I SPLIT"
Letter to Edward Meeks, January 18, 1947, in
Selected Letters of Raymond Chandler, ed.
Frank MacShane (New York: Columbia
University Press, 1981), 86.

126 "VIGOROUS WRITING"
The Elements of Style, illustrated ed.
(New York: Penguin, 2005), 39.

126 "I REALLY DO NOT"
"Poetry and Grammar," in Lectures in America
(Boston: Beacon, 1935), 210.

127 "PERFECT GRAMMAR"
Untitled manuscript, May 6, 1898,
in Autobiography of Mark Twain:
The Complete and Authoritative Edition, ed.
Harriet Elinor Smith, vol. 1 (Berkeley:
University of California Press, 2010), 120.

IDEAS

128 "ORIGINAL THOUGHTS"
A Week at the Airport (New York: Vintage, 2010), 42.

129 "IDEAS ARE LIKE"
Interview by Robert van Gelder, Cosmopolitan, April 1947, 18.

130 "I ALWAYS THINK"
"Scott Spencer," interview by Lorrie Moore, BOMB, no. 67 (Spring 1999): http://bombmagazine.org/article/2228/scott-spencer.

130 "IDEAS ARE THE EASY"
Interview by Killian Fox, Guardian, September 8, 2012, https://www.theguardian.com/books/2012/sep/09/michael-chabon-telegraph-avenue-interview.

130 "THE MORE I THINK"
"Where Do You Get Your Ideas From?" (1987), in Dancing at the Edge of the World: Thoughts on Words, Women, Places (New York: Grove, 1989), 193.

131 "ALL MY LIFE"
Sam Weller, Listen to the Echoes: The Ray Bradbury Interviews (Brooklyn: Melville House, 2010), 204.

131 "WHAT COULD BE"
"Not I, but the Father within Me," in Henry Miller on Writing (New York: New Directions, 1964), 79.

INFLUENCE

132 "TO TAKE"
William Blake: Poems (New York: Vintage, 2016), introduction, xiii.

133 "BLAKE LED"
"The Art of Fiction No. 195," interview by Sarah Fay, Paris Review, no. 183 (Winter 2007): https://www.theparisreview.org/interviews/5816/kenzaburo-oe-the-art-of-fiction-no-195-kenzaburo-oe.

134 "AS LONG AS"
Letter to Mikhail Menshikov, January 28, 1900, in The Selected Letters of Anton Chekhov, ed. Lillian Hellman, trans. Sidonie Lederer New York: Farrar, Straus, 1955), 262.

134 "OF ALL THE"
Interview by Hans Ulrich Obrist (2006), in Hans Ulrich Obrist: Interviews, ed. Charles Arsène-Henry, Shumon Basar, and Karen Marta, vol. 2 (Milan: Charta, 2010), 121.

134 "I WOULD VERY"
"By the Book," New York Times Book Review, November 23, 2016, https://www.nytimes.com/2016/11/23/books/review/amos-oz-by-the-book.html.

135 "RUSHDIE GOT"
Interview by Jonathan Safran Foer, BOMB, no. 81 (Fall 2002): http://bombmagazine.org/article/2519/jeffrey-eugenides.

135 "I ALWAYS TELL"
"Spokane Words," interview by Tomson Highway, Aboriginal Voices, January–March 1997, reprinted in Conversations with Sherman Alexie, ed. Nancy J. Peterson (Jackson: University Press of Mississippi, 2009), 26.

136 "I REVERE"
Charles Ruas, Conversations with American Writers (New York: Alfred A. Knopf, 1985), 311.

136 "DON'T BE"
"Ten Rules for Writing Fiction: Part 1," Guardian, February 19, 2010, https://www.theguardian.com/books/2010/feb/20/ten-rules-for-writing-fiction-part-one.

137 "JAMES JOYCE"
Interview by Herbert Gold, Paris Review, no. 41 (Summer–Fall 1967): https://www.theparisreview.org/interviews/4310/vladimir-nabokov-the-art-of-fiction-no-40-vladimir-nabokov.

138 "I'M ALWAYS TURNING"
Interview by Kaveh Akbar, Dive Dapper, December 8, 2014, https://www.divedapper.com/interview/claudia-rankine/.

138 "LIKE MOST"
"The Hum Inside the Skull, Revisited," New York Times, January 16, 2005, http://www.nytimes.com/2005/01/16/books/review/the-hum-inside-the-skull-revisited.html.

138 "MY EAR FOR"
"The Hum Inside the Skull: A Symposium," New York Times, May 13, 1984, http://www.nytimes.com/1984/05/13/books/the-hum-inside-the-skull-a-symposium.html.

138 "WILLIAM TREVOR'S"
"The Hum Inside the Skull, Revisited," New York Times, January 16, 2005, http://www.nytimes.com/2005/01/16/books/review/the-hum-inside-the-skull-revisited.html.

138 "WILLIAM FAULKNER'S"
Interview by Noah Charney, Daily Beast, May 16, 2012, http://www.thedailybeast.com/the-david-eagleman-interview-how-i-write.

138 "DISCOVERING PROUST"
"The Discovery of Oneself," interview by Ioanna Kohler, Paris Review blog, July 1, 2014, https://www.theparisreview.org/blog/2014/07/01/the-discovery-of-oneself-an-interview-with-daniel-mendelsohn/.

139 "I DIDN'T WANT"
Interview by Al Alvarez, BBC broadcast, March 11, 1967, quoted in Maurice Mierau, "Formally Speaking: Screaming in Pentameter," Contemporary Verse 2, September 1, 2009, http://www.contemporaryverse2.ca/en/essays/excerpt/formally-speaking-screaming-in-pentameter.

140 "I LEARNED"
Jonathan Kandell, "Octavio Paz, Mexico's Literary Giant, Dead at 84," New York Times, April 21, 1998, https://partners.nytimes.com/library/books/042198obit-paz.html.

140 "WHENEVER I READ"
"By the Book," New York Times Book Review, April 12, 2012, http://www.nytimes.com/2012/04/15/books/review/the-author-of-squirrel-seeks-chipmunk-would-like-to-go-back-in-time-and-collect-kindling-for-flannery-oconnor.html.

141 "MUSIC IS"
Letter to Viktor Polzer, March 23, 1940, in Letters of Thomas Mann: 1889–1955, ed. and trans. Richard and Clara Winston (New York: Alfred A. Knopf, 1971), 328.

141 "MY GREATEST"
Interview by Miles Marshall Lewis, Believer, November 2004, http://www.believermag.com/issues/200411/?read=interview_wilson.

141 "THE EARLY GODARD"
Interview by Rosemary Carroll, BOMB, no. 17 (Fall 1986): http://bombmagazine.org/article/821/angela-carter.

142 "THE QUESTION"
"The Hum Inside the Skull, Revisited," New York Times, January 16, 2005, http://www.nytimes.com/2005/01/16/books/review/the-hum-inside-the-skull-revisited.html.

142 "THE ONLY BOOKS"
"A Book That Influenced Me," in Two Cheers for Democracy (New York: Harcourt, Brace, 1951), 222.

143 "AN ACCIDENT"
"The Hum Inside the Skull, Revisited," New York Times, January 16, 2005, http://www.nytimes.com/2005/01/16/books/review/the-hum-inside-the-skull-revisited.html.

LOVE

144 "I NEVER SHIED"
Why Be Happy When You Could Be Normal? (New York: Grove, 2011), 77.

145 "LOVE MAY BE"
Dust Tracks on a Road (New York: HarperPerennial, 1996), 203.

145 "LOVE IS NOT"
Interview by Vince Pennington, Kentucky Review 13, nos. 1/2 (Spring 1996), reprinted in Conversations with Wendell Berry, ed. Morris Allen Gruber (Jackson: University Press of Mississippi, 2007), 42.

146 "YOU MAY DEPEND"
The Table Talk and Omniana of Samuel Taylor Coleridge (London: Oxford University Press, 1917), 59.

146 "WE HEADED HOME"
Just Kids (New York: Ecco, 2010), 107.

146 "I THINK FOR MOST"
"Hilton Als and Junot Diaz," in Upstairs at the Strand: Writers in Conversation at the Legendary Bookstore, ed. Jessica Strand and Andrea Aguilar (New York: W. W. Norton, 2016), 19.

146 "I SHALL NEVER"
Letter to Grace Norton, November 3, 1884, in Henry James Letters, ed. Leon Edel, vol. 3, 1883–1895 (Cambridge, MA: Belknap, 1980), 54.

146 "I SOON REALIZED"
Dorothy Lobrano Guth and Martha White, eds. Letters of E. B. White, rev. ed. (New York: HarperPerennial, 2007), 81.

147 "NEVER MARRY"
"What I Wish I'd Known," in I Feel Bad About My Neck and Other Thoughts on Being a Woman (New York: Vintage, 2008), 123.

148 "I LOVE PETER"
The Diary of a Young Girl: The Definitive Edition, ed. Otto H. Frank and Mirjam Pressler, trans. Susan Massotty (New York: Random House, 1995), 16.

148 "DON'T WE ALL"
Interview by Emma Brockes, Guardian, March 21, 2014, https://www.theguardian.com/books/2014/mar/21/chimamanda-ngozi-adichie-interview.

149 "THE RIGHT SORT"
Cahiers/Notebooks, vol. 1 (Frankfurt am Main Germany: Peter Lang, 2000), 553.

149 "RELATIONSHIPS"
Anya Raza, "Write, Never Marry, and
Other Love Advice from Simone de Beauvoir's
Editor," Lenny Letter, April 21, 2017,
http://www.lennyletter.com/life/interviews/
a808/an-interview-with-acclaimed-writer-
and-editor-diana-athill/.

149 "I CAN'T DIVIDE"
Letter to Georg Kreisel, late October 1967,
in Living on Paper: Letters from Iris Murdoch,
1934–1995, ed. Avril Horner and Anne Rowe
(Princeton, NJ: Princeton University Press,
2016), 347.

149 "I AM BESIDE"
Letter to Louise Colet, August 9, 1846,
in Letters of Gustave Flaubert, ed. Richard
Rumbold, trans. J. M. Cohen (London:
George Weidenfeld and Nicolson, 1950), 31.

149 "NOW I KNOW"
Letter to Irene Miner Weisz, October 25, 1945,
in The Selected Letters of Willa Cather, ed.
Andrew Jewell and Janis Stout (New York:
Alfred A. Knopf, 2013), 627.

149 "FROM THE MOMENT"
Love and Living, ed. Naomi Burton Stone
and Brother Patrick Hart (New York:
Harcourt, 1979), 27.

150 "I LIKE NOT ONLY"
Letter to Georgiana Burne-Jones,
May 11, 1875, in George Eliot's Life as
Related in Her Letters and Journals, ed.
J. W. Cross, vol. 3 (Edinburgh: Blackwood
and Sons, 1885), 258.

150 "I CANNOT EXIST"
Letter to Fanny Brawne, October 13, 1819,
in The Selected Letters of John Keats, ed.
Lionel Trilling (New York: Farrar, Straus
and Young, 1951), 247.

150 "I AM WRITING"
Letter to Olivia Shakespear,
May 25, 1926, in A. Norman Jeffares,
W. B. Yeats: Man and Poet (New York:
Barnes and Noble, 1966), 214.

151 "THERE IS NO"
Journal entry, July 25, 1839, in The Journal:
1837–1861, ed. Damion Searls (New York: New
York Review of Books, 2009), 7.

MONEY

152 "I DON'T WRITE"
Interview by John Wesley Harding, BOMB,
no. 46 (Winter 1994): http://bombmagazine.
org/article/1737/haruki-murakami.

153 "I AM AFRAID"
Letter to J. B. Pinker, February 16, 1918,
in The Letters of D. H. Lawrence, ed.
James T. Boulton and Andrew Robertson,
vol. 3, pt. 1, 1916–21 (Cambridge:
Cambridge University Press, 2002), 211.

153 "MONEY—AS SCARCE"
Letter to Maria Kiseleva, September 21, 1886,
in The Selected Letters of Anton Chekhov, ed.
Lillian Hellman, trans. Sidonie Lederer
(New York: Farrar, Straus, 1955), 15.

154 "MONEY IS A"
Charles Ruas, Conversations with
American Writers (New York: Alfred A. Knopf,
1985), 248.

154 "I REMEMBER"
I Remember (New York: Granary Books,
2001), 116.

154 "WHAT A BORE"
Letter to Julian Huxley, May 18, 1934, in
Aldous Huxley: Selected Letters, ed. James
Sexton (Chicago: Ivan R. Dee, 2007), 295.

155 "I DON'T EXPECT"
Quoted in Brian St. Pierre, John Steinbeck:
The California Years (San Francisco:
Chronicle Books, 1983), 82.

156 "I HAVE SPENT"
Letter to Alexander Vrangel,
ca. September 10, 1865, in Fyodor Dostoevsky:
Complete Letters, ed. and trans. David A. Lowe,
vol. 2, 1860–1867 (Ann Arbor, MI:
Ardis, 1989), 173.

156 "I'VE EXHAUSTED"
Letter to Gregory Bellow, ca. February 1961,
in Saul Bellow: Letters, ed. Benjamin Taylor
(New York: Viking, 2010), 213.

156 "IF I DON'T"
Letter to Max Perkins, ca. November 5, 1923,
in Dear Scott/Dear Max: The Fitzgerald–
Perkins Correspondence, ed. John Kuehl
and Jackson R. Bryer (New York: Charles
Scribner's Sons, 1971), 68.

156 "HOW ONE GRUDGES"
Letter to Ottoline Morrell, June 10, 1919, in
The Collected Letters of Katherine Mansfield,
ed. Vincent O'Sullivan and Margaret Scott,
vol. 2, 1918–1919 (Oxford: Clarendon,
1987), 327.

156 "JUST SIGNED"
Letter to Arna Bontemps, January 28, 1961,
in Selected Letters of Langston Hughes, ed.
Arnold Rampersad and David Roessel
(New York: Alfred A. Knopf, 2015), 369.

156 "I HAVEN'T SEEN"
Letter to Charles Fisher, July 15, 1941,
in Selected Letters of Dylan Thomas, ed.
Constantine Fitzgibbon (New York:
New Directions, 1966), 256.

156 "THE ONLY REASON"
Arnold Samuelson, With Hemingway:
A Year in Key West and Cuba
(New York: Random House, 1984), 13.

156 "I ADMIRE"
Diary entry, February 1953, in The Diary
of Anaïs Nin, ed. Gunther Stuhlmann, vol. 5,
1947–1955 (New York: Swallow, 1974), 107.

157 "I DON'T YET"
Mary Braggiotti, "Misery Begets Genius,"
New York Post, March 20, 1945, 21.

ORIGINALITY

158 "STEAL"
"More Advice for the Recent Graduate,"
author's website, May 25, 2017, http://
austinkleon.com/2017/05/25/more-advice-
for-the-recent-graduate.

159 "YOU HAVE TO"
Interview by Jonathan Safran Foer, BOMB,
no. 81 (Fall 2002): http://bombmagazine.org/
article/2519/jeffrey-eugenides.

159 "EVERY AUTHOR"
"To Write as One Talks," in Henry Miller on
Writing (New York: New Directions, 1964), 49.

160 "I'M BEGINNING"
Letter to Eugenio Scalfari, June 5, 1943, in
Italo Calvino: Letters, 1941–1985, ed. Michael
Wood, trans. Martin McLaughlin (Princeton,
NJ: Princeton University Press, 2013), 27.

160 "THE POINT IS"
Dorothy Tooker, "The Editors Meet
William Carlos Williams," A.D. 3, no. 1
(Winter 1952), reprinted in Interviews with
William Carlos Williams: "Speaking Straight
Ahead," ed. Linda Welshimer Wagner
(New York: New Directions, 1976), 29.

160 "I BY NO MEANS"
February 17, 1832, entry, in Conversations
of Goethe with Eckermann and Soret,
trans. John Oxenford (London: George Bell
and Sons, 1882), 565.

160 "I QUOTE OTHERS"
"Of the Education of Children," in
The Works of Michael de Montaigne:
Comprising His Essays, Letters, and Journey
through Germany and Italy, ed. William Hazlitt,
4th ed. (Philadelphia: J. W. Moore, 1849), 86.

160 "THE ONLY WAY"
A Writer's Notebook (Westport, CT:
Greenwood, 1970), 273.

160 "WHEN YOU IMITATE"
Interview by Wesley Wehr, Antioch Review
39, no. 3 (Summer 1981): 322.

160 "THE TRUE ARTIST"
Bruce Bashford, Oscar Wilde: The Critic as
Humanist (Madison, NJ: Fairleigh Dickinson
University Press, 1999), 116.

161 "THE GOOD POET"
The Sacred Wood: Essays on Poetry and
Criticism (London: Methuen, 1920), 114.

161 "I AM PROBABLY"
"The Art of Fiction No. 23," interview
by Julian Mitchell and Gene Andrewski,
Paris Review, no. 22 (Autumn–Winter
1959–60): https://www.theparisreview.org/
interviews/4720/lawrence-durrell-the-
art-of-fiction-no-23-lawrence-durrell.

161 "ORIGINALITY IS"
"How to Be a Writer: 10 Tips from
Rebecca Solnit," Literary Hub, September 13,
2016, http://lithub.com/how-to-be-a-
writer-10-tips-from-rebecca-solnit/.

PLOT

162 "THE LAST THING"
The Thoughts of Blaise Pascal,
trans. C. Kegan Paul (London: George Bell
and Sons, 1889), 302.

163 "I ALWAYS KNOW"
Interview by Charles Ruas (1981), in
Conversations with Toni Morrison, ed. Danille
Taylor-Guthrie (Jackson: University Press of
Mississippi, 1994), 101.

163 "THE FIRST"
"To a Young Writer," in The Faith of a Writer:
Life, Craft, Art (New York: Ecco, 2003), 27–28.

163 "THE LAST PAGE"
Interview, HBO, n.d., http://www.hbo.com/
olive-kitteridge/episodes/01/01-pharmacy/
interview/elizabeth-strout.html.

164 "I'M NOT"
"Two Kinds of Aboutness," interview by
Adam Vitcavage, Millions, November 22, 2016,
http://www.themillions.com/2016/11/
two-kinds-aboutness-millions-interviews-
michael-chabon.html.

164 "WHEN IN DOUBT"
"The Simple Art of Murder," Saturday Review
of Literature, April 15, 1950, 14.

165 "I CAN'T DO"
Interview by Graham Swift, <u>BOMB</u>, no. 29
(Fall 1989): http://bombmagazine.org/
article/1269/kazuo-ishiguro.

165 "I HAVE NO"
Interview by Ari Shapiro, <u>Morning Edition</u>,
NPR, June 16, 2015, http://www.npr.
org/2015/06/16/414669606/kate-
atkinson-tells-book-club-how-she-crafts-
characters-at-all-life-stages.

165 "DON'T BEGIN"
Letter to Trevor Hughes, January 1933,
in <u>Selected Letters of Dylan Thomas</u>, ed.
Constantine Fitzgibbon (New York:
New Directions, 1966), 12.

165 "THE ORDER OF"
Interview by J. D. O'Hara (1981), in
<u>Not-Knowing: The Essays and Interviews of
Donald Barthelme</u>, ed. Kim Herzinger
(New York: Random House, 1997), 282–83.

165 "NO STORY SHOULD"
Letter to Sheridan Le Fanu, May 26, 1870,
in <u>The Selected Letters of Charles Dickens</u>, ed.
Jenny Hartley (Oxford: Oxford University
Press, 2012), 436.

166 "PLOT IS"
<u>Zen in the Art of Writing</u> (Santa Barbara, CA:
Joshua Odell Editions, 1990), 130.

167 "I START WITH"
"The Art of Fiction No. 32," interview by
Steven Marcus, <u>Paris Review</u>, no. 31 (Winter–
Spring 1964): https://www.theparisreview.
org/interviews/4503/norman-mailer-the-art-
of-fiction-no-32-norman-mailer.

POETRY

168 "YOU DON'T ASK"
"Geography of the Imagination," interview by
Alexandra Johnson, <u>Christian Science Monitor</u>,
March 23, 1978, reprinted in <u>Conversations
with Elizabeth Bishop</u>, ed. George Monteiro
(Jackson: University Press of Mississippi,
1996), 99.

169 "AUDEN"
"The Art of Fiction No. 151," interview by
Francesca Riviere, <u>Paris Review</u>, no. 146
(Spring 1998): https://www.theparisreview.
org/interviews/1156/martin-amis-the-art-
of-fiction-no-151-martin-amis.

169 "YEATS"
Interview by David Kennedy,
August 5, 1993, transcript, http://writing.
upenn.edu/~afilreis/88/koch.html.

170 "IT IS RAINING"
Journal entry, July 1950–July 1953, in
<u>The Unabridged Journals of Sylvia Plath:
1950–1962</u>, ed. Karen V. Kukil (New York:
Anchor Books, 2000), 9.

170 "POETRY IS NOT"
Interview by Adrienne Rich, <u>Signs</u> 6, no. 4
(Summer 1981): 720.

170 "I OWE"
Letter to Louis Untermeyer,
October 12, 1939, in <u>The Letters of
Robert Frost to Louis Untermeyer</u> (New York:
Holt, Rinehart and Winston, 1963), 319.

170 "IF PROSE"
Interview by Kate Kellaway, <u>Guardian</u>, October
30, 2016, https://www.theguardian.com/
books/2016/oct/30/anne-carson-do-not-
believe-art-therapy-interview-float.

170 "I DON'T BELIEVE"
Interview by Jacqueline Jones Lamon,
<u>Mosaic</u>, no. 17 (January 2007):
https://mosaicmagazine.org/lucille-
clifton-interview.

170 "TO BRING POETRY"
John C. Thirlwall, "William Carlos Williams's
<u>Paterson</u>," <u>New Directions</u> 17 (1961): 253.

171 "THE BEST"
"Notes on the Art of Poetry," in <u>The Poems
of Dylan Thomas</u>, ed. Daniel Jones
(New York: New Directions, 2003), xxii.

171 "I AM SENDING"
Letter to Georges Izambard, August 25, 1870,
in <u>Rimbaud: Complete Works, Selected Letters</u>,
trans. Wallace Fowlie (Chicago: University of
Chicago Press, 1966), 299.

172 "POETRY (AT ANY RATE)"
Letter to J. B. Sutton, December 20, 1940, in
<u>Selected Letters of Philip Larkin: 1940–1985</u>, ed.
Anthony Thwaite (New York: Farrar,
Straus and Giroux, 1993), 5–6.

172 "IF I FEEL"
Quoted in a letter from Thomas
Wentworth Higginson to Mary Channing
Higginson, August 16, 1870, in <u>The Letters
of Emily Dickinson</u>, ed. Thomas H. Johnson
and Theodora Ward (Cambridge, MA:
Belknap, 1960), 474.

172 "A TRULY"
"Untelling the Hour," interview by
Richard Jackson (1979), in <u>Richard
Jackson, Acts of Mind: Conversations with
Contemporary Poets</u> (Tuscaloosa: University
of Alabama Press, 1983), 13–14.

173 "LET IT ALL"
<u>The House by the Sea</u> (New York:
W. W. Norton, 1977), 49.

PUBLISHING

174 "I SUFFER"
Interview by Sam Merrill, <u>Playboy</u>,
June 1975, reprinted in <u>Conversations with
Joseph Heller</u>, ed. Adam J. Sorkin (Jackson:
University Press of Mississippi, 1993), 163.

175 "I THINK"
Interview by Alex Clark, <u>Guardian</u>,
January 10, 2010, https://www.theguardian.
com/culture/2011/jan/10/jane-gardam-
life-writing.

176 "MY RECORD"
Interview by Aileen Gallagher, <u>Vulture</u>,
September 29, 2010, http://www.vulture.
com/2010/09/the_vulture_transcript_
david_s.html.

176 "NO MORE TALK"
Letter to Mania Péron, April 29, 1951, in
<u>The Letters of Samuel Beckett</u>, ed. George
Craig et al., vol. 2, <u>1941–1956</u> (Cambridge:
Cambridge University Press, 2011), 248.

177 "I USED TO GO"
Interview by Charlotte Higgins, <u>Guardian</u>,
October 15, 2016, https://www.theguardian.
com/books/2016/oct/15/margaret-atwood-
interview-english-pen-pinter-prize.

177 "ONLY ONE"
"Hilton Als and Junot Diaz," in
<u>Upstairs at the Strand: Writers in Conversation
at the Legendary Bookstore</u>, ed. Jessica Strand
and Andrea Aguilar (New York: W. W.
Norton, 2016), 37.

177 "I HAVE A STACK"
Editorial, <u>New York Times</u>,
November 16, 2013, http://www.nytimes.
com/2013/11/17/opinion/sunday/
billy-collins.html.

177 "THINK ABOUT"
Interview by Alison Beard, <u>Harvard Business
Review</u>, September 2015, https://hbr.org/
2015/09/lifes-work-salman-rushdie.

177 "MY EXPERIENCES"
Letter to Agnes E. Meyer, October 27, 1943,
in <u>Letters of Thomas Mann: 1889–1955</u>, ed.
and trans. Richard and Clara Winston
(New York: Alfred A. Knopf, 1971), 429.

177 "BOOK TOURS"
Interview by Robert Birnbaum, <u>Identity Theory</u>
June 16, 2003, http://www.identitytheory.
com/michael-lewis-moneyball-interview/.

178 "HERE IS"
Letter to Maxwell Perkins, early February 1937
in <u>The Only Thing That Counts: The Ernest
Hemingway/Maxwell Perkins Correspondence
1925–1947</u>, ed. Matthew J. Bruccoli
(New York: Scribner, 1996), 248.

179 "ON THE PROOFS"
Letter to Norah Smallwood, early 1962,
in <u>Living on Paper: Letters from Iris Murdoch,
1934–1995</u>, ed. Avril Horner and Anne Rowe
(Princeton, NJ: Princeton University Press,
2016), 222.

179 "PUBLISHERS ARE LIKE"
Diary entry, May 8, 1935, in <u>Locked Rooms
and Open Doors: Diaries and Letters,
1933–1935</u> (New York: Harcourt Brace
Jovanovich, 1974), 271.

180 "I AM NO SPEAKER"
Letter to Bo Beskow, November 1, 1962,
in <u>Steinbeck: A Life in Letters</u>, ed.
Elaine Steinbeck and Robert Wallsten
(New York: Viking, 1975), 748.

180 "I TURNED UP"
Interview by Robert Birnbaum,
<u>Identity Theory</u>, October 27, 2005, http://
www.identitytheory.com/adam-nicolson/.

180 "FOR ME"
"The Not-Quite End of the Book Tour," <u>Atlantic</u>
October 17, 2015, https://www.theatlantic.
com/entertainment/archive/2015/10/the-
modern-face-of-book-tours/407641/.

181 "THE ANTIDOTE"
"10 Things I Learned on Book Tour,"
author's website, June 21, 2012,
http://austinkleon.com/2012/06/21/
10-things-i-learned-on-book-tour.

182 "WHY IS IT"
<u>Journal of Solitude</u> (New York: W. W. Norton,
1973), 151–52.

182 "MY FIRST BOOK"
Interview by Jarrett Earnest, <u>Brooklyn Rail</u>,
May 3, 2016, http://brooklynrail.org/
2016/05/art/john-ashbery-with-jarrett-
earnest.

182 "IT IS A VERY"
Letter to Charles Scribner, November 11, 1905,
in <u>The Letters of Edith Wharton</u>, ed.
R. W. B. Lewis and Nancy Lewis (New York:
Charles Scribner's Sons, 1988), 95.

182 "I CAN'T STAND"
"Sitting Down with Louise Glück," interview
by Cindy Ok, <u>Yale Herald</u>, November 8, 2013.

182 "THE BOOK JUMPED"
Letter to Prince Sadruddin Aga Khan,
July 5, 1979, in Selected Letters of
William Styron, ed. Rose Styron
and R. Blakeslee Gilpin (New York:
Random House, 2012), 535.

183 "I NEVER EXPECTED"
"Harper Lee, Author of
'To Kill a Mockingbird,' Dies at 89,"
New York Times, February 19, 2016,
https://www.nytimes.com/ 2016/02/
20/arts/harper-lee-dies.html.

183 "THE LITTLE BOOKS"
Letter to Angela Burdett Coutts,
August 23, 1858, in The Selected Letters of
Charles Dickens, ed. Jenny Hartley
(Oxford: Oxford University Press, 2012), 343.

183 "I AM NEVER"
My Several Worlds: A Personal Record
(New York: John Day, 1954), 180.

183 "THE PRINCIPAL"
Journal entry, January 1, 1855, in
Louisa May Alcott: Her Life, Letters,
and Journals, ed. Ednah D. Cheney (Boston:
Roberts Brothers, 1889), 79.

184 "IT TAKES"
"Ten Minutes with J. D. Salinger,"
interview by Greg Herriges, Oui Magazine,
January 1979, reprinted in J. D. Salinger:
The Last Interview and Other Conversations, ed.
David Streitfeld (Brooklyn: Melville House,
2016), 39.

185 "I GAVE"
Interview by Mary Laura Philpott,
August 29, 2016, Literary Hub, http://lithub.
com/ann-patchett-on-stealing-stories-book-
tours-and-staying-off-twitter/.

PUNCTUATION

186 "BE CAREFUL"
"Ten Rules of Writing," in Lou Salomé,
Nietzsche, ed. and trans. Siegfried Mandel
(Urbana: University of Illinois Press, 2001), 78.

187 "I NEVER COULD"
"Poetry and Grammar," in Lectures in America
(Boston: Beacon, 1935), 215.

187 "I DECIDED"
Marcia Minor, "An Author Discusses His Craft,"
Daily Worker, December 13, 1938, 7.

188 "SEMICOLONS"
"Robert Gottlieb, The Art of Editing No. 1,"
interview by Larissa MacFarquhar,
Paris Review, no. 132 (Fall 1994): http://
www.theparisreview.org/interviews/1760/
robert-gottlieb-the- art-of-editing-no-1-
robert-gottlieb.

188 "DO NOT USE"
A Man without a Country
(New York: Seven Stories, 2005), 23.

189 "TOO MANY"
"How to Punctuate," Spin, September 1985, 15.

189 "AN EXCLAMATION"
Sheilah Graham and Gerold Frank,
Beloved Infidel: The Education of a Woman
(New York: Henry Holt, 1958), 198.

189 "KEEP YOUR"
"Ten Rules for Writing Fiction: Part 1,"
Guardian, February 19, 2010, https://
www.theguardian.com/books/2010/feb/
20/ten-rules-for-writing-fiction-part-one.

190 "I SHARE"
Interview by Geoff Hancock, Canadian Fiction
Magazine, no. 59 (May 1987), reprinted in
Conversations with Bharati Mukherjee, ed.
Bradley C. Edwards (Jackson: University Press
of Mississippi, 2009), 14.

190 "COMMAS"
Mary Norris, "Holy Writ," New Yorker,
February 23, 2015, http://www.newyorker.
com/magazine/2015/02/23/holy-writ.

190 "I LIKE"
Interview by Sarah Crown, Guardian,
January 22, 2010, https://www.theguardian.
com/books/2010/jan/23/el-doctorow-
homer-and-langley.

191 "IF YOU AREN'T"
"Punctuation and Grammar," in
Steering the Craft: A Twenty-First-
Century Guide to Sailing the Sea of Story
(Boston: Mariner Books, 2015), 11.

READING

192 "READ TO"
Letter to Mademoiselle Leroyer de Chantepie,
June 16, 1867, in John Charles Tarver,
Gustave Flaubert as Seen in His Works
and Correspondence (Westminster:
Archibald Constable, 1895), 234.

193 "I WOULD RATHER"
Interview by John Detrixhe, Bookslut,
December 2005, http://www.bookslut.com/
features/2005_12_007310.php.

194 "I WAS A READER"
Interview by Claire E. White,
Internet Writing Journal, March 1999,
http://www.writerswrite.com/journal/
mar99/a-conversation-with-neil-gaiman-3991.

194 "WORD BY WORD"
Reading Like a Writer (New York:
HarperCollins, 2006), 5.

194 "YOU THINK"
Jane Howard, "Doom and Glory of Knowing
Who You Are," Life, May 24, 1963, 89.

194 "SOME PEOPLE"
"One of Uncle Tom's Children,"
interview by Peter Lennon, Guardian,
December 8, 1960, 8.

194 "THROUGHOUT MY"
"By the Book," New York Times Book Review,
April 12, 2012, http://www.nytimes.
com/2012/04/15/books/review/
the-author-of-squirrel-seeks-chipmunk-
would-like-to-go-back-in-time-and-collect-
kindling-for-flannery-oconnor.html.

195 "MOST OF"
"By the Book," New York Times Book
Review, July 12, 2012, http://www.nytimes.
com/2012/07/15/books/review/
dave-eggers-by-the-book.html.

195 "I DON'T NEED"
"By the Book," New York Times Book
Review, April 4, 2013, http://www.nytimes.
com/2013/04/07/books/review/isabel-
allende-by-the-book.html.

196 "THE PLEASURE"
Letter to Ottoline Morrell, ca.
January 24, 1922, in The Collected
Letters of Katherine Mansfield, ed.
Vincent O'Sullivan and Margaret Scott,
vol. 5, 1922–1923 (Oxford: Oxford
University Press, 2008), 20.

197 "MORNING READING"
"By the Book," New York Times Book Review,
November 17, 2016, https://www.nytimes.
com/2016/11/20/books/review/zadie-
smith-by-the-book.html.

198 "I'D READ"
"Sherman Alexie, Literary Rebel,"
interview by John and Carl Bellante,
Bloomsbury Review, May–June 1994, reprinted
in Conversations with Sherman Alexie, ed.
Nancy J. Peterson (Jackson: University Press
of Mississippi, 1993), 12.

198 "MY MOTHER MADE"
Interview by Diane Osen, National Book
Foundation, n.d., http://www.nationalbook.
org/authorsguide_gnaylor.html.

198 "I DISCOVERED"
"The Art of Fiction No. 203," interview
by Sam Weller, Paris Review, no. 192
(Spring 2010): https://www.theparisreview.
org/interviews/6012/ray-bradbury-the-art-
of-fiction-no-203-ray-bradbury.

199 "I WAS CONSTANTLY"
Interview by Adrienne Rich, Signs 6, no. 4
(Summer 1981): 716.

199 "I REMEMBER"
I, Asimov: A Memoir (New York:
Doubleday, 1994), 30.

200 "I HAPPEN TO"
"The Art of Editing No. 1," interview by
Larissa MacFarquhar, Paris Review, no. 132
(Fall 1994): http://www.theparisreview.org/
interviews/1760/robert-gottlieb-the-art-of-
editing-no-1-robert-gottlieb.

200 "I FIND THAT"
Letter to Blanche Jennings,
June 25, 1908, in The Collected Letters of
D. H. Lawrence, ed. Harry T. Moore, vol. 1
(New York: Viking, 1962), 18.

200 "ALTHOUGH WE"
Robert Michael Pyle, "Between
Climb and Cloud: Nabokov among the
Lepidopterists," in Nabokov's Butterflies:
Unpublished and Uncollected Writings, ed.
Brian Boyd and Robert Michael Pyle
(Boston: Beacon, 2000), 70.

200 "I LIKED BOOKS"
Smile Please: An Unfinished Autobiography
(New York: Harper and Row, 1979), 50–51.

201 "IF YOU DON'T"
"The 'Craft' of Writing Horror Stories,"
interview by Terry Gross, Fresh Air, NPR,
October 10, 2000, posted July 2, 2010,
http://www.npr.org/templates/story/story.
php?storyId=128239303.

202 "MY IDEAL STATE"
Alexandra Alter, "Can Climate
Change Be Funny?," Wall Street Journal,
March 25, 2010, https://www.wsj.com/
articles/SB1000142405274870411730457 5
137993028761062.

202 "I WOULD LIKE"
"May 2005," in Housekeeping vs. the Dirt
(San Francisco: Believer Books, 2006), 51.

203 "KNOWING ABOUT"
Letter to William Maxwell, Spring 1957,
in What There Is to Say We Have Said:
The Correspondence of Eudora Welty
and William Maxwell, ed. Suzanne
Marrs (Boston: Houghton Mifflin
Harcourt, 2011), 110.

READING LIST

204 "IF YOU WANT"
Interview by Stuart Spencer, BOMB, no. 31 (Spring 1990): http://bombmagazine.org/article/1310/joyce-carol-oates.

205 "READ MONTAIGNE"
Letter to Mademoiselle Leroyer de Chantepie, June 1857, in Letters of Gustave Flaubert, ed. Richard Rumbold, trans. J. M. Cohen (London: George Weidenfeld and Nicolson, 1950), 115.

206 "I WAKE UP"
Letter to Alexei Suvorin, October 25, 1891, in The Selected Letters of Anton Chekhov, ed. Lillian Hellman, trans. Sidonie Lederer (New York: Farrar, Straus, 1955), 155.

206 "I'M GLAD"
Letter to Isa Bezzera, July 16, 1950, in Italo Calvino: Letters, 1941–1985, ed. Michael Wood, trans. Martin McLaughlin (Princeton, NJ: Princeton University Press, 2013), 61.

206 "READ CHEKHOV"
"Learning from Chekhov," in Writers on Writing, ed. Robert Pack and Jay Parini (Hanover, NH: University Press of New England, 1991), 231.

207 "I HAVE READ JAMES"
Letter to Robert McAlmon, June 18, 1921, in The Selected Letters of Marianne Moore, ed. Bonnie Costello (New York: Knopf, 1997), 164.

207 "I'M READING"
Journal entry, December 10, 1977, in As Consciousness Is Harnessed to Flesh: Journals and Notebooks, 1964–1980, ed. David Rieff (New York: Farrar, Straus and Giroux, 2012), 446.

207 "HAVE YOU READ"
Letter to Sara Norton, February 24, 1902, in The Letters of Edith Wharton, ed. R. W. B. Lewis and Nancy Lewis (New York: Charles Scribner's Sons, 1988), 59.

207 "THE BEST DICKENS"
Letter to Dom Bede Griffiths, November 5, 1954, in The Collected Letters of C. S. Lewis, ed. Walter Hooper, vol. 3, Narnia, Cambridge and Joy, 1950–1963 (New York: HarperCollins, 2007), 522.

207 "A POEM BY"
Diary entry, n.d., in Etty: The Letters and Diaries of Etty Hillesum, 1941–1943, ed. Klaas A. D. Smelik, trans. Arnold J. Pomerans (Grand Rapids, MI: William B. Eerdmans, 2002), 86.

207 "YEATS'S AUTOBIOGRAPHY"
Journal entry, March 16, 1941, in Alfred Kazin's Journals, ed. Richard M. Cook (New Haven, CT: Yale University Press, 2011), 23.

208 "IF I HAD TO"
"Politics vs. Literature: An Examination of Gulliver's Travels" (1946), in The Collected Essays, Journalism and Letters of George Orwell, ed. Sonia Orwell and Ian Angus, vol. 4, In Front of Your Nose: 1945–1950 (London: Secker and Warburg, 1968), 220.

208 "EVERY YOUNG AUTHOR"
Letter to Max Perkins, September 18, 1919, in Dear Scott/Dear Max: The Fitzgerald–Perkins Correspondence, ed. John Kuehl and Jackson R. Bryer (New York: Charles Scribner's Sons, 1971), 22.

208 "I AM READING MOBY DICK"
Letter to Lady Ottoline Morrell, February 7, 1916, in The Letters of D. H. Lawrence, ed. Aldous Huxley (London: William Heinemann, 1932), 318.

208 "I HOPE YOU DON'T"
Letter to Maryat Lee, May 24, 1960, in The Habit of Being: The Letters of Flannery O'Connor, ed. Sally Fitzgerald (New York: Farrar, Straus and Giroux, 1979), 398.

208 "I SAT"
"On Rapture," in I Feel Bad About My Neck and Other Thoughts on Being a Woman (New York: Vintage, 2008), 119.

208 "I AM ALTERNATELY"
Letter to Osso Basler, August 2, 1953, in Letters of Thomas Mann: 1889–1955, ed. and trans. Richard and Clara Winston (New York: Alfred A. Knopf, 1971), 657.

208 "I AM READING ANOTHER"
Letter to Frank Thompson, November 12, 1943, in Living on Paper: Letters from Iris Murdoch, 1934–1995, ed. Avril Horner and Anne Rowe (Princeton, NJ: Princeton University Press, 2016), 36.

209 "I DON'T LIKE"
Letter to Lady Ottoline Morrell, January 3, 1929, in Aldous Huxley: Selected Letters, ed. James Sexton (Chicago: Ivan R. Dee, 2007), 214.

209 "I BELIEVE"
"The Art of Fiction No. 195," interview by Sarah Fay, Paris Review, no. 183 (Winter 2007): https://www.theparisreview.org/interviews/5816/kenzaburo-oe-the-art-of-fiction-no-195-kenzaburo-oe.

REJECTION

210 "NOBODY SEEMS"
Quoted in Brian St. Pierre, John Steinbeck: The California Years (San Francisco: Chronicle Books, 1983), 45.

211 "A PORTRAIT OF"
Letter to James B. Pinker, July 8, 1917, in Letters of James Joyce, ed. Richard Ellmann, vol. 2 (New York: Viking, 1966), 399.

211 "I HAVE SEVERAL"
Barnaby Conrad and Monte Schulz, eds., Snoopy's Guide to the Writing Life (Cincinnati, OH: Writer's Digest Books, 2002), 162.

212 "THE PLAY"
Letter to Mikhail Chekhov, October 18, 1896, in The Selected Letters of Anton Chekhov, ed. Lillian Hellman, trans. Sidonie Lederer (New York: Farrar, Straus, 1955), 193.

212 "IF AND WHEN"
Barbara Bauer and Robert F. Moss, "Feeling Rejected? Join John Updike, Mailer, Oates…," New York Times, July 21, 1985, http://www.nytimes.com/1985/07/21/books/feeling-rejected-join-updike-mailer-oates.html.

212 "I REMEMBER"
Interview by Charles Ruas and Bill Lentch, WBAI-FM New York, 1975.

212 "MY BOOK WATT"
Letter to Gwynedd and George Reavey, June 21, 1945, in The Letters of Samuel Beckett, ed. George Craig et al., vol. 2, 1941–1956 (Cambridge: Cambridge University Press, 2011), 16.

212 "OF COURSE HENRY"
Journal entry, October 6, 1959, in The Journals of Sylvia Plath, ed. Ted Hughes and Frances McCullough (New York: Anchor Books, 1998), 320.

212 "REJECTIONS ARE"
Barbara Bauer and Robert F. Moss, "Feeling Rejected? Join John Updike, Mailer, Oates…," New York Times, July 21, 1985, http://www.nytimes.com/1985/07/21/books/feeling-rejected-join-updike-mailer-oates.html.

213 "DEVELOPING"
Twitter, September 9, 2010, 9:22 a.m., http://twitter.com/alaindebotton.

RESEARCH

214 "TAKE NOTHING"
Something of Myself: For My Friends Known and Unknown (Garden City, NY: Doubleday, Doran, 1937), 235.

215 "IF YOU PUT"
Interview by Ed Finn, Slate, February 6, 2015, http://www.slate.com/articles/technology/future_tense/2015/02/margaret_atwood_interview_the_author_speaks_on_hope_science_and_the_future.html.

215 "THE WRONG"
"How to Be a Writer: 10 Tips from Rebecca Solnit," Literary Hub, September 13, 2016, http://lithub.com/how-to-be-a-writer-10-tips-from-rebecca-solnit/.

216 "I START"
Interview by Felicity Librie, Fiction Writers Review, January 6, 2011, http://fictionwritersreview.com/interview/many-voices-an-interview-with-tracy-chevalier/.

216 "THE BEST"
"Kahlo, Trotsky and Kingsolver," interview by Cynthia Crossen, Wall Street Journal, October 30, 2009, https://www.wsj.com/articles/SB10001424052748704335904574497491708178938.

216 "THERE IS NO"
A Writer's Notebook (Westport, CT: Greenwood, 1970), 324.

216 "THINGS GET"
"The Art of Fiction No. 226," interview by Mona Simpson, Paris Review, no. 212 (Spring 2015): https://www.theparisreview.org/interviews/6360/hilary-mantel-art-of-fiction-no-226-hilary-mantel.

216 "WHEN YOU WRITE"
Bill Katovsky, "David Foster Wallace: A Profile," Arrival, April 1987, reprinted at McSweeney's, November 7, 2008, https://www.mcsweeneys.net/articles/david-foster-wallace-a-profile.

217 "YOU CAN'T TELL"
"Two Kinds of Aboutness," interview by Adam Vitcavage, Millions, November 22, 2016, http://www.themillions.com/2016/11/two-kinds-aboutness-millions-interviews-michael-chabon.html.

ROUTINE

218 "ROUTINE IS"
Letter to "A," February 10, 1962, in The Habit of Being: The Letters of Flannery O'Connor, ed. Sally Fitzgerald (New York: Farrar, Straus and Giroux, 1979), 465.

219 "WHEN I SIT"
"Peace! It's Wonderful!," in Henry Miller on Writing (New York: New Directions, 1964), 96.

220 "I SHARPEN"
Elaine Steinbeck and Robert Wallstein, eds., Steinbeck: A Life in Letters (New York: Viking, 1975), preface, viii.

220 "FOR THE PAST"
Interview by Noah Charney, Daily Beast, February 6, 2013, http://www.thedailybeast.com/karen-russell-how-i-write.

220 "I HAVEN'T MADE"
Interview by Paula Vogel, BOMB, no. 99 (Spring 2007): http://bombmagazine.org/article/2902/sarah-ruhl.

220 "I GET UP"
Letter to Ivan Turgenev, October 3, 1875, in Letters of Gustave Flaubert, ed. Richard Rumbold, trans. J. M. Cohen (London: George Weidenfeld and Nicolson, 1950), 196.

220 "THERE WERE TIMES"
Interview by Maria Shriver, O: The Oprah Magazine, March 9, 2011, http://www.oprah.com/entertainment/Maria-Shriver-Interviews-Poet-Mary-Oliver/2.

221 "I SIT DOWN"
Letter to Ronald Lane Latimer, January 8, 1935, in Letters of Wallace Stevens, ed. Holly Stevens (New York: Alfred A. Knopf, 1966), 273.

221 "THE BEST TIME"
Meredith Maran, ed., Why We Write (New York: Plume, 2013), 110.

SELF-DOUBT

222 "THE WHOLE"
Letter to Mikhail Dostoevsky, February 9, 1864, in Fyodor Dostoevsky: Complete Letters, ed. and trans. David A. Lowe, vol. 2, 1860–1867 (Ann Arbor, MI: Ardis, 1989), 88.

223 "I'M SENDING"
Letter to Bernard Berenson, November 23, 1912, in The Letters of Edith Wharton, ed. R. W. B. Lewis and Nancy Lewis (New York: Charles Scribner's Sons, 1988), 284.

223 "FEEL TERRIBLE"
Letter to Norah Smallwood, December 27, 1958, in Living on Paper: Letters from Iris Murdoch, 1934–1995, ed. Avril Horner and Anne Rowe (Princeton, NJ: Princeton University Press, 2016), 192.

223 "THIS IS A TERRIBLE"
Letter to Stanislaus Joyce, April 4, 1905, in Letters of James Joyce, ed. Richard Ellmann, vol. 2 (New York: Viking, 1966), 87.

223 "I HARDLY"
Letter to Mavis McIntosh, February 4, 1935, in John Steinbeck: A Documentary Volume, ed. Luchen Li, Dictionary of Literary Biography, vol. 309 (Farmington Hills, MI: Thomson Gale, 2005), 59.

223 "I SUFFER"
"The Art of Fiction No. 23," interview by Julian Mitchell and Gene Andrewski, Paris Review, no. 22 (Autumn–Winter 1959–60): https://www.theparisreview.org/interviews/4720/lawrence-durrell-the-art-of-fiction-no-23-lawrence-durrell.

223 "ON GETTING"
Diary entry, February 9, 1923, in Letters of C. S. Lewis, ed. W. H. Lewis (New York: Harcourt, Brace and World, 1966), 86.

223 "I HOPE"
Letter to Harvey Swados, September 28, 1961, in Saul Bellow: Letters, ed. Benjamin Taylor (New York: Viking, 2010), 229.

224 "LIKE MY HERO"
Emma Brockes, "A Life in Writing," Guardian, February 7, 2011, https://www.theguardian.com/culture/2011/feb/07/michael-cunningham-life-writing.

224 "AT EVERY TURN"
"The Art of Fiction No. 202," interview by Sarah Fay, Paris Review, no. 191 (Winter 2009): https://www.theparisreview.org/interviews/5991/ha-jin-the-art-of-fiction-no-202-ha-jin.

224 "I DON'T THINK"
"Original Mythology," interview by Richard Burgin (1968), in Jorge Luis Borges: The Last Interview and Other Conversations (Brooklyn: Melville House, 2013), 91.

225 "WONDER IF"
Journal entry, July 1858, in Louisa May Alcott: Her Life, Letters, and Journals, ed. Ednah D. Cheney (Boston: Roberts Brothers, 1889), 95.

225 "I'M SCARED"
"Adventures in the Skin Trade: Colum McCann and Michael Ondaatje in Conversation," PEN World Voices Festival, May 4, 2008.

226 "WHEN I WRITE"
Charles Ruas, Conversations with American Writers (New York: Alfred A. Knopf, 1985), 187.

227 "THE WORST"
Letter to unknown recipient, June–July 1953, in The Unabridged Journals of Sylvia Plath: 1950–1962, ed. Karen V. Kukil (New York: Anchor Books, 2000), 545.

SENTENCE

228 "I CONSIDER"
"By the Book," New York Times Book Review, January 3, 2013, http://www.nytimes.com/2013/01/06/books/review/francine-prose-by-the-book.html.

229 "YOU WANT"
"The Art of Fiction No. 78," interview by Jordan Elgrably, Paris Review, no. 91 (Spring 1984): https://www.theparisreview.org/interviews/2994/james-baldwin-the-art-of-fiction-no-78-james-baldwin.

230 "THE SINGLE-SENTENCE"
On Writing: A Memoir of the Craft (New York: Pocket Books, 2002), 128.

230 "THE SENTENCES"
"Untelling the Hour," interview by Richard Jackson (1979), in Richard Jackson, Acts of Mind: Conversations with Contemporary Poets (Tuscaloosa: University of Alabama Press, 1983), 15.

230 "I CAN HANG ON"
Interview by Scott Simon, Weekend Edition Saturday, NPR, March 18, 2013, http://www.npr.org/2013/03/30/175605206/life-after-life-the-many-deaths-and-do-overs-of-ursula-todd.

230 "A SINGLE"
"The Art of Fiction No. 199," interview by Christopher Cox, Paris Review, no. 188 (Spring 2009): https://www.theparisreview.org/interviews/5901/annie-proulx-the-art-of-fiction-no-199-annie-proulx.

230 "THERE ARE TIMES"
Interview by Carolyn Kellogg, Jacket Copy (blog), Los Angeles Times, January 26, 2010, http://latimesblogs.latimes.com/jacketcopy/2010/01/elizabeth-gilbert-part-2.html.

230 "A SENTENCE"
The Writings of Henry David Thoreau, vol. 1, A Week on the Concord and Merrimack Rivers (Boston: Houghton, Mifflin, 1894), 136.

231 "THE SENTENCE IS"
"The Art of Fiction No. 200," interview by Belinda McKeon, Paris Review, no. 200 (Spring 2009): https://www.theparisreview.org/interviews/5907/john-banville-the-art-of-fiction-no-200-john-banville.

231 "THAT'S MY ONLY"
Interview by Kay Bonetti, Missouri Review 8, no. 3 (1985): 86.

SEX

232 "GREAT SEX IS"
"A Forbidden Territory Familiar to All," in Writers on Writing: Collected Essays from the New York Times (New York: Times Books, 2002), 135.

233 "WHEN YOU'RE NOT"
"By the Book," New York Times Book Review, September 16, 2012, http://www.nytimes.com/2012/09/16/books/review/nicholson-baker-by-the-book.html.

234 "WHEN I WAS"
"By the Book," New York Times Book Review, April 4, 2013, http://www.nytimes.com/2013/04/07/books/review/isabel-allende-by-the-book.html.

234 "I WAS VERY"
Interview by Walter Sutton, Minnesota Review 1, no. 3 (April 1961), reprinted in Interviews with William Carlos Williams: "Speaking Straight Ahead," ed. Linda Welshimer Wagner (New York: New Directions, 1976), 55.

234 "I AM VERY INCOMPETENTLY"
Letter to Georg Kreisel, late October 1967, in Living on Paper: Letters from Iris Murdoch, 1934–1995, ed. Avril Horner and Anne Rowe (Princeton, NJ: Princeton University Press, 2016), 347.

234 "YOU CAN TELL"
"This Much I Know," Guardian, December 10, 2016, https://www.theguardian.com/lifeandstyle/2016/dec/10/slavoj-zizek-we-are-all-basically-evil-egotistical-disgusting.

234 "READING A BOOK"
"Books in Bed," in How to Be Alone: Essays (New York: Farrar, Straus and Giroux, 2002), 246.

234 "THE ONLY PERSON"
"A Visit with Joan Didion," interview by Sara Davidson, New York Times, April 3, 1977, sec. 7, 38.

235 "I WOULDN'T"
Frank Gado, ed., First Person: Conversations on Writers and Writing (Schenectady, NY: Union College Press, 1973), 100.

235 "ABSTRACTLY"
Twitter, January 27, 2010, 2:22 p.m., http://twitter.com/alaindebotton.

STORY

236 "THERE IS NO"
Dust Tracks on a Road (New York: HarperPerennial, 1996), 176.

237 "WHEN ANYBODY"
"Writing Short Stories," in Mystery and Manners: Occasional Prose, ed. Sally and Robert Fitzgerald (New York: Farrar, Straus and Giroux, 1970), 96.

238 "I NEVER FEEL"
Interview by Diane Thiel, Crossroads: The Journal of the Poetry Society of America, no. 61 (Spring 2004), reprinted in Conversations with Sherman Alexie, ed. Nancy J. Peterson (Jackson: University Press of Mississippi, 2009), 152.

239 "WHEN YOU FEEL"
Interview by Aishwarya Subramanyam, Elle India, July 1, 2016, http://elle.in/magazine/arundhati-roy-you-know-her-politics-you-know-her-fiction/.

239 "THE SHORT STORY"
Interview by Kima Jones, Rumpus, January 1, 2014, http://therumpus.net/2014/01/the-rumpus-interview-with-edwidge-danticat/.

239 "WITH A SHORT STORY"
Interview by Liz Hoggard, Guardian, March 30, 2014, https://www.theguardian.com/books/2014/mar/30/yiyun-li-my-generation-kinder-than-solitude-tiananmen-square.

239 "BEFORE I WROTE"
One Writer's Beginnings (Cambridge, MA: Harvard University Press, 1984), 14.

239 "ONCE WE HEAR"
Catherine Burns, ed., All These Wonders: True Stories About Facing the Unknown (New York: Crown Archetype, 2017), foreword, xiii.

240 "THROUGH STORY"
"The Operating Instructions" (2002), in Words Are My Matter (Easthampton, MA: Small Beer, 2016), 4.

240 "I THINK THERE"
Interview by Lauren O'Neal, Rumpus, April 4, 2013, http://therumpus.net/2013/04/the-rumpus-interview-with-karen-russell/.

240 "I AM A"
On the Move: A Life (New York: Vintage Books, 2016), 384.

241 "A STORY SHOULD"
Journal entry, June 27, 1973, in As Consciousness Is Harnessed to Flesh: Journals and Notebooks, 1964–1980, ed. David Rieff (New York: Farrar, Straus and Giroux, 2012), 359.

SUBJECT

242 "ONE DOES NOT"
Letter to Madame Roger des Genettes, ca. 1861, in Letters of Gustave Flaubert, ed. Richard Rumbold, trans. J. M. Cohen (London: George Weidenfeld and Nicolson, 1950), 135.

243 "I DISCOVERED"
"The Art of Fiction No. 12," interview by Jean Stein, Paris Review, no. 12 (Spring 1956): https://www.theparisreview.org/interviews/4954/william-faulkner-the-art-of-fiction-no-12-william-faulkner.

243 "THE LARGER"
"The Old Magician at Home," interview by Israel Shenker, New York Times Book Review, January 9, 1972, http://www.nytimes.com/books/97/03/02/lifetimes/nab-v-magician.html.

243 "MAKE THE FAMILIAR"
William Grimes, "Bharati Mukherjee, Writer of Immigrant Life, Dies at 76," New York Times, February 1, 2017, https://www.nytimes.com/2017/02/01/books/bharati-mukherjee-dead-author-jasmine.html.

243 "I WRITE ABOUT"
Diary entry, November 1934, in The Diary of Anaïs Nin, ed. Gunther Stuhlmann, vol. 1, 1931–1934 (New York: Swallow, 1994), 359.

243 "PEOPLE LOVE"
On Writing: A Memoir of the Craft (New York: Pocket Books, 2002), 157.

243 "I KEEP WRITING"
"The Unwritten Biography," interview by Edward Hirsch, Poets.org, August 29, 2001, https://www.poets.org/poetsorg/text/unwritten-biography-philip-levine-and-edward-hirsch-conversation.

244 "MY JOB"
"Lydia Davis," interview by Francine Prose, BOMB, no. 60 (Summer 1997): http://bombmagazine.org/article/2086/lydia-davis.

244 "I HAVE"
"Adventures in the Skin Trade: Colum McCann and Michael Ondaatje in Conversation," PEN World Voices Festival, New York Public Library, May 4, 2008, transcript, http://colummccann.com/interviews/pen-conversation-with-michael-ondaatje/.

244 "IN DESCRIBING"
Interview by Bill Buford, Granta, no. 21 (Spring 1987), reprinted at author's website, http://kapuscinski.info/an-interview-by-bill-buford.html.

244 "I'M AFRAID"
Interview by Francine Prose, BOMB, no. 60 (Summer 1997): http://bombmagazine.org/article/2086/lydia-davis.

244 "I'VE ALWAYS BEEN"
Interview by Mary Laura Philpott, August 29, 2016, Literary Hub, http://lithub.com/ann-patchett-on-stealing-stories-book-tours-and-staying-off-twitter/.

244 "MY GOAL"
Jan Dalley, "Life after 'Nemesis,'" Financial Times, June 24, 2011, https://www.ft.com/content/bcfc4554-9d87-11e0-9a70-00144feabdc0.

245 "WE NEVER KNOW"
Interview by Alex Clark, Guardian, January 10, 2011, https://www.theguardian.com/culture/2011/jan/10/jane-gardam-life-writing.

SUCCESS

246 "DON'T CONFUSE"
"Ten Rules for Writing Fiction: Part 2," Guardian, February 19, 2010, https://www.theguardian.com/books/2010/feb/20/10-rules-for-writing-fiction-part-two.

247 "I NEVER WANTED"
"Reflections of a Maverick," interview by Julius Lester, New York Times Book Review, May 27, 1984, http://www.nytimes.com/books/98/03/29/specials/baldwin-reflections.html.

247 "I NEVER DO"
Interview by David Barsamian, Progressive, July 16, 2007, http://progressive.org/magazine/interview-arundhati-roy/.

248 "LOOK AT ME"
Charles Ruas, Conversations with American Writers (New York: Alfred A. Knopf, 1985), 39.

248 "I WROTE"
Interview by Linda Richards, January Magazine, November 2000, https://www.januarymagazine.com/profiles/atwood.html.

249 "PEOPLE ASSOCIATE"
Charles Ruas, Conversations with American Writers (New York: Alfred A. Knopf, 1985), 85.

250 "THE PULITZER"
"People of the Book: Interview," author's website, June 28, 2015, http://geraldinebrooks.com/people-of-the-book-interview/.

250 "IT'S AMAZING"
Letter to Christopher Isherwood, July 4, 1937, in Selected Letters of E. M. Forster, ed. Mary Lago and P. N. Furbank, vol. 2, 1921–1970 (Cambridge, MA: Belknap, 1985), 152.

250 "EVERYBODY LOOKS"
Letter to Michael Dostoevsky, November 16, 1845, in Letters of Fyodor Michailovitch Dostoevsky to His Family and Friends, trans. Ethel Colburn Mayne, 2nd ed. (New York: Macmillan, 1917), 28–29.

250 "THE UTMOST"
Letter to Maxime Du Camp, June 26, 1852, in Letters of Gustave Flaubert, ed. Richard Rumbold, trans. J. M. Cohen (London: George Weidenfeld and Nicolson, 1950), 67.

250 "NO ONE"
Interview by Kay Bonetti, Missouri Review 8, no. 3 (1985): 85.

251 "WHEN PEOPLE WRITE"
Interview by Libby Brooks, Guardian, April 17, 2015, https://www.theguardian.com/books/2015/apr/17/irvine-welsh-interview-a-decent-ride.

251 "WHILE I AM"
Letter to Irita Van Doren, August 28, 1951, in Letters of Thomas Mann: 1889–1955, ed. and trans. Richard and Clara Winston (New York: Alfred A. Knopf, 1971), 629.

251 "REPORTERS SIT"
Journal entry, August 1872, in Louisa May Alcott: Her Life, Letters, and Journals, ed. Ednah D. Cheney (Boston: Roberts Brothers, 1889), 266.

251 "ALONG WITH"
Interview by Sam Merrill, Playboy, June 1975, reprinted in Conversations with Joseph Heller, ed. Adam J. Sorkin (Jackson: University Press of Mississippi, 1993), 164.

TECHNOLOGY

252 "I'M CERTAINLY"
"The Art of Fiction No. 85," interview by Thomas Frick, Paris Review, no. 94 (Winter 1984): https://www.theparisreview.org/interviews/2929/j-g-ballard-the-art-of-fiction-no-85-j-g-ballard.

253 "TECHNOLOGY IS"
"Considering the Alternative," in I Feel Bad About My Neck and Other Thoughts on Being a Woman (New York: Vintage, 2008), 130.

253 "I AM A"
"The Art of Fiction No. 139,"
interview by Jerome Brooks, Paris Review,
no. 133 (Winter 1994): https://
www.theparisreview.org/interviews/
1720/chinua-achebe-the-art-of-fiction-
no-139-chinua-achebe.

254 "I AM NOT"
Interview by Chris Wallace,
Interview, November 2, 2015,
http://www.interviewmagazine.com/
culture/umberto-eco.

255 "THE ONLY"
"Ten Rules for Writing Fiction: Part 1,"
Guardian, February 19, 2010, https://
www.theguardian.com/books/2010/feb/20/
ten-rules-for-writing-fiction-part-one.

255 "I DON'T KNOW"
"The Art of Fiction No. 35," interview
by Madeleine Gobeil, Paris Review, no. 34
(Spring–Summer 1965): https://www.
theparisreview.org/interviews/4444/
simone-de-beauvoir-the-art-of-fiction-
no-35-simone-de-beauvoir.

255 "I HAVE AN OLD"
Interview by Jacqueline Jones Lamon,
Mosaic, no. 17 (January 2007): https://
mosaicmagazine.org/lucille-clifton-interview.

255 "I DON'T HAVE"
Interview by Isaac Chotiner, Slate,
November 16, 2016, http://www.slate.com/
articles/arts/books/2016/11/a_
conversation_with_zadie_smith_about_
cultural_appropriation_male_critics.html.

255 "IMAGINE"
Letter to Hedwig Buller,
December 24, 1924, in Letters of Thomas
Mann: 1889–1955, ed. and trans.
Richard and Clara Winston (New York:
Alfred A. Knopf, 1971), 130.

256 "AUDIOBOOKS"
"By the Book," New York Times Book Review,
October 13, 2013, http://www.nytimes.
com/2013/10/13/books/review/scott-
turow-by-the-book.html.

257 "NOVELS THAT"
A Man without a Country (New York:
Seven Stories, 2005), 17.

TITLE

258 "I DON'T WANT"
Letter to Francesco Leonetti,
February 19, 1957, in Italo Calvino: Letters,
1941–1985, ed. Michael Wood, trans.
Martin McLaughlin (Princeton, NJ:
Princeton University Press, 2013), 127.

259 "I DON'T FUCK"
"Zadie, Take Three," interview by
Jessica Murphy Moo, Atlantic, October 2005,
https://www.theatlantic.com/magazine/
archive/2005/10/zadie-take-three/304294/.

260 "MOST OF"
Interview by Scholastic students, n.d.,
https://www.scholastic.com/teachers/
articles/teaching-content/judy-blume-
interview-transcript/.

260 "I HAVE AN"
Letter to Max Perkins, October 27, 1924,
in Dear Scott/Dear Max: The Fitzgerald–
Perkins Correspondence, ed. John Kuehl and
Jackson R. Bryer (New York: Charles Scribner's
Sons, 1971), 81.

260 "DICKENS KNEW"
"Ten Rules for Writing Fiction: Part 1,"
Guardian, February 19, 2010, https://
www.theguardian.com/books/2010/feb/20/
ten-rules-for-writing-fiction-part-one.

260 "THE HANDMAID'S TALE"
"The Art of Fiction No. 121," interview by
Mary Morris, Paris Review, no. 117 (Winter
1990): https://www.theparisreview.org/
interviews/2262/margaret-atwood-the-art-
of-fiction-no-121-margaret-atwood.

260 "WE HAVE A TITLE"
Letter to Mr. and Mrs. Louis Paul, September
1938, in Steinbeck: A Life in Letters, ed.
Elaine Steinbeck and Robert Wallsten
(New York: Viking, 1975), 170.

260 "THINKING ABOUT"
Letter to Martin Secker, May 24, 1920,
in The Letters of D. H. Lawrence, ed.
Aldous Huxley (London: William Heinemann,
1932), 507.

260 "STILL NO"
Letter to Carl Brandt, November 29, 1986,
in The Selected Letters of Wallace Stegner, ed.
Page Stegner (Berkeley: Shoemaker and Hoard,
2007), 133.

261 "EVERY ONE"
"The Art of Fiction No. 81," interview
by Christian Salmon, Paris Review, no. 92
(Summer 1984): https://www.theparisreview.
org/interviews/2977/milan-kundera-the-art-
of-fiction-no-81-milan-kundera.

261 "CLAUDE IS"
Letter to Alfred A. Knopf, August 26, 1921,
in The Selected Letters of Willa Cather, ed.
Andrew Jewell and Janis Stout
(New York: Alfred A. Knopf, 2013), 303.

262 "I HAVE A FILE"
Interview by Carrie Brownstein,
Interview, January 21, 2014,
http:// www.interviewmagazine.com/
culture/miranda-july-1/.

262 "I ANSWERED"
Charles Ruas, Conversations with American
Writers (New York: Alfred A. Knopf, 1985), 20.

262 "NOT 'TRILOGY'"
Letter to John Calder, January 6, 1959,
in The Letters of Samuel Beckett, ed.
George Craig et al., vol. 3, 1957–1965
(Cambridge: Cambridge University Press,
2014), 191.

263 "AS USUAL"
Letter to Cecil Dawkins, October 9, 1958, in
The Habit of Being: The Letters of Flannery
O'Connor, ed. Sally Fitzgerald (New York:
Farrar, Straus and Giroux, 1979), 298.

263 "ALTHOUGH"
Waiting for the Barbarians: Essays from the
Classics to Pop Culture (New York: New York
Review of Books, 2012), foreword, ix.

263 "IN MY COUNTRY"
Interview by Rachel Donadio,
New York Times, December 9, 2014,
https://www.nytimes.com/2014/12/
10/books/writing-has-always-been-a-
great-struggle-for-me.html.

264 "I HAVE PECULIAR"
Letter to Hamish Hamilton, October 6, 1946,
in Selected Letters of Raymond Chandler,
ed. Frank MacShane (New York: Columbia
University Press, 1981), 80.

265 "THE TITLES"
Interview by Robert Birnbaum, Identity
Theory, October 27, 2005, http://www.
identitytheory.com/ adam-nicolson/.

TOOLS

266 "WEARING DOWN"
"The Art of Fiction No. 21," interview by
George Plimpton, Paris Review, no. 18 (Spring
1958): https://www.theparisreview.org/
interviews/4825/ernest-hemingway-the-art-
of-fiction-no-21-ernest-hemingway.

267 "MY PEN"
"Putting Pen to Paper, but Not Just Any Pen or
Just Any Paper," New York Times, July 5, 1999,
http://www.nytimes.com/1999/07/05/
books/putting-pen-to-paper-but-not-just-any-
pen-or-just-any-paper.html.

267 "I ALWAYS WRITE"
Dan Crowe and Philip Oltermann, eds.,
How I Write: The Secret Lives of Authors
(New York: Rizzoli, 2007), 117.

267 "MY SCHEDULE"
Interview by Herbert Gold, Paris Review,
no. 41 (Summer–Fall 1967): https://www.
theparisreview.org/interviews/4310/
vladimir-nabokov-the-art-of-fiction-no-40-
vladimir-nabokov.

268 "DON'T BE"
Meredith Maran, ed., Why We Write
(New York: Plume, 2013), 182.

269 "DO KEEP"
"Ten Rules for Writing Fiction: Part 1,"
Guardian, February 19, 2010, https://www.
theguardian.com/books/2010/feb/20/ten-
rules-for-writing-fiction-part-one.

270 "WHEN I SIT"
"My Vocation," in The Little Virtues, trans.
Dick Davis (New York: Seaver Books, 1962), 53.

270 "MELODRAMA"
"The Art of Fiction No. 3," interview by
Simon Raven and Martin Shuttleworth, Paris
Review, no. 3 (Autumn 1953): https://www.
theparisreview.org/interviews/5180/graham-
greene-the-art-of-fiction-no-3-graham-greene.

271 "THE TOOLS"
"The Art of Fiction No. 12," interview by
Jean Stein, Paris Review, no. 12 (Spring
1956): https://www.theparisreview.org/
interviews/4954/william-faulkner-the-art-of-
fiction-no-12-william-faulkner.

272 "MY FIRST"
Slouching towards Bethlehem (New York:
Farrar, Straus and Giroux, 2008), 133.

272 "ALWAYS CARRY"
"Ten Rules for Writing Fiction: Part 2,"
Guardian, February 19, 2010, https://www.
theguardian.com/books/2010/feb/20/
10-rules-for-writing-fiction-part-two.

272 "I WILL WRITE"
Shelby Grantham, "Intimate Collaboration
or 'A Novel Partnership,'" reprinted
in Conversations with Louise Erdrich and
Michael Dorris, ed. Allan Chavkin and
Nancy Feyl Chavkin (Jackson: University
Press of Mississippi, 1994), 10.

273 "MY IDEA"
"Where Do You Get Your Ideas," author's
website, n.d., http://www.neilgaiman.com/
Cool_Stuff/Essays/Essays_By_Neil/Where_
do_you_get_your_ideas%3F.

273 "THE WHITE PAGE"
"The Artist as Musician," in A Woman Speaks:
The Lectures, Seminars, and Interviews
of Anaïs Nin, ed. Evelyn J. Hinz (Chicago:
Swallow, 1975), 219.

TRUTH

274 "TRUTH IS TO BE"
"The Art of Fiction No. 118," interview by
James R. Hepworth, Paris Review, 68
(Summer 1990): https://www.theparisreview.
org/interviews/2314/wallace-stegner-the-
art-of-fiction-no-118-wallace-stegner.

275 "THE TRUTH IS"
Interview by Kay Bonetti, Missouri Review 15,
no. 2 (1992): 126.

275 "PAGE AFTER PAGE"
"Elena Ferrante Explains Why, for the
Last Time, You Don't Need to Know Her Name,"
interview by Elissa Schappell, Vanity Fair,
August 28, 2015, http://www.vanityfair.com/
culture/2015/08/elena-ferrante-interview-
the-story-of-the-lost-child-part-two.

276 "I THINK I TELL"
"The Art of Fiction No. 165," interview by
Shusha Guppy, Paris Review, no. 157 (Winter
2000): https://www.theparisreview.org/
interviews/562/julian-barnes-the-art-of-
fiction-no-165-julian-barnes.

276 "I WANT TO WRITE"
Interview by Belinda Luscombe, Time,
April 8, 2013, http://time.com/123087/
10-questions-with-maya-angelou/.

277 "I DON'T FEEL"
Interview by Poets.org, September 15, 2009,
https://www.poets.org/poetsorg/text/
claudia-rankine-conversation.

278 "I DON'T CARE"
Interview by Hilary Holladay, April 11, 1998,
in Hilary Holladay, Wild Blessings: The Poetry
of Lucille Clifton (Baton Rouge: Louisiana
State University Press, 2012), 187.

279 "FACTS ARE"
Interview by Alison Beard, Harvard Business
Review, September 2015, https://hbr.org/
2015/09/lifes-work-salman-rushdie.

WORDS

280 "THE WORDS"
Interview by Ben Pfeiffer, Rumpus, November
26, 2014, http://therumpus.net/2014/11/
the-rumpus-interview-with-richard-ford/.

281 "WORDS ARE"
"Surgeons and the Soul," address at the
Royal College of Surgeons annual dinner,
February 1923, reprinted in A Book of Words
(New York: Charles Scribner's Sons, 1928), 237.

282 "EVERY WORD"
"A Sacred Magic Can Elevate the Secular
Storyteller," in Writers on Writing:
Collected Essays from the New York Times
(New York: Times Books, 2002), 262.

282 "OTHER PEOPLE'S"
"That Crafty Feeling," in Changing My Mind:
Occasional Essays (New York:
Penguin, 2010), 102.

283 "INTERESTING VERBS"
"Ten Rules for Writing Fiction: Part 1,"
Guardian, February 19, 2010, https://
www.theguardian.com/books/2010/feb/
20/ten-rules-for-writing-fiction-part-one.

283 "WHY USE"
Interview by Jessica Draper, Studio
International, June 19, 2016, http://www.
studiointernational.com/index.php/harland-
miller-interview-tonight-we-make-history.

283 "INCOMPETENCE"
ABC of Reading (New York: New Directions,
1960), 63.

283 "THE INUIT"
"The Art of Fiction No. 121," interview by
Mary Morris, Paris Review, no. 117 (Winter
1990): https://www.theparisreview.org/
interviews/2262/margaret-atwood-the-art-
of-fiction-no-121-margaret-atwood.

283 "I'VE ALWAYS SENSED"
Interview by Penguin.com, author's website,
n.d., http://www.carol-shields.com/
larryspartyinterview.pdf.

283 "THE MUSIC"
Interview by Kate Waldman, Paris Review blog,
March 2, 2011, https://www.theparisreview.
org/blog/2011/03/02/adrienne-rich-on-
'tonight-no-poetry-will-serve'/.

283 "WHENEVER I READ"
The Difficulty of Being, trans. Elizabeth Sprigge
(New York: Coward-McCann, 1967), 116.

283 "IMPOVERISHED"
"The Art of Editing No. 1," interview by
Larissa MacFarquhar, Paris Review, no. 132
(Fall 1994): http://www.theparisreview.org/
interviews/1760/robert-gottlieb-the-art-of-
editing-no-1-robert-gottlieb.

284 "IF I COULD STRIKE"
"President Obama and Marilynne Robinson:
A Conversation—II," New York Review of Books,
November 19, 2015, http://www.nybooks.com/
articles/2015/11/19/president-obama-
marilynne-robinson-conversation-2/.

284 "THE WORD 'CREATIVE'"
"The Art of Poetry No. 27," interview
by Elizabeth Spires, Paris Review, no. 80
(Summer 1981): https://www.theparisreview.
org/interviews/3229/elizabeth-bishop-
the-art-of-poetry-no-27-elizabeth-bishop.

285 "SUMMER"
Edith Wharton, A Backward Glance
(New York: D. Appleton-Century, 1934), 249.

286 "SURELY"
"My Life's Sentences," Opinionator
(blog), New York Times, March 17, 2012,
https://opinionator.blogs.nytimes.
com/2012/03/17/my-lifes-sentences.

286 "A WRITER LIVES"
"In Awe of Words," Exonian, March 3, 1954,
quoted in "The Art of Fiction No. 45," interview
by Nathaniel Benchley, Paris Review, no. 48
(Fall 1969): https://www.theparisreview.org/
interviews/3810/john-steinbeck-the-art-of-
fiction-no-45-john-steinbeck.

286 "WORDS, SO"
May 18, 1848, entry, "Passages from
Hawthorne's Note-Books," Atlantic Monthly
18, no. 110 (December 1866), reprinted in
The Atlantic Monthly: A Magazine of
Literature, Science, Art and Politics, vol. 18
(Boston: Ticknor and Fields, 1866), 690.

286 "THE WRITER"
Lucinda Moore, "Growing Up Maya Angelou,"
Smithsonian Magazine, April 2003, http://
www.smithsonianmag.com/arts-culture/
growing-up-maya-angelou-79582387/.

286 "DO NOT DRESS"
The Elements of Style, illustrated ed.
(New York: Penguin, 2005), 111.

287 "DON'T SAY"
Letter to a child in America, June 26, 1956,
in Letters of C. S. Lewis, ed. W. H. Lewis
(New York: Harcourt, Brace and World,
1966), 271.

287 "WELL-WISHERS"
Interview by Jane Howard, Life,
November 20, 1964, 68.

287 "THE RIGHT WORD"
"Advice," in Afterthought: Pieces about
Writing (London: Longmans, 1962), 211.

287 "INDIVIDUAL WORDS"
Interview by Claire Schwartz, TriQuarterly,
no. 150 (Summer–Fall 2016): http://www.
triquarterly.org/issues/issue-150/interview-
claudia-rankine.

287 "WORDS HAVE WEIGHT"
The Summing Up (London: William
Heinemann, 1948), 39.

288 "I BELIEVE"
Interview by Geoff Hancock, reprinted in
Conversations with Bharati Mukherjee, ed.
Bradley C. Edwards (Jackson: University Press
of Mississippi, 2009), 19.

289 "LOVE"
William Grimes, "Remembering a Seducer,"
New York Times, October 23, 2014,
https://www.nytimes.com/2014/10/24/
books/a-dylan-thomas-centennial-in-
new-york.html.

WRITER'S BLOCK

290 "YESTERDAY"
Journal entry, April 8, 1914, in
The Diaries of Franz Kafka, ed. Max Brod,
trans. Martin Greenberg, vol. 2, 1914–1923
(New York: Schocken, 1949), 31.

291 "I HAD WRITER'S"
Joan Zyda, "Elizabeth Bishop, Observer of
Poetry," Chicago Tribune, June 4, 1978, sec. 5, 4.

291 "I'VE BEEN"
Interview by Charles Ruas and Bill Lentch,
WBAI-FM New York, 1975.

291 "NEVER STOP"
"Ten Rules for Writing Fiction: Part 2,"
Guardian, February 19, 2010, https://www.
theguardian.com/books/2010/feb/20/10-
rules-for-writing-fiction-part-two.

291 "I FEEL INTUITIVELY"
"Deborah Eisenberg and George Saunders,"
in Upstairs at the Strand, ed. Jessica Strand
and Andrea Aguilar (New York:
W. W. Norton, 2016), 11.

291 "I AM BEGINNING"
Diary entry, May 19, 1935, in Locked
Rooms and Open Doors (New York: Harcourt
Brace Jovanovich, 1974), 276.

292 "ROME"
Letter to Robert Loomis, March 16, 1953,
in Selected Letters of William Styron, ed.
Rose Styron and R. Blakeslee Gilpin
(New York: Random House, 2012), 174.

292 "I ONCE WROTE"
Carlos L. Dews, ed., Illumination and
Night Glare (Madison: University of Wisconsin
Press, 1999), 37.

292 "PEOPLE HAVE"
"The Eye of the Reporter, The Heart of the
Novelist," New York Times, September
23, 2002, http://www.nytimes.
com/2002/09/23/books/writers-on-
writing-the-eye-of-the-reporter-the-heart-of-
the-novelist.html.

292 "BLOCK"
"Draft No. 4," New Yorker,
April 29, 2013, http://www.newyorker.com/
magazine/2013/04/29/draft-no-4.

292 "THERE IS ALL"
"The Deadly Sins/Sloth; Nearer, My Couch,
to Thee," New York Times, June 6, 1993,
http://www.nytimes.com/books/97/05/
18/reviews/pynchon-sloth.html.

292 "WRITER'S BLOCK IS"
"Edward Albee and Paul Auster," in
Upstairs at the Strand, ed. Jessica Strand
and Andrea Aguilar (New York:
W. W. Norton, 2016), 76.

292 "IF YOU GET STUCK"
"Ten Rules for Writing Fiction: Part 2,"
Guardian, February 19, 2010, https://www.
theguardian.com/books/2010/feb/20/10-
rules-for-writing-fiction-part-two.

293 "IT WOULD BE"
Journal entry, July 6, 1919, in
The Counterfeiters: With Journal of the
Counterfeiters, trans. Justin O'Brien
(New York: Vintage Books, 1973), 408–9.

WRITING

294 "GOOD PROSE"
Why I Write (New York: Penguin, 2005), 10.

295 "THE WRITER IS"
Interview by David Barsamian, Progressive,
July 16, 2007, http://progressive.org/
magazine/interview-arundhati-roy/.

295 "THE ONLY END"
"Review of a Free Enquiry into the Nature and
Origin of Evil," in The Works of Samuel Johnson,
vol. 8 (London: Nichols and Son, 1801), 48.

295 "THE WRITER'S ART"
"Show," in If There Were Anywhere but
Desert, trans. Keith Waldrop (Barrytown, NY:
Station Hill, 1988), 27.

295 "THE MOST ESSENTIAL"
"The Art of Fiction No. 21," interview by
George Plimpton, Paris Review, no. 18 (Spring
1958): https://www.theparisreview.org/
interviews/4825/ernest-hemingway-the-art-
of-fiction-no- 21-ernest-hemingway.

295 "IT PUTS ME"
Interview by Charles D'Ambrosio,
BOMB, no. 108 (Summer 2009):
http://bombmagazine.org/article/3305/nam-le.

295 "OUR JOB"
Interview by T. Cole Rachel,
Creative Independent, March 17, 2017,
https://thecreativeindependent.com/
people/hilton-als-on-writing/.

295 "A WRITER IS NOT"
Letter to Madame M. V. Kiselyov, January 14,
1887, in Letters of Anton Chekhov to His
Family and Friends, trans. Constance Garnett
(New York: Macmillan, 1920), 57.

296 "GOOD WRITING"
Charles Ruas, Conversations with American
Writers (New York: Alfred A. Knopf, 1985), 211.

297 "DON'T TELL"
Letter to Jane Gaskell, September 2, 1957,
in The Collected Letters of C. S. Lewis, ed.
Walter Hooper, vol. 3, Narnia, Cambridge
and Joy, 1950–1963 (New York: HarperCollins,
2007), 879.

298 "IT IS NECESSARY"
"Selections from Twelve Days (1928),"
in Vita Sackville-West: Selected Writings,
ed. Mary Ann Caws (New York: Palgrave
Macmillan, 2003), 125.

298 "YOU SHOULD FEEL"
Interview by A. M. Homes, BOMB, no. 57
(Fall 1996): http://bombmagazine.org/
article/2004/tobias-wolff.

298 "THE BEST THING"
Interview by Paul M. Angle, Poets.org,
April 18, 2017, https://www.poets.org/
poetsorg/text/we-asked-gwendolyn-brooks-
about-creative-environment-illinois.

298 "IF YOU'RE LONELY"
Interview by Michael Clarkson,
Niagara Falls Review, November 12, 1979,
reprinted in J. D. Salinger: The Last Interview
and Other Conversations, ed. David Streitfeld
(Brooklyn: Melville House, 2016), 54.

298 "WHY AM I"
Interview by Bill Buford, Granta, no. 21
(Spring 1987), reprinted at author's website,
http://kapuscinski.info/an-interview-by-bill-
buford.html.

298 "GOOD WRITERS"
ABC of Reading (New York: New Directions,
1960), 32.

299 "THIS ABOVE ALL"
Letter One, February 17, 1903, in
Letters to a Young Poet, trans. M. D. Herter
Norton, rev. ed. (New York: W. W. Norton,
1954), 18–19.

299 "I'M JUST"
Journal entry, ca. October 1836,
in Christine Alexander, Early Writings of
Charlotte Brontë (Buffalo, NY: Prometheus
Books, 1983), 143.

300 "IT WAS ONLY"
Diary entry, March 1933, in The Diary of
Anaïs Nin, ed. Gunther Stuhlmann, vol. 1,
1931–1934 (New York: Swallow, 1966), 185.

300 "THE PROCESS"
Interview by Sandra Lim, National Book
Foundation, n.d., http://www.nationalbook.
org/nba2014_p_gluck_interv.html.

301 "I STARTED"
"Spokane Words: Tomson Highway Raps
with Sherman Alexie," interview by Tomson
Highway, Aboriginal Voices, January–March
1997, reprinted in Conversations with
Sherman Alexie, ed. Nancy J. Peterson (Jackson:
University Press of Mississippi, 2009), 25.

301 "THERE'S A CERTAIN"
Interview by Karen Heller, Independent,
September 8, 2016, http://www.independent.
co.uk/arts-entertainment/books/features/
jonathan-safran-foer-interview-the-meaning-
of-the-book-is-not-something-that-is-
mine-a7231901.html.

301 "I WANT TO BE"
Carlos L. Dews, ed., Illumination and
Night Glare: The Unfinished Autobiography
of Carson McCullers (Madison: University
of Wisconsin Press, 1999), 38.

301 "OVER A LIFETIME"
On the Move: A Life (New York: Vintage,
2016), 384.

301 "MY FRIEND"
Interview by Alison Beard, Harvard Business
Review, September 2015, https://hbr.
org/2015/09/lifes-work-salman-rushdie.

302 "I USED TO"
Interview by Teresa Burns Gunther, Bookslut,
May 2013, http://www.bookslut.com/
features/2013_05_020064.php.

302 "WOULD YOU"
Letter to Sylvia Payne, April 24, 1906, in
The Collected Letters of Katherine Mansfield, ed.
Vincent O'Sullivan and Margaret Scott, vol. 1,
1903–1917 (Oxford: Clarendon, 1984), 19.

302 "DOESN'T WRITING"
Letter to William Canine, October 6, 1949,
in Selected Letters of William Styron, ed.
Rose Styron and R. Blakeslee Gilpin
(New York: Random House, 2012), 62.

303 "WRITING SAVED"
"This Much I Know," Guardian,
December 10, 2016, https://www.
theguardian.com/lifeandstyle/2016/
dec/10/slavoj-zizek-we-are-all-basically-
evil-egotistical-disgusting.

304 "I'VE SEEN"
Joel Lovell, "George Saunders Has
Written the Best Book You'll Read This Year,"
New York Times Magazine, January 3, 2013,
http://www.nytimes.com/2013/01/06/
magazine/george-saunders-just-wrote-the-
best-book-youll-read-this-year.html.

304 "THE GOOD WRITER"
Journal entry, ca. 1867, in
The Journals and Miscellaneous
Notebooks of Ralph Waldo Emerson, ed.
Ronald A. Bosco and Glen M. Johnson,
vol. 16 (Cambridge, MA: Belknap, 1982), 54.

304 "WHAT I WOULD"
"Looking for a Garde of Which to
Be Avant," interview by Hugh Kennedy
and Geoffrey Polk, Whiskey Island,
Spring 1993, reprinted in Conversations
with David Foster Wallace, ed.
Stephen J. Burn (Jackson: University
Press of Mississippi, 2012), 16.

304 "YOU'RE GOING"
"12 Truths I Learned from Life and Writing,"
TED Talk, April 2017, transcript, https://
www.ted.com/talks/anne_lamott_12_truths_i_
learned_from_life_and_writing/transcript.

304 "DO NOT WRITE"
"One-Way Street," in Reflections: Essays,
Aphorisms, Autobiographical Writings, ed.
Peter Demetz, trans. Edmund Jephcott (New
York: Harcourt Brace Jovanovich, 1978), 81.

304 "WRITING IS"
The Difficulty of Being, trans.
Elizabeth Sprigge (New York: Coward-McCann,
1967), 134.

305 "A REAM"
My Several Worlds: A Personal Record
(New York: John Day, 1954), 407.

LAST PAGE

336 "IF THERE'S A BOOK"
Twitter, October 30, 2013, 5:26 p.m.,
http://twitter.com/tonimorrison/
status/395708227888771072.

Phaidon Press Limited
Regent's Wharf
All Saints Street
London N1 9PA

Phaidon Press Inc.
65 Bleecker Street
New York, NY 10012

phaidon.com

First published 2018
© 2018 Phaidon Press Limited

ISBN 978 0 7148 7581 1

A CIP catalog record for this book is available from the
British Library and the Library of Congress.

Researcher and Project Editor: Sara Bader
Editorial Assistant: Simon Hunegs
Production Controller: Lisa Fiske
Design: Julia Hasting
Typesetting: Elana Schlenker

Title quotation by Oliver Sacks: quoted in Bill Hayes, journal
entry, January 11, 2010, in Insomniac City: New York, Oliver,
and Me (New York: Bloomsbury, 2017), 51.

Printed in China

IF THERE'S A BOOK YOU WANT TO READ, BUT IT HASN'T BEEN WRITTEN YET, THEN YOU MUST WRITE IT.

TONI MORRISON